Voyage to Paradise

MARSH TEMPLE

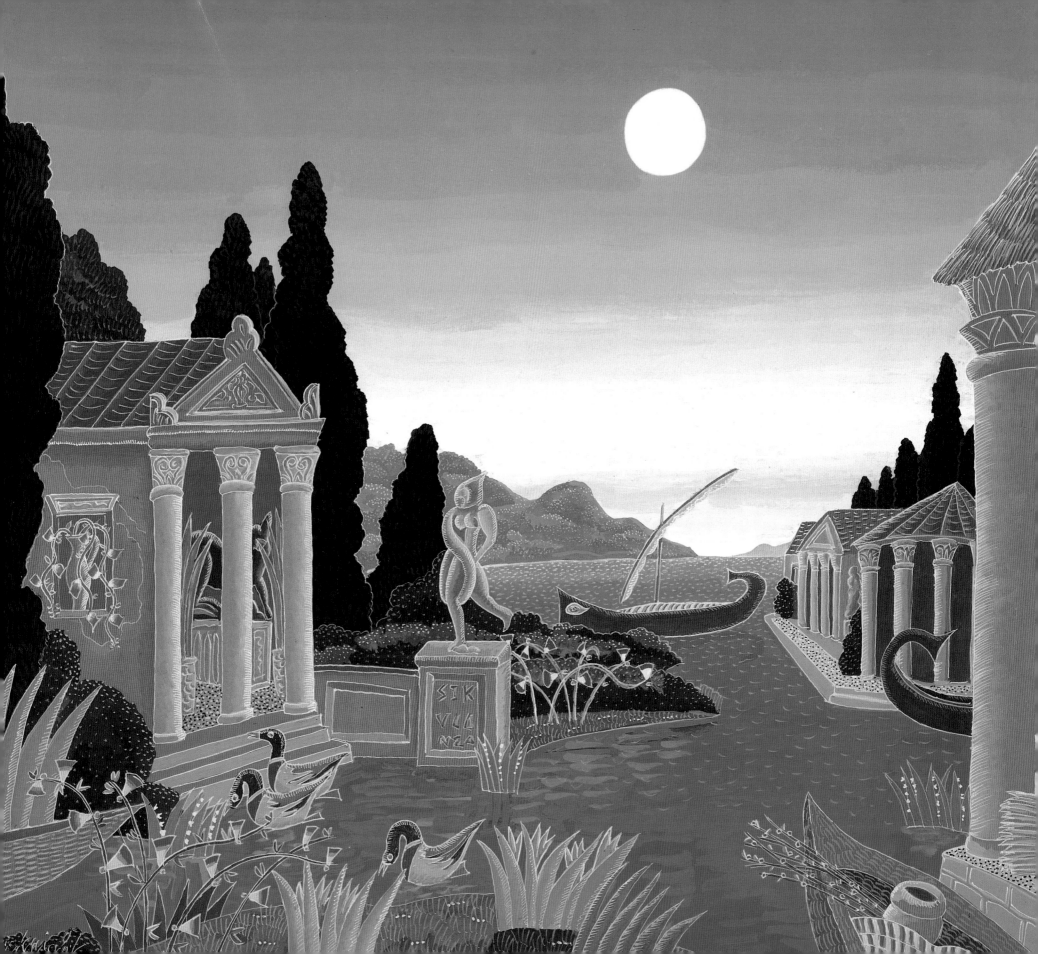

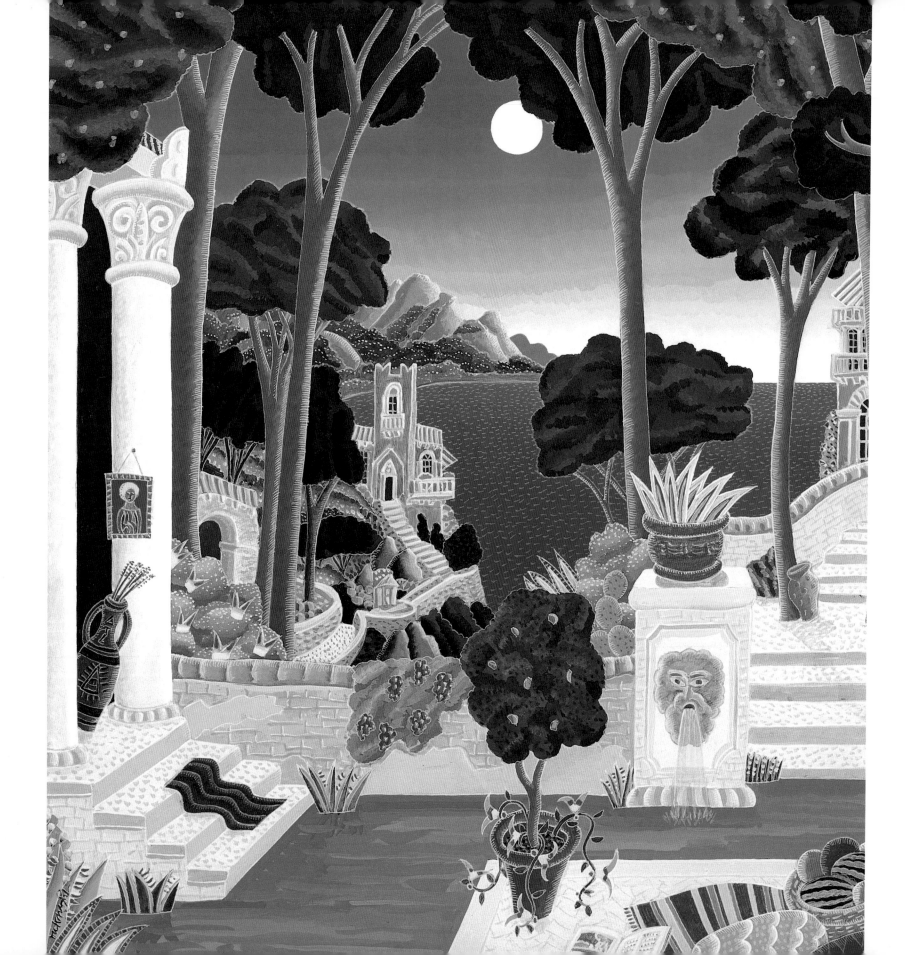

Voyage to Paradise

A VISUAL ODYSSEY

THOMAS McKNIGHT

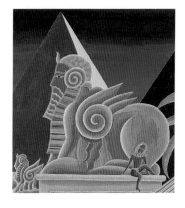

Text by Annie Gottlieb

HarperSanFrancisco

A Division of HarperCollins*Publishers*

In addition to thanking Ed Marquand and his staff for their ideas and tireless efforts, I also wish to especially thank my wife, Renate. Operating behind the scenes, she does a good deal of the work and has an ineffable sense of design and color.

—*Thomas McKnight*

Thomas McKnight prints and posters are published by Chalk & Vermilion, 200 Greenwich Avenue, Greenwich, CT 06830.

FIRST EDITION

Library of Congress Cataloging-in-Publication Data
McKnight, Thomas.
 Voyage to paradise / Thomas McKnight ; with text by Annie Gottlieb. — 1st ed.
 p. cm.
 Includes bibliographical references.
 ISBN 0–06–250807–5 (alk. paper) (hardbound)
 ISBN 0–06–250977–2 (alk. paper) (softbound)
 1. McKnight, Thomas—Themes, motives. I. Gottlieb, Annie. II. Title.
 NE2237.5.M35A4 1993
 769.92—dc20 92-42295
 CIP

93 94 95 96 97 MRQ 10 9 8 7 6 5 4 3 2 1

This edition is printed on acid-free paper that meets the American National Standards Institute Z39.48 Standard.

The author gratefully acknowledges the publishers who kindly granted permission to quote from the following publications:

The Berlitz Travellers Guide to Northern Italy and Rome and *The Berlitz Travellers Guide to Southern Italy and Rome.* Copyright © 1992 by Root Publishing Company. Reprinted by permission of Berlitz Publishing Company, Inc.

Care of the Soul, by Thomas Moore. Copyright © 1992 by Thomas Moore. Reprinted by permission of HarperCollins Publishers.

The Colossus of Maroussi, by Henry Miller. Copyright © 1941 by Henry Miller. Reprinted by permission of New Directions Publishing Corporation.

The Cult of the Black Virgin, by Ean Begg. London: Arkana, 1985. Copyright © 1985 by Ean Begg. Reprinted by permission of Penguin Books Ltd.

Dreaming the Dark, by Starhawk. Copyright © 1982 by Miriam Simos. Reprinted by permission of Beacon Press.

The Golden Ass of Apuleius, by Marie-Louise von Franz. Copyright © by Marie-Louise von Franz. Reprinted by arrangement with Shambhala Publications, Inc., 300 Massachusetts Ave., Boston, MA 02115.

The Greek Islands, by Lawrence Durrell. Copyright © 1978 by Lawrence Durrell. Reprinted by permission of Viking Penguin, a division of Penguin Books USA Inc.

The Hero and the Goddess: The Odyssey as Mystery and Initiation, by Jean Houston. Copyright © 1992 by Jean Houston. Reprinted by permission of Random House, Inc.

The Hero Journey in Dreams, by Jean Dalby Clift and Wallace B. Clift. Copyright © 1988 by Jean Dalby Clift and Wallace B. Clift. Reprinted by permission of The Crossroad Publishing Company.

Italian Journey (1786–1788), by Johann Wolfgang von Goethe. All rights reserved. Reprinted by permission of Pantheon Books, a division of Random House, Inc.

Prospero's Cell and *Reflections on a Marine Venus,* by Lawrence Durrell. Copyright the estate of Lawrence Durrell. Reprinted by permission of Faber and Faber Ltd. and Curtis Brown Ltd., London, on behalf of the Estate of Lawrence Durrell.

Re-Visioning Psychology, by James Hillman. Copyright © 1975 by James Hillman. Reprinted by permission of HarperCollins Publishers, Inc.

Venice Observed, by Mary McCarthy. Copyright © 1963. Reprinted by permission of Harcourt Brace & Company.

The World in Color: Greece, Dore Ogrizek, ed. Copyright © 1955. Reprinted by permission of McGraw-Hill, Inc.

Front cover: *Temple Precinct*
Back cover: *Temple of Demeter*
Frontispiece: *Ligurian Pool*
Page 8: *Sculptor's Studio*
Photographs by Robert Skinner, except page 246 © by Anthony Edgeworth
Designed by Marquand Books, Inc.
Printed in Japan

Note

All the paintings illustrated are made with casein pigments, a milk-based emulsion similar to that used for Renaissance frescoes. The paintings are typically about 16 by 18 inches, but some of the allegorical canvases with many figures range up to 48 by 52 inches.

Often the artist creates two versions of a painting. The smaller version, on paper (most of those pictured here), is used as a matrix for printmaking. It is also used as a model for larger paintings in either casein or acrylic on canvas.

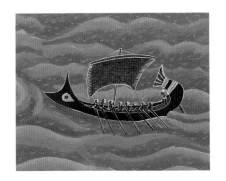

Contents

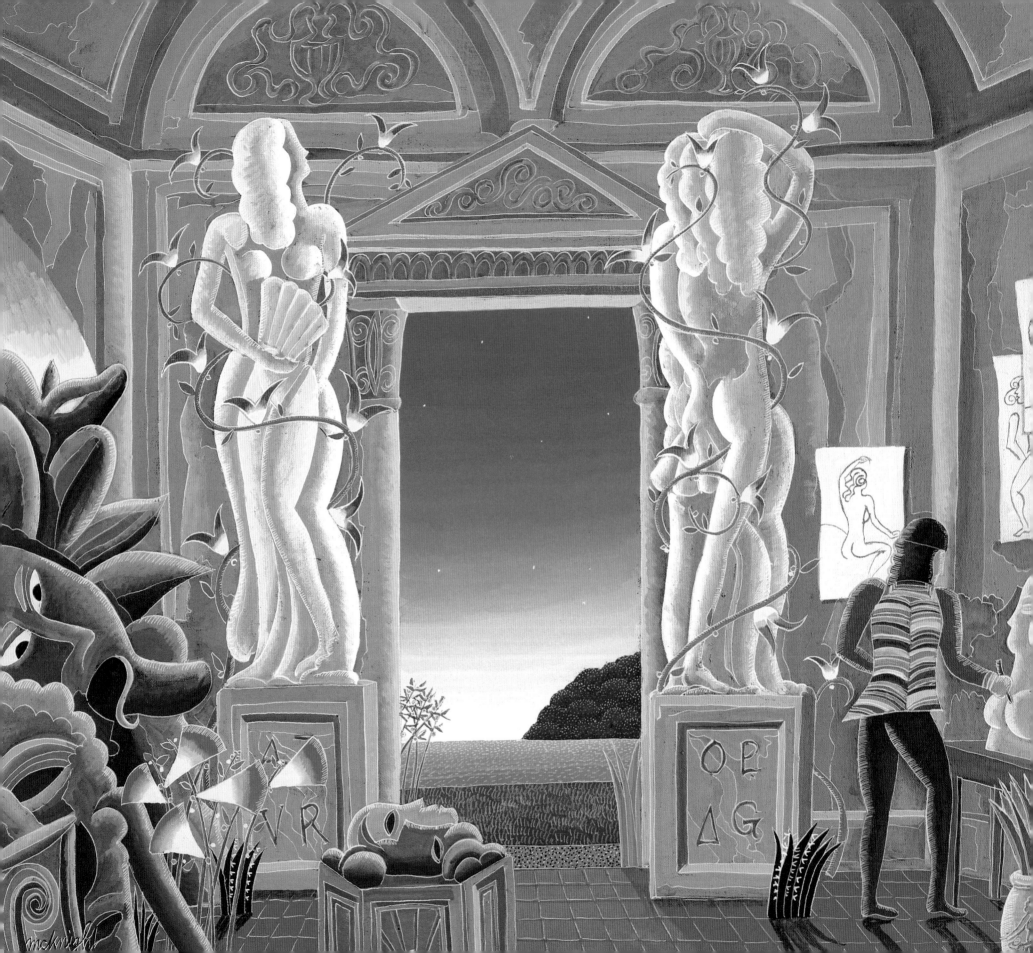

Foreword

I have always felt that the artist's role is to communicate his or her vision by using strong images—images that transcend the everyday materials from which they are fabricated. For me, success comes when I create an image my imagination can live inside, in the way that other artists' images have lived within me.

A gallery of images in your memory is not the same as collecting art in that you don't have to *own* anything. A particularly strong image can be a catalyst for emotion, just as an opera or a poem, and it can come equally from a painting or an orange-crate label. At first, you're fascinated with it and then you wonder why one in particular means more to you than others. Why, for instance, does Bellini's *Feast of the Gods* haunt me more than almost any other Renaissance painting? Is it because I loved it when I was fourteen? You can live with an image, recall it in your mind's eye, examine it like a beach pebble from different angles, and ponder its meaning. Eventually you may put it back on memory's shelf, but when you retrieve it, it still glows—now even more strongly, with its aura of nostalgia for a long lost time.

Images that evoke such feelings can come from art or simply from fading snapshots, tail fins, and flamingo swizzle sticks. What differentiates art from other imagery is its layers of meaning. I don't need to understand neo-Platonism or have lived at the time of the Medici to love Botticelli's *Primavera*; nor do I need to have practiced voodoo to feel the power of a Haitian mask. Although studying the background and genesis of art can help us appreciate its deeper layers, we are already equipped to enjoy all but its most esoteric forms simply because we are human.

Unfortunately, we live in a time when the preponderance of graphic visual forms are beyond most people's interest or understanding. Much

visual art has been hijacked by theoreticians who use it to illustrate arid theories, and by dealers and collectors who employ it as a totem for other things—prestige, propaganda, being "with-it." In the process, the majority of people have been forced to find their dream images in movies, television, and the work of artists and illustrators who ply their craft in art-world backwaters.

I suppose that after you flip through this book, you may decide that my work falls happily into that backwater class. You may then wonder, Why these images? Why, in an age when digitalized information whizzes invisibly through our homes and jet contrails crisscross the sky, does an artist create such anachronistic pictures: Nubian maidens crouching in front of pyramids, classical temples and sphinxes, resorts without telephone wires, towns without automobiles?

The simple answer is that when I paint I try to integrate what is real about a place or thing with its underlying truth—its invisible soul. The process is the opposite of impressionism or photography, which attempt to fix in time a fleeting moment. I attempt to evoke with color, form, and imagination the essence of a place or thing without so much regard for historical accuracy. My images of Mykonos, for example, are readily identifiable with the real island, but they heighten what is unique about Mykonos by concentrating on its most characteristic curves and colors and leaving out its scuffs and tourist debris. In this way, my images of the island resemble those in dreams or in icons, in which only the essentials matter.

Voyage to Paradise contains those pictures closest to my soul image of the world. That world is a place where past and present meet, where major

and minor deities preside, dwelling in the springs, forests, hilltops, sea-coasts, and in all the humanmade places—wells, terraces, temples, cities. A room may be empty when I paint it, but a nymph has just left and her presence is still felt.

In the real world I feel most akin to those special places where this sense of numinosity occurs. (Could these be the places where the physical world intersects with the spiritual?) As a child I spent countless after-noons reading about antiquity; as an adult I keep returning to the lands where ancient Greece, Rome, and Egypt left their ruins. I feel truly at home basking in Greece's dry, thyme-scented summers or wandering through history-soaked Venetian alleys. And I'm also enamored of south-ern regions—to the palm trees and the boom of surf, to the islands where colors are most uninhibited.

Lately, my greatest challenge has been to try to combine all these loves—dry hills, indigo seas, ruins, purple bougainvillea, white stucco walls, lateen-rigged coasters—into pictures of imaginary places and crea-tures, and thereby invent a kind of paradise within. This is a Garden of Eden from which we cannot be expelled.

In the following pages, two winding paths converge on their way to paradise. One you can trace in my paintings—the other in Annie Gottlieb's wise words. Together they may inspire you to collect your own souvenirs to furnish your own Arcadia.

—Thomas McKnight

· I ·

Where the Journey Begins

MASSACHUSETTS SUN PORCH

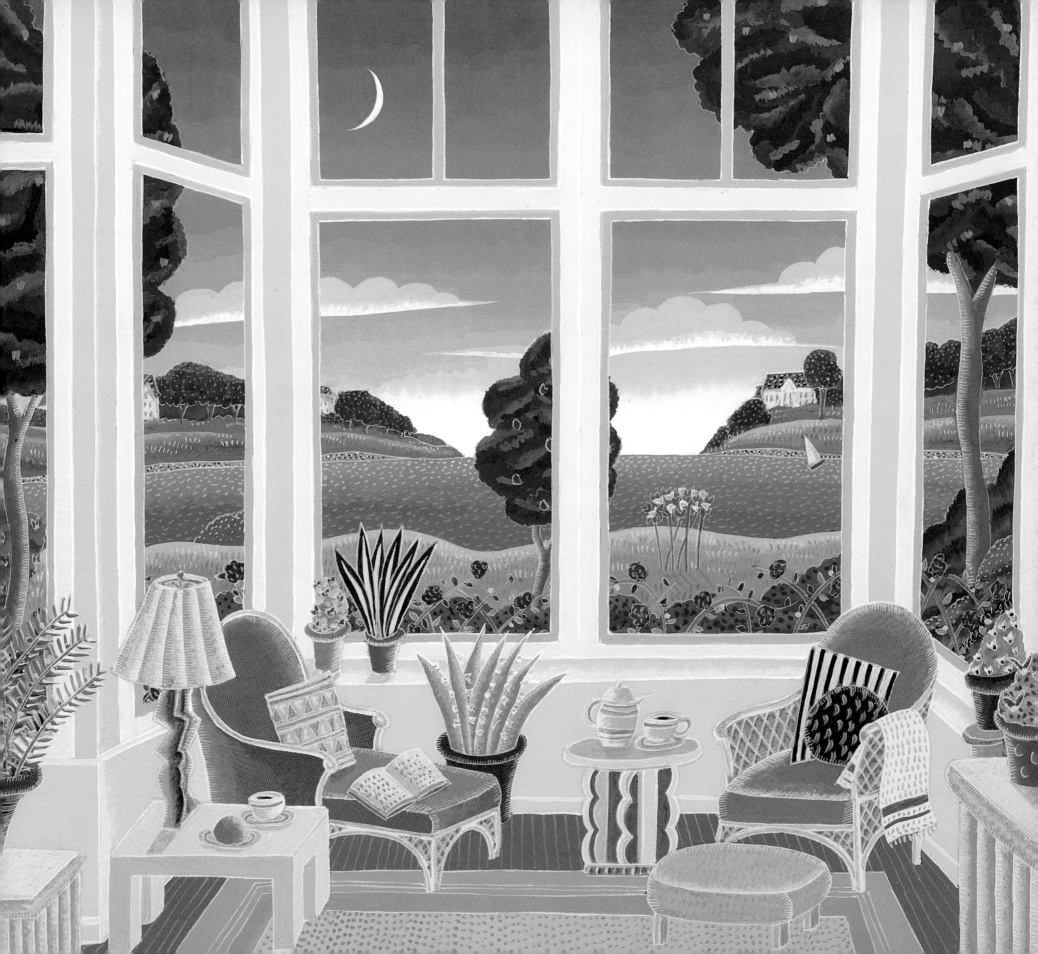

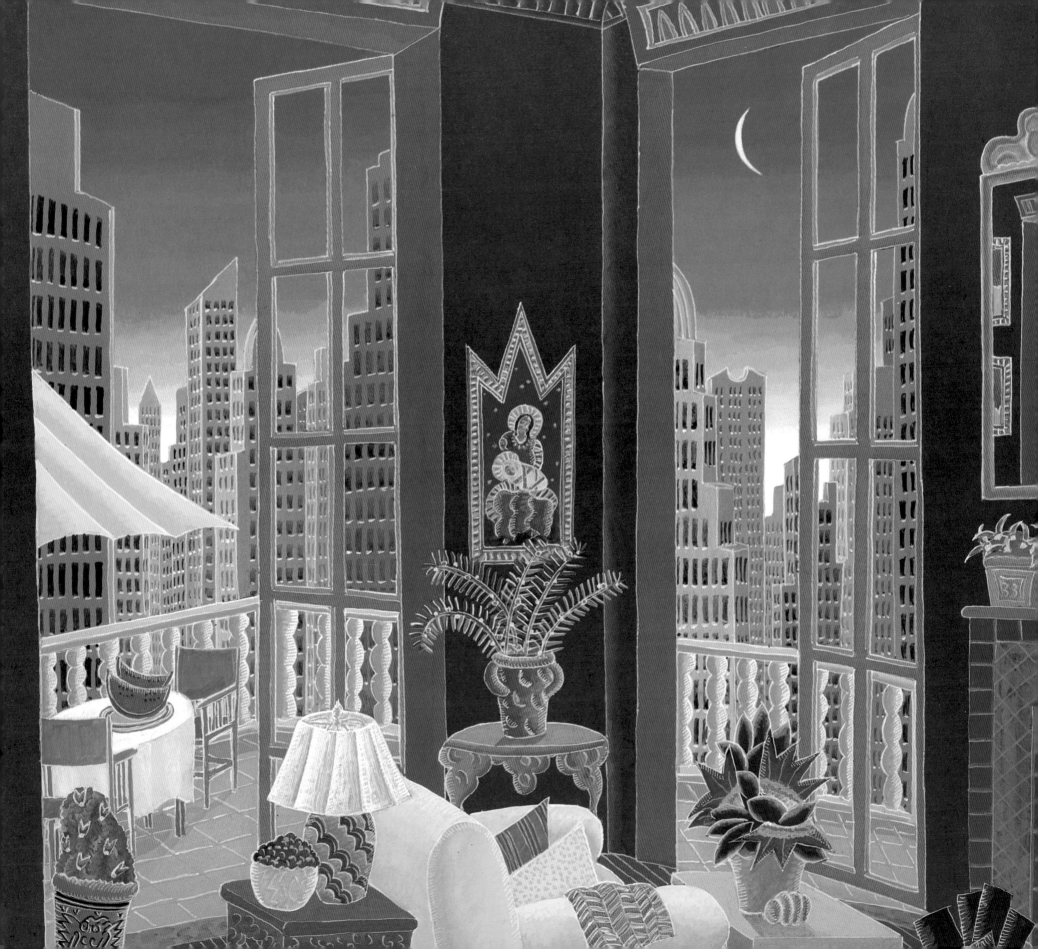

Home

Close your eyes and let the comfort of the word *home* waft through you like the smell of baking bread. What image does that word conjure for you, more than any other? A particular childhood room, more vivid in your mind's eye than anything you've seen today? Or is it your current kitchen, the room where everyone gravitates for coffee and confidences, because that's where the heartbeat of the house can be felt? Has that room been made especially cozy and appealing in honor of its "homeness"? Or is home a place you haven't found yet? Where do you imagine it, how do you furnish it in your dreams? You know the feeling, "home," and you surely have visual images to go with it, whether remembered or imagined—and those are not two different things. Memory and imagination both draw images up from the deep psyche where sensory data have "suffered a sea-change" into something more intimate and permanent. Home is an idea we carry within us, whether we've been there physically or not.

Home is what I recognize in these images by Thomas McKnight. I seem to know these rooms I've never seen before. It is the *feeling* of home he's painted—centered, here-and-now, held in the familial embrace of sheltering walls and facing chairs. In each room we can find what T. S. Eliot called "the still point of the turning world": front and center, just a few steps in front of us if we were to walk in, the focus of the composition's loving attention. There's a feeling of arrival and rest, and of refreshment: stand or sit just here, and you'll refill with energy. These pictures tell me that our impulse to make our homes beautiful is not for others' eyes, but for our own. Choosing a chair or print, decorating a room, we create a spiritual battery with the power to recharge us.

Today, we have a new idea of home: a "haven in a heartless world," wired with alarm systems, barricaded against crime and industrial poisons. The more we withdraw into it, the harsher and uglier the outside world becomes, the more we withdraw . . . until our rooms are as stuffy as a fearful, held breath. McKnight's airy rooms breathe beauty in and out as freely as the homes of our long-ago childhood, with their never-locked doors and windows flung wide. He reminds us that "home" was once a planet with pure lakes and unpolluted skies. We must be able to remember and imagine that world before we can re-create it. Beauty has to well up from within us; the ambient ugliness did, spewing out of human greed like waste from a pipe. But we will need a drastic renewal of the sources of the imagination—what Aldous Huxley called "cleansing the doors of perception." And what cleanses vision is motion.

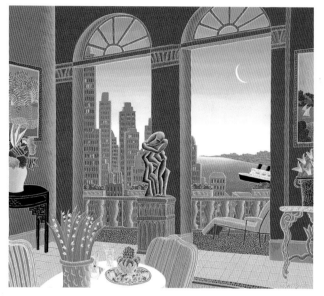

The human eye must move to see at all. An immobilized eye goes blind until it is freed to dart like a feeding minnow. When we have stared too long at the same chair, the same face, the same hill or skyline, we stop seeing it.

16

BERKSHIRE STUDIO

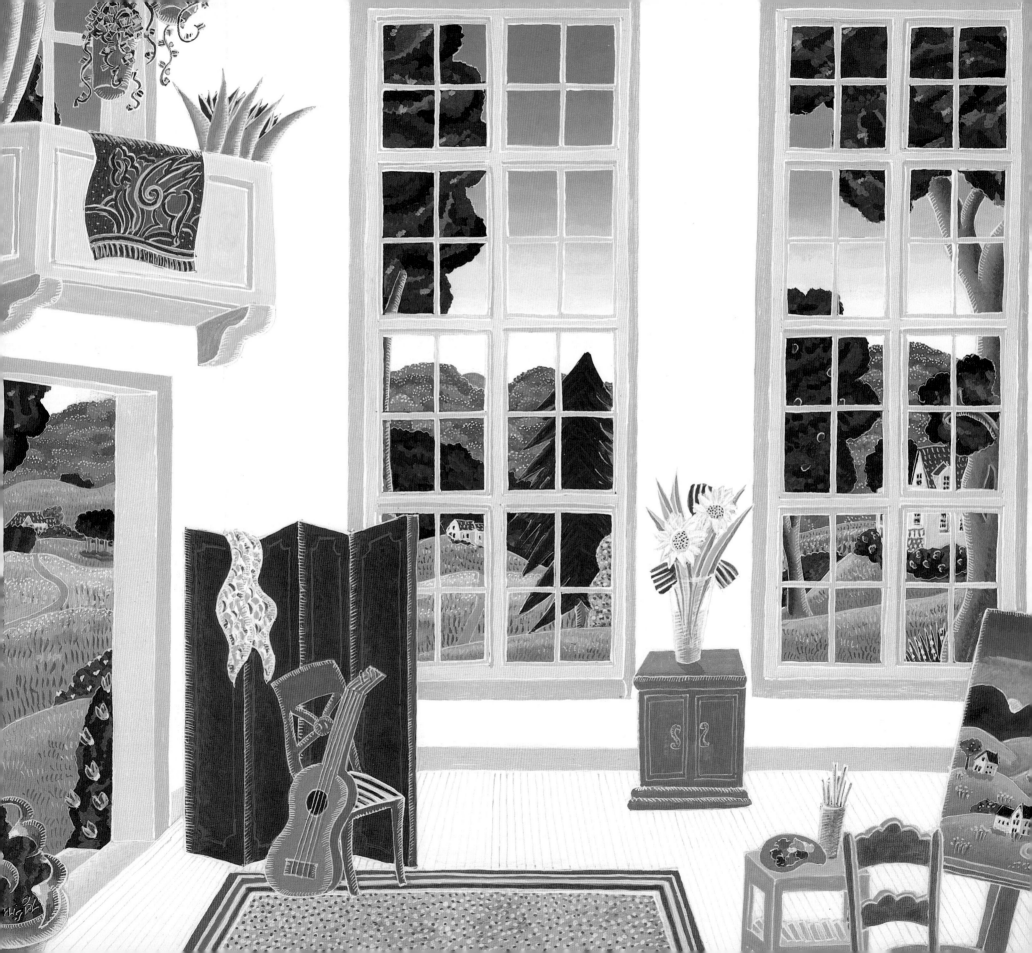

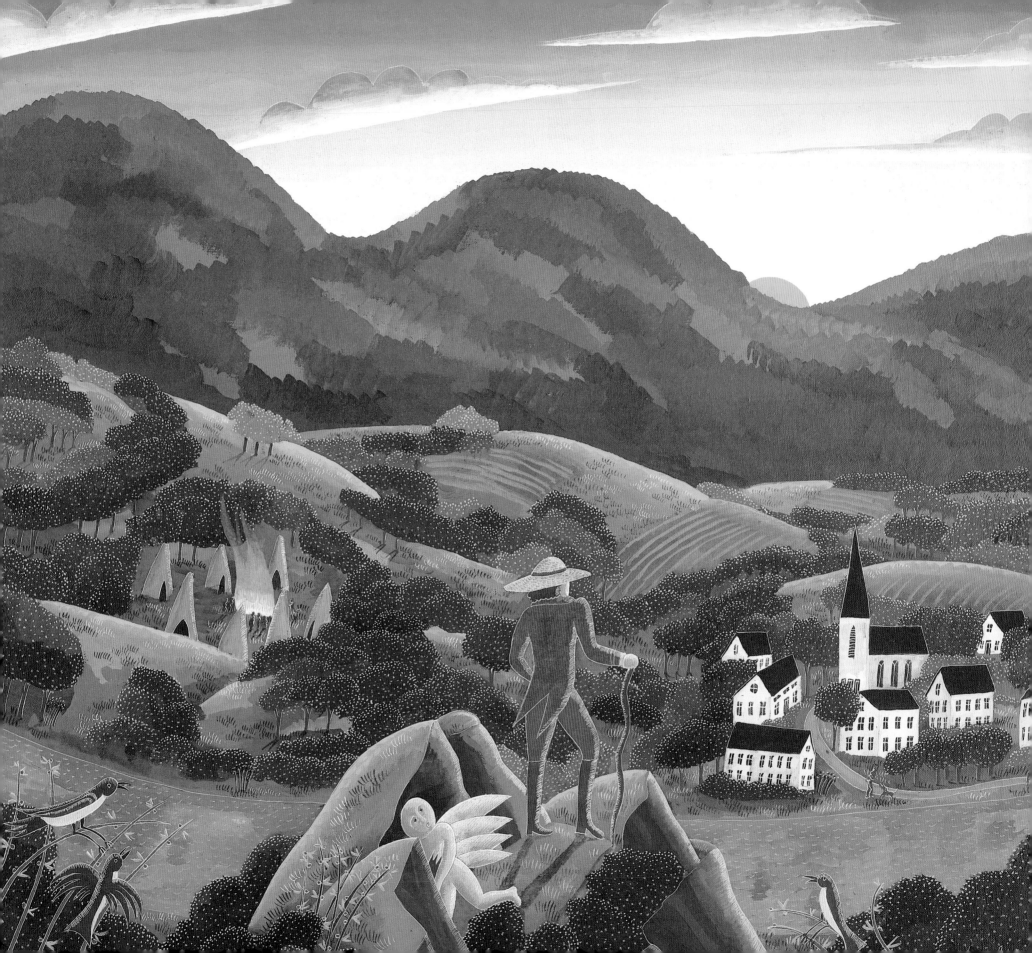

Then, we "get the urge for going," as Tom Rush used to sing. We call the travel agent and start looking at resort brochures. We think of it as escape, getting away from it all, recreation. But look at that word: *re-creation*. The most frivolous tourism hides a quest for the same goal as the Grail: renewal of our own lives and the health of our blighted land. Hope springs eternal on the faces at the airport. We are deeply convinced that paradise can be found on earth.

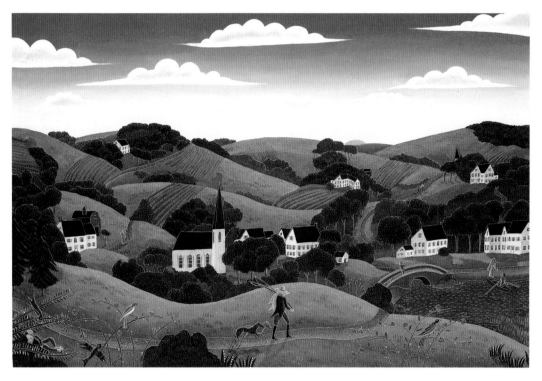

CONNECTICUT VALLEY

Leaving Home

There is a moving away from the home place. . . . The hero departs from the way things have been. There may have been a dissatisfaction with the status quo or boredom with the way things were. The question of departure from the home place often entails what [Joseph] Campbell called the "call to adventure" . . . perhaps experienced only as a deep longing without quite knowing why or what for.

—Jean Dalby Clift and Wallace B. Clift,
The Hero Journey in Dreams

NEW ENGLAND VALLEY

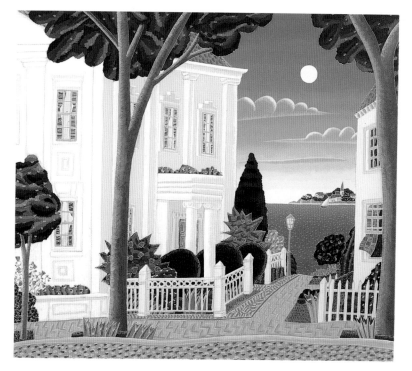

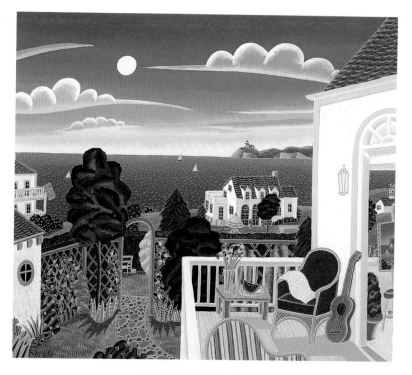

ORANGE STREET, NANTUCKET

NANTUCKET PORCH

If Thomas McKnight knows how to paint home, he also knows how to paint the urge to leave it. It starts with an open window or door. The wind comes in, stirring things; its motion suggests and tempts; it fills our sails. In New England and Manhattan, McKnight's "home" landscapes, the wind brings a rumor of the sea, for millennia so much a synonym for travel that the Greeks called it the great road. In mid-Manhattan you can't see the ocean, but gulls wheel and cry over the mastlike skyscrapers, and on good days the wind smells of salt. Coastal New England is veined with salt marshes and inlets; ship-shaped clouds sail overhead. Before you know it you're out under the open sky. Toss your staff into the air, like the wandering samurai in Kurosawa's film *Yojimbo*, and follow the way it falls. Thomas McKnight says that starting a painting is like starting out on a journey: tentative and errant at first, the charcoal stick, like the traveler's staff, chooses its own direction.

And in his landscapes, all roads lead to the sea.

CAPE COD

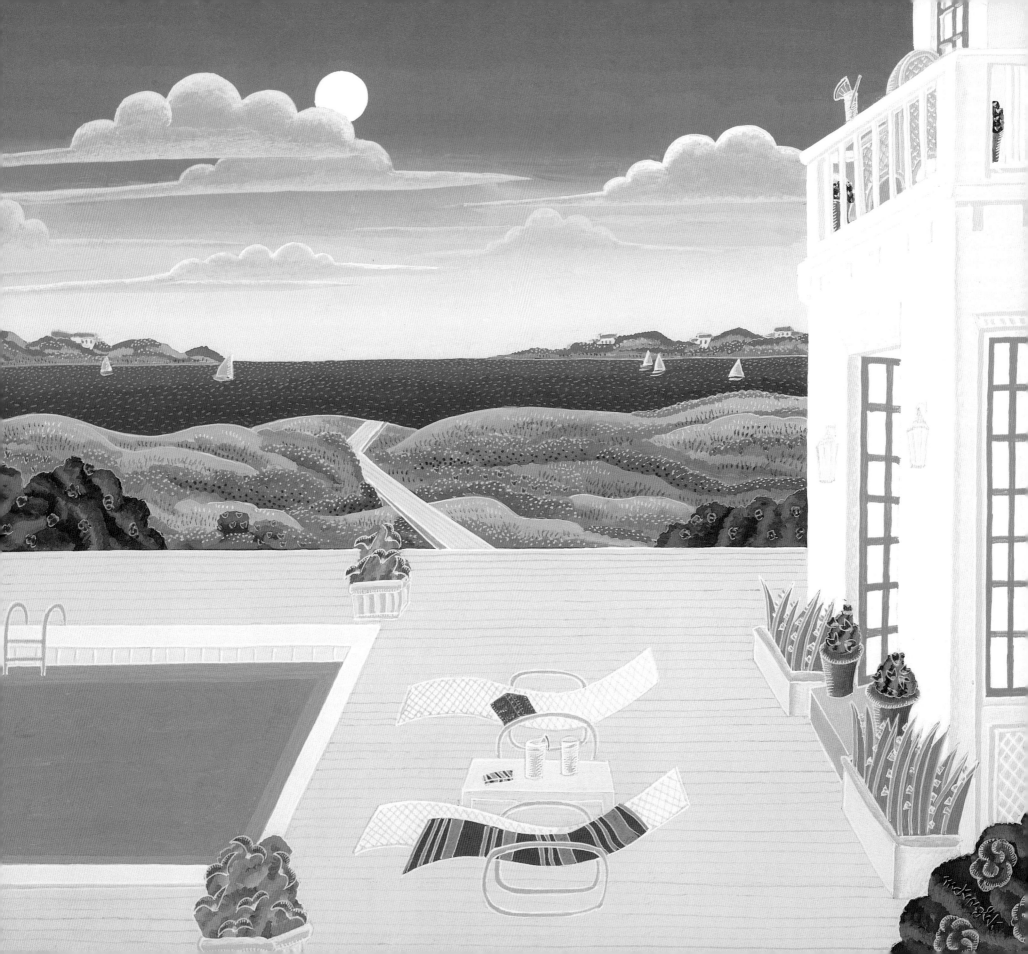

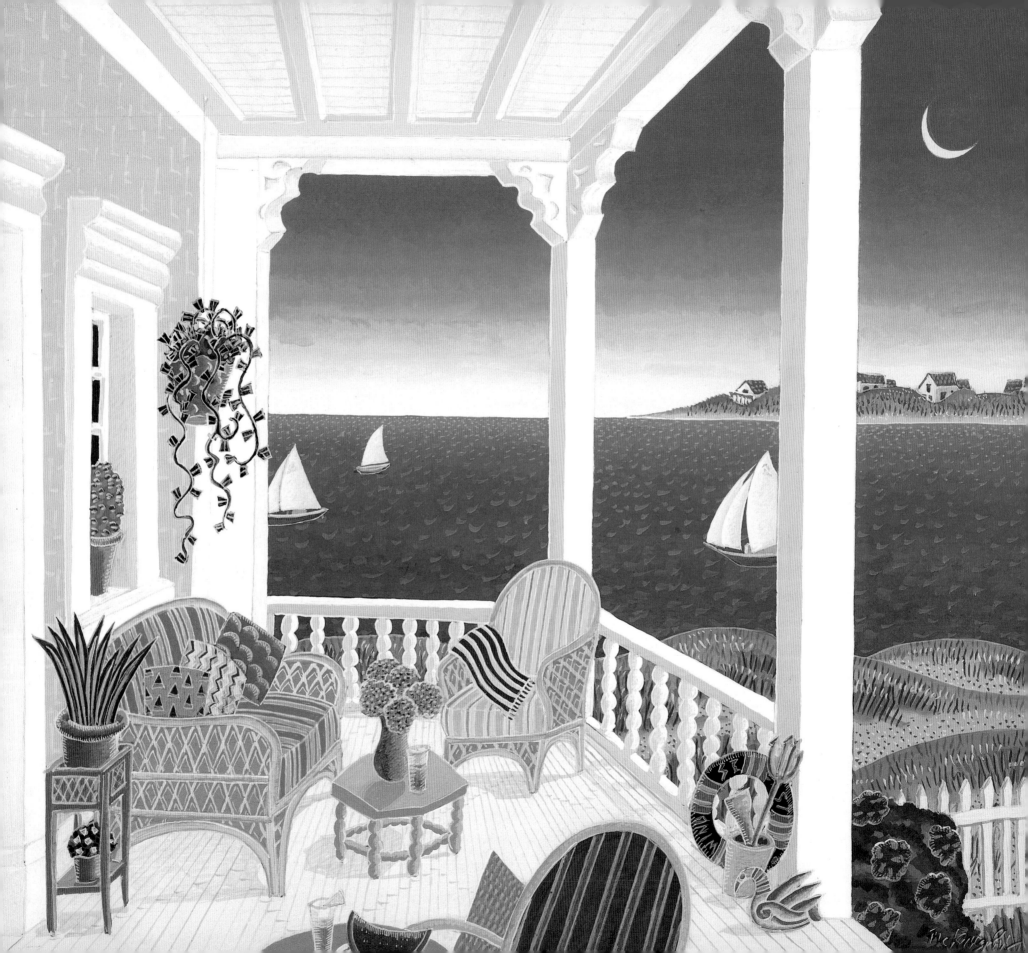

"Journey" is a motif that lives as deep in us as "home" does. In fact, they are a pair, like the fixed and the moving foot of the compass you learned to use in school. Our horoscopes are made up of fixed stars and moving planets, whose very name means "wanderer." For every snug image in our language—"a man's home is his castle," "home is where the heart is," "home sweet home" —there is another image of our essential nomadism and homelessness, our incurable searching and yearning. "The little foxes have holes, and the birds of the air have nests; but the son of man hath not where to lay his head" is one of the most haunting sayings of Jesus.

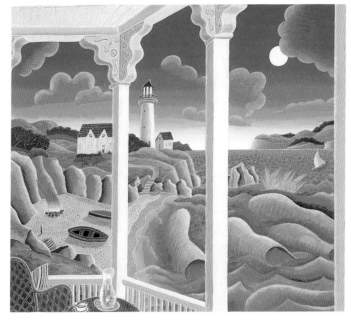

"You can stay here as one stays overnight in a caravanserai—when the morning comes you have to go," said a more recent and controversial spiritual teacher, Rajneesh. I imagine our traveler arriving at the edge of the continent, staying overnight with friends on Nantucket Island— fingering the guitar on the porch, reclining beside the pool—but always gazing out to sea, feeling the pull to journey farther. The promise of Paradise lies beyond that horizon. Finally it's time to walk down to land's end, to the lighthouse that will guide the ship that comes for us, as fires on the beach once brought boats safely ashore.

LIGHTHOUSE POINT

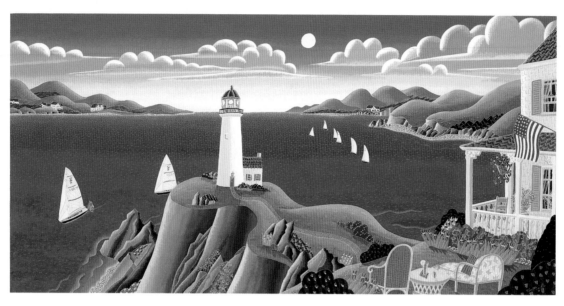

NEWPORT

Of course, the ship—or plane—that arrives for us is the boat of Ulysses. His voyage, with all its unforeseen turnings, is the prototype for every trip we take. No matter how we plan, it is the surprises, and even the near-disasters, that become the highlight of our travels—and the best stories. "There is a Bible in every wanderer's bedroom, where there might better be the *Odyssey*," writes archetypal psychologist James Hillman. What we forget is that through all his adventures, Odysseus was trying to go home.

In *The Hero and the Goddess* Jean Houston writes, "Home is the pivotal purpose of *The Odyssey*. In the beginning, home is a wasteland, ruined by feasting and riotous suitors. In the end, home is cleansed and restored. Odysseus' major task is to put his home—his local culture and civilization—to rights. But before he can do so, he must embark on a great voyage of self-discovery through all the other realms of being." He would visit ancient civilizations and enchanted islands, meet sea monsters, nymphs, gods, and goddesses. And so will we.

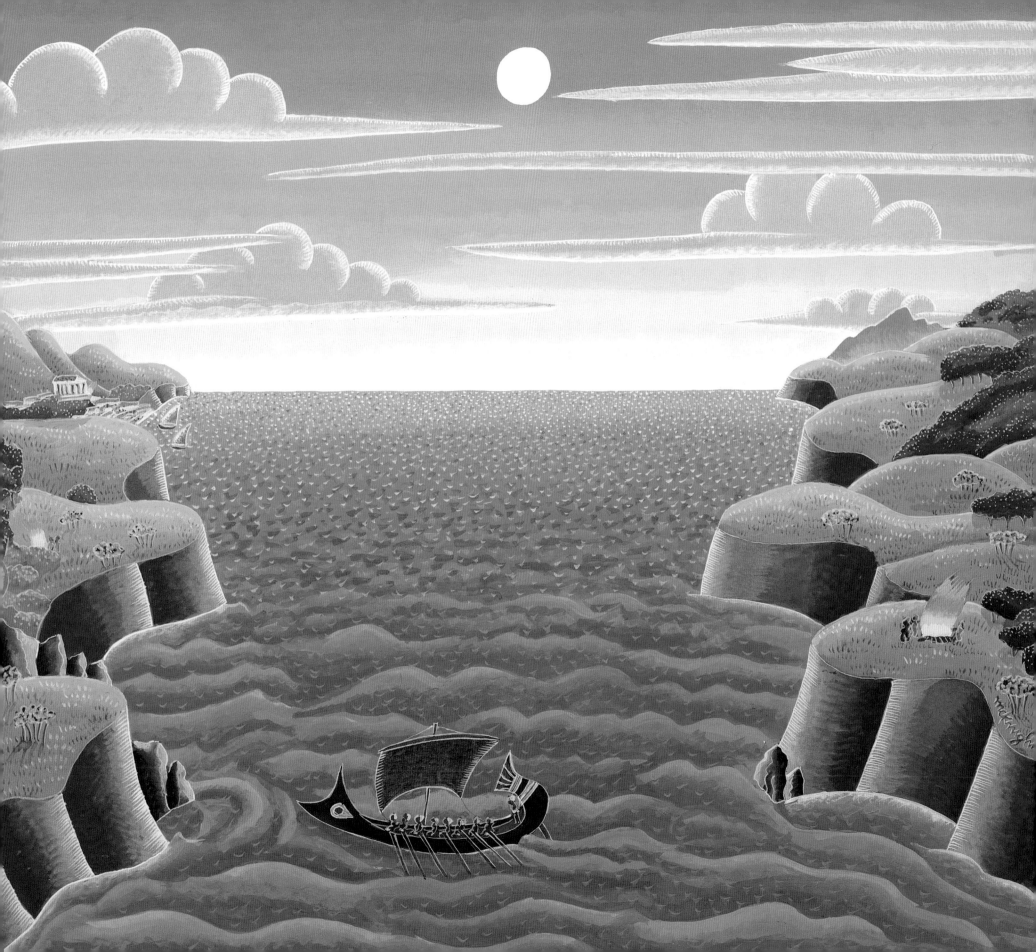

· II ·

The Voyage Down

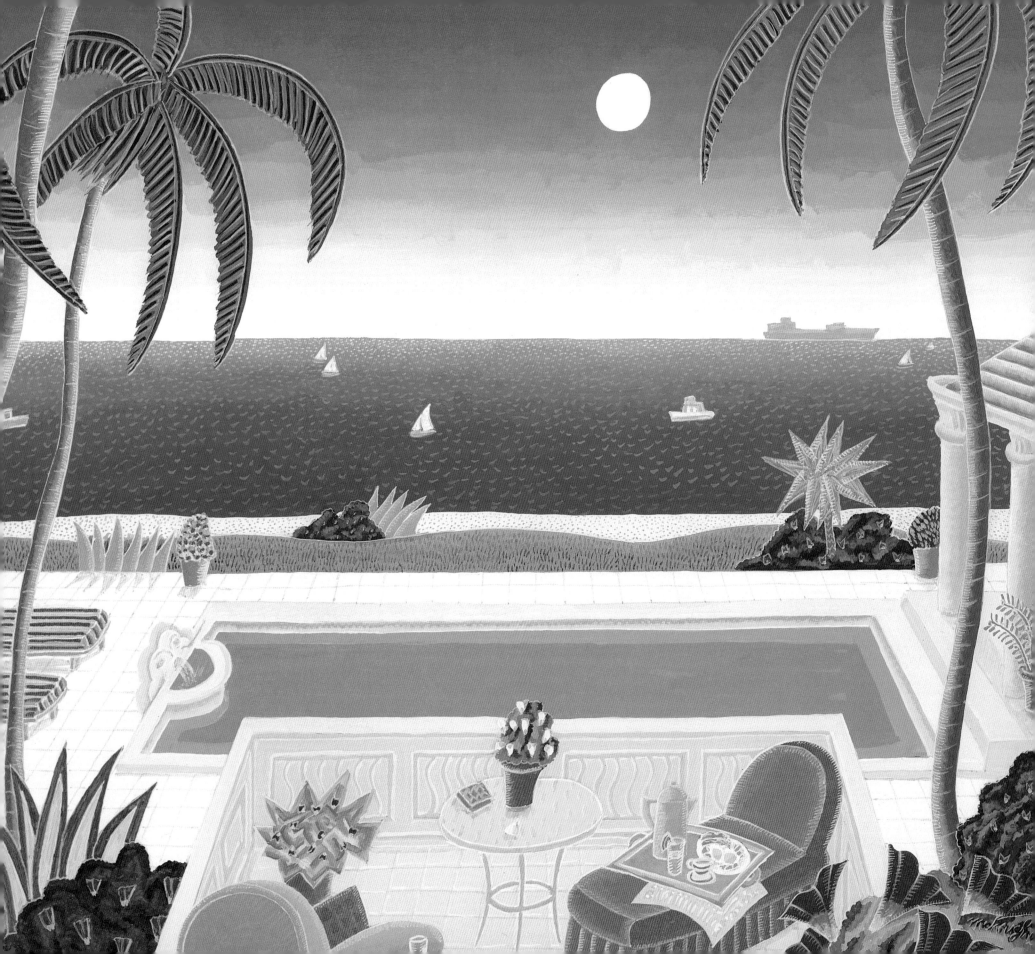

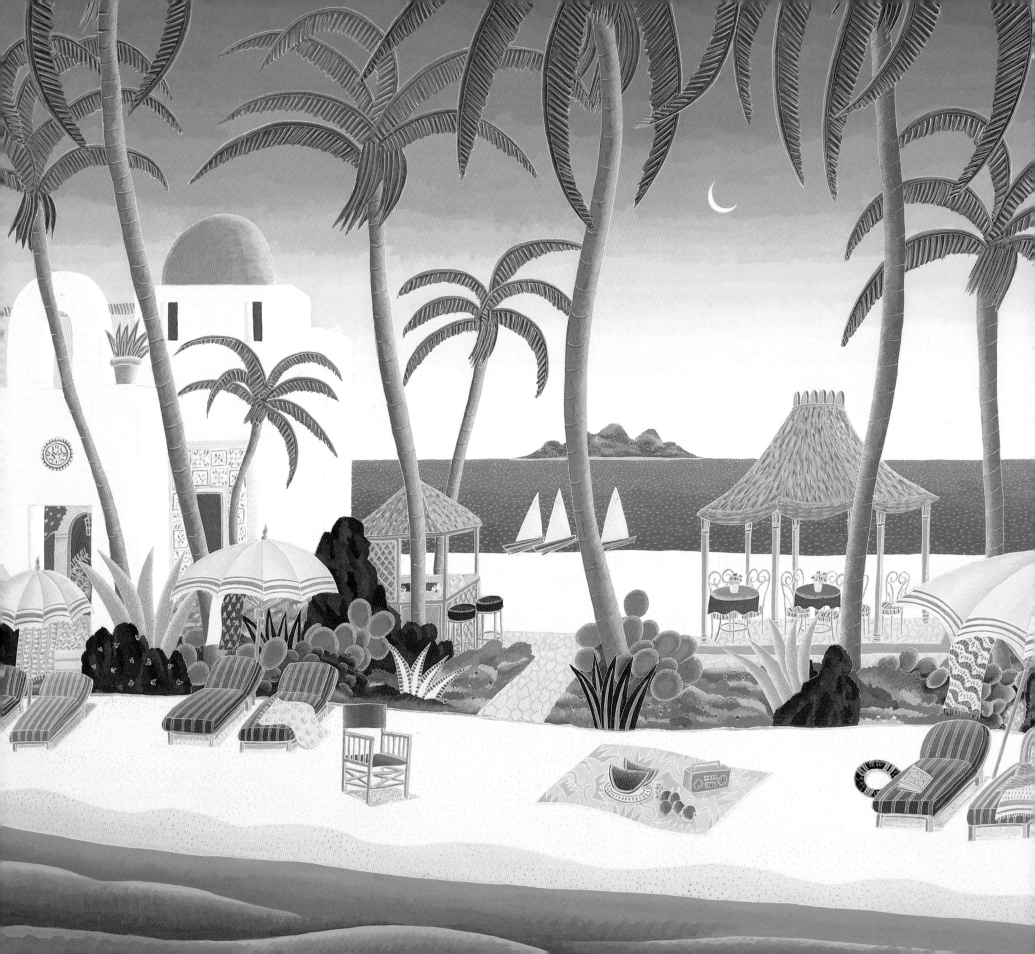

Turning Sunward

There is a shortcut to paradise, in the simple, physical, biblical sense: a place where you don't have to work or wear clothes. A ticket to Florida, Hawaii, or the Caribbean will get your body there in short order. It will take your awareness longer to catch up, to trickle down like a handful of warm sand from your harried head into your body and senses. But everything in the tropics seems deliberately designed to hasten that transition: the caress of moist, fragrant air as you walk down the plane's steps; the blaze of tropical flowers along the road in from the airport; the color of the pool at your hotel, a captured gem of lagoon water; and above all, all around you, the silly shape of palm trees.

CARIBBEAN LAGOON

I am sure that there are very good evolutionary and ecological reasons why palm trees look the way they do. It must have to do with wind and salt, with yielding to hurricanes and hoarding water. And yet those forces made a form that is the quintessence of leisure and liberation. Was that by accident? Or is it just that we associate "palm tree" with "vacation"? If we did all our serious work under palm trees, would palms look somber to us (and firs frivolous)? No, I'm afraid we'd just take a lot more siestas. The shape of a palm tree is intrinsically sensuous, whimsical, and daffy. They look like pinwheels, like Quixote's windmills, like slender brown girls with sun-streaked mops, undulating to the merengue. (When castaway Odysseus washed up on a beach at the feet of a beautiful girl, Nausicaa, he compared her to "a magnificent young palm tree" on the island of Delos, under which the gods Apollo and Artemis were said to have been born.) The way palms look, the carefree mood they coax, is, to me, one of the two strongest hints that this world was made by an artist. The other is that the vast sun is 93 million miles away, and the modest moon is 240,000 miles away, and *they both look the same size in the sky.* Go figure.

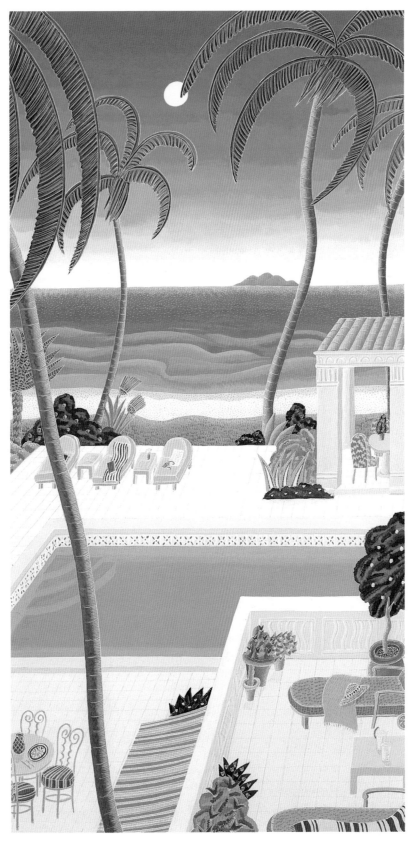

HAWAIIAN LAGOON

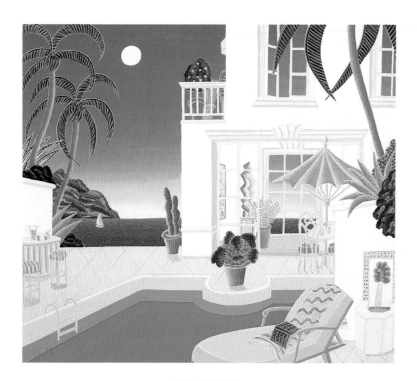

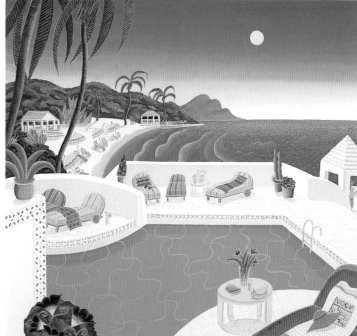

GULF POOL ANTIGUA BEACH CLUB

The word *tropics* comes from the Greek *tropikos*, "pertaining to a turn." (Odysseus the wanderer was called *polytropos*, taking many turns.) Geographically, the tropics are the "torrid zone" between the Tropic of Cancer and the Tropic of Capricorn, the parallels of latitude that mark the sun's most northern and southern points for shedding direct perpendicular rays at noon on midsummer's day and the winter solstice. A "tropic" is the line where the sun "turns," starting its journey back toward the other pole of the seasons. From the same root comes "tropism," a plant's—or a tourist's—instinctive turning toward the sun. We incline and yearn toward the tropics as the other pole of our too-polarized existence. Key West balladeer Jimmy Buffett wrote a song called "Changes in Latitude, Changes in Attitude": we go "down south" to go "down there," into the hot and humid body. At home we live too much in our minds; on a tropical beach or terrace we are mindless, "spaced out" with our cool drink and fat paperback. At home we work too hard, in the tropics not at all—which also palls. "Vacation" becomes, after a time, vacant. And then back north we go, like the sun, caroming endlessly between two opposite lines of latitude. Rested and sated, we are ready to resume our other half-life.

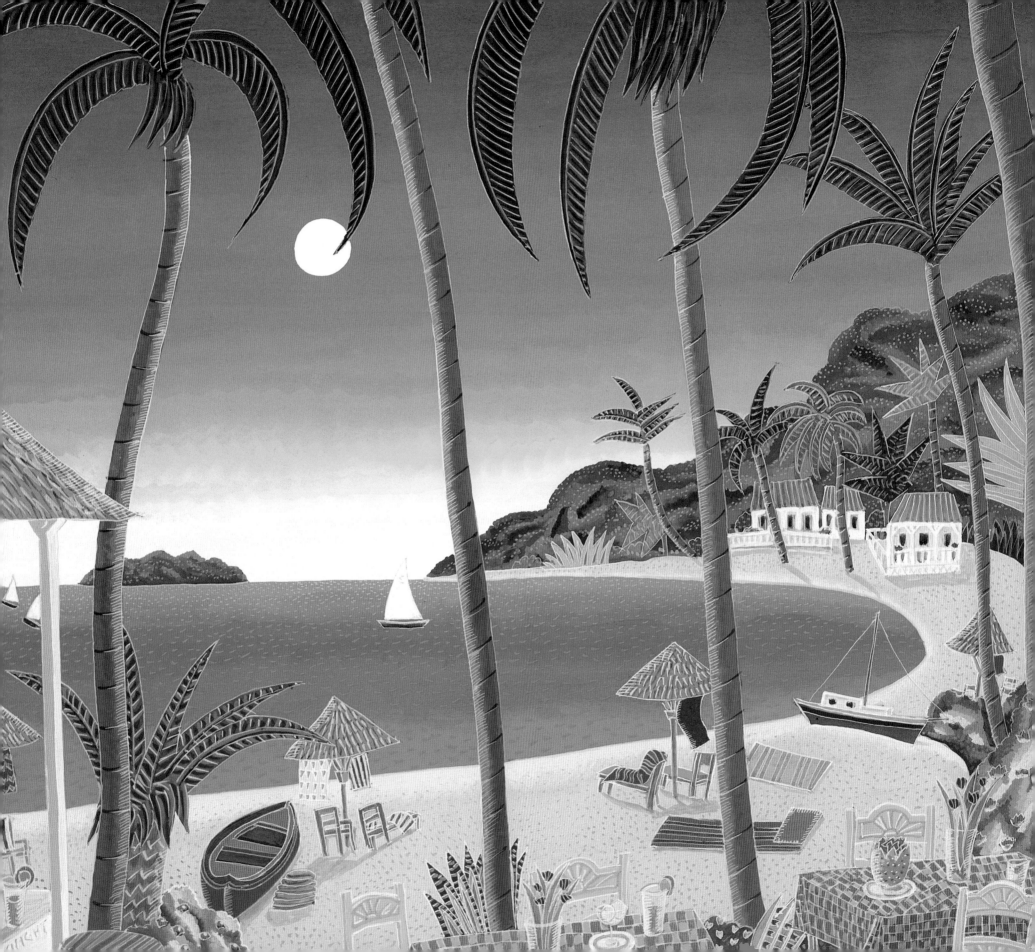

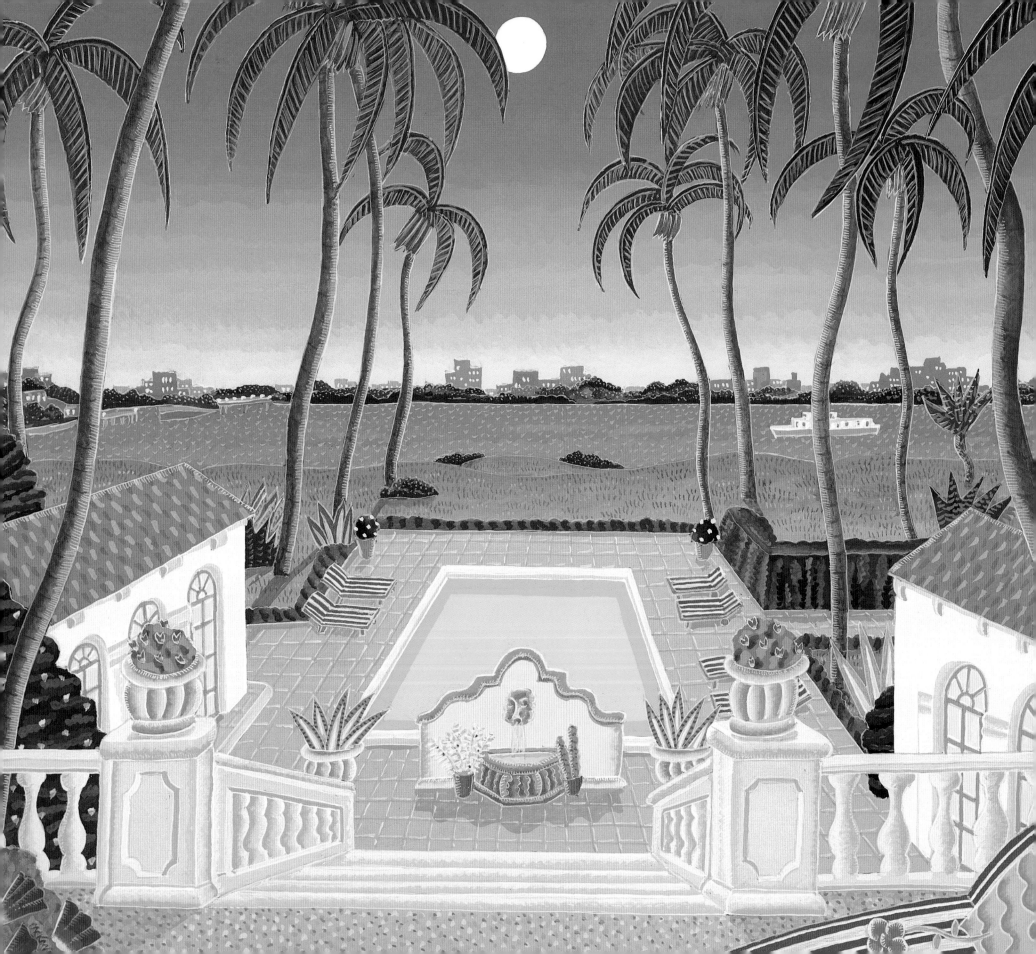

Yet there is another kind of journey south, one that is not a flight from work into pleasure, but a search for their common root, before mind and senses split. If you've felt drawn to the culture of the Caribbean or Mexico, and not just their resorts, you are on that quest. The gods of voodoo, the masked processionals of Carnival and the Day of the Dead, may stir memories that we once had our own gods (and processionals). An ancestral memory is built into the architecture of the tropics and subtropics, for the ships of the Spanish came first to Florida and the Caribbean, bringing the pastel walls and red-tiled roofs of another southern sea: the Mediterranean.

The houses in Palm Beach, where Thomas McKnight lives for part of the year, recall those of the Riviera. And in many of his paintings, Caribbean and Mediterranean scenes are, if not interchangeable, deeply akin. By either sea he finds the curve of a cove, the vivid blues of sky and water, the bright colors strong sun inspires in flowers, fruits, and fabrics. And each is a world of coastal vistas and islands, where life on land, embraced by water, has the surrounded, spotlit quality of a dream. But while to us

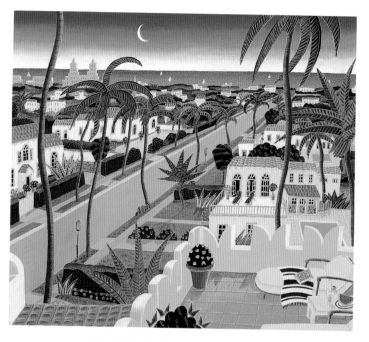

CLARKE AVENUE, PALM BEACH

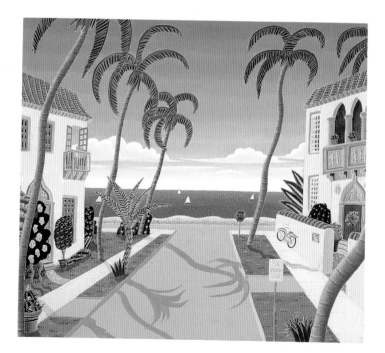

NORTH OCEAN BOULEVARD, PALM BEACH

the Caribbean may be, as Club Med ads promise, "the antidote to civilization," the Mediterranean is its source. As adults remember the first childhood home where their mind's eye opened—bright, shadowy, alive with large presences—we collectively remember the Mediterranean, its sun-soaked hills; dark sea; and sail-chasing, spirit-spurring wind. It is the well to which Western culture has returned again and again in times of exhaustion, turning southward in search of rebirth.

ANTIGUA

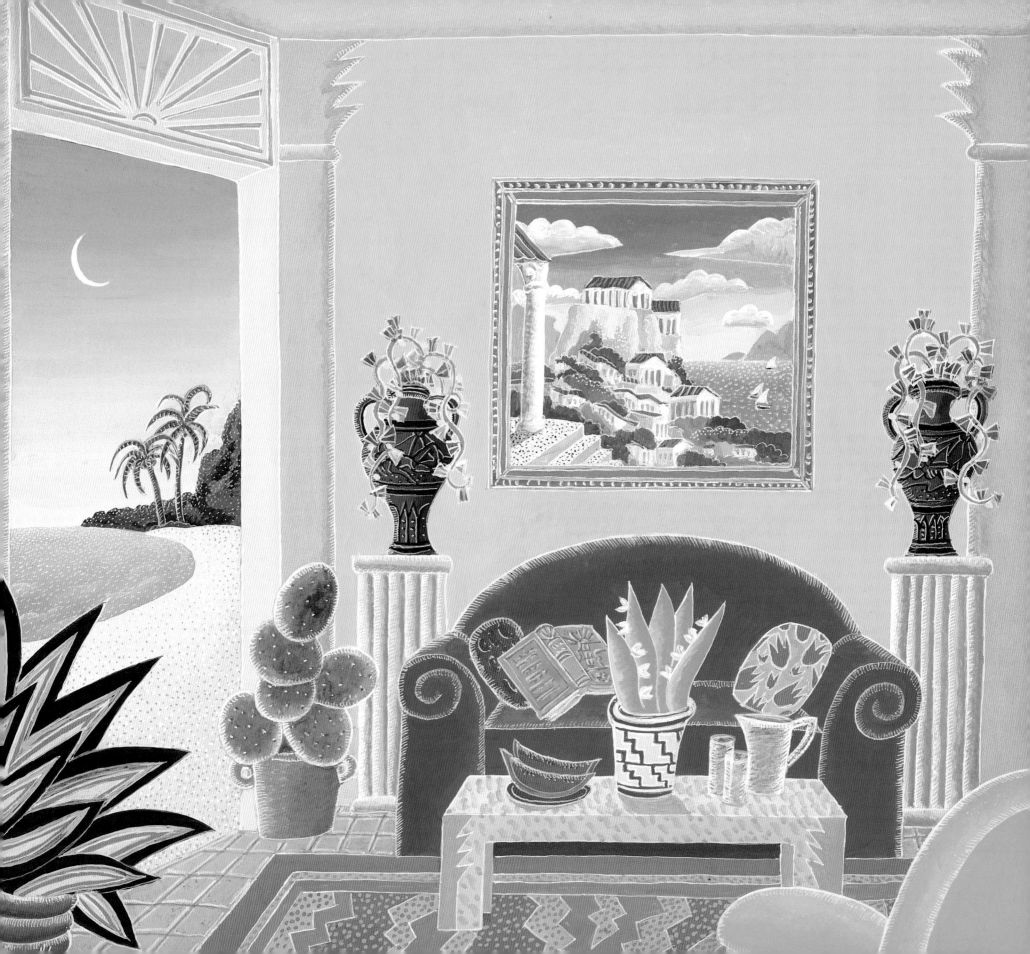

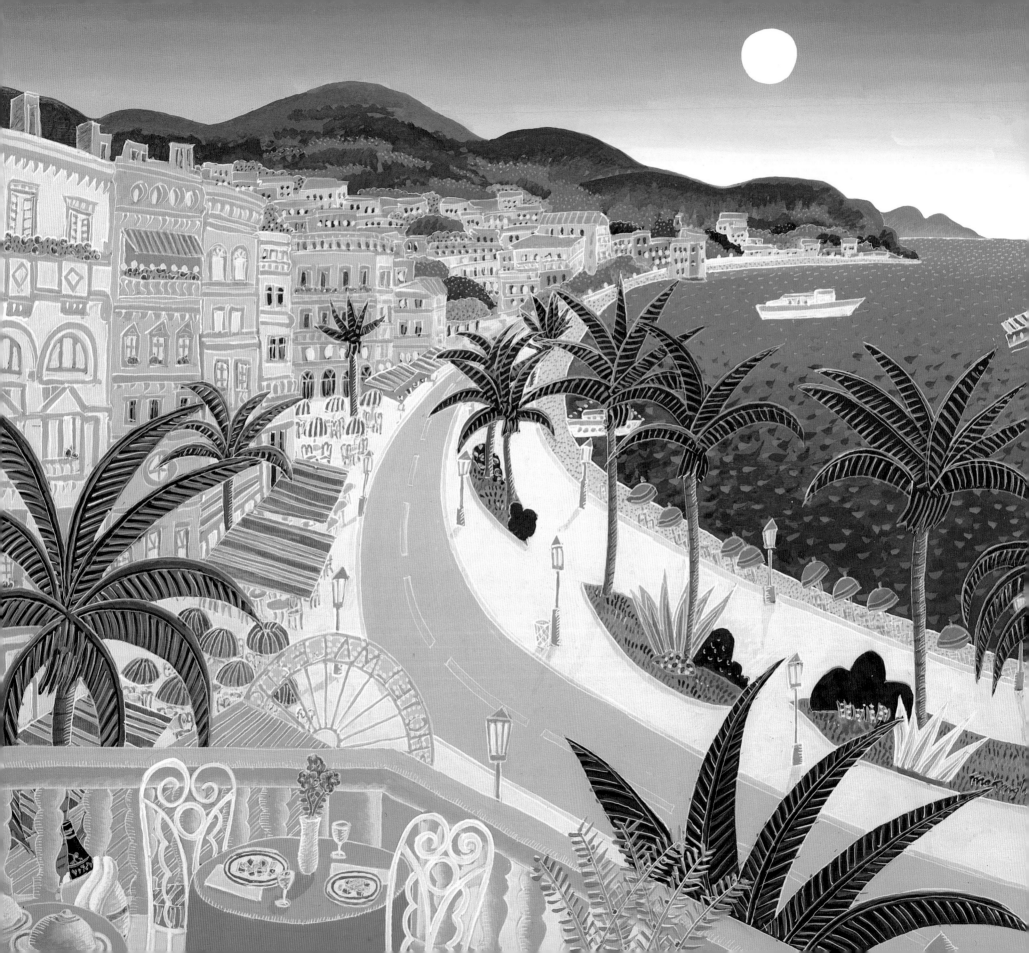

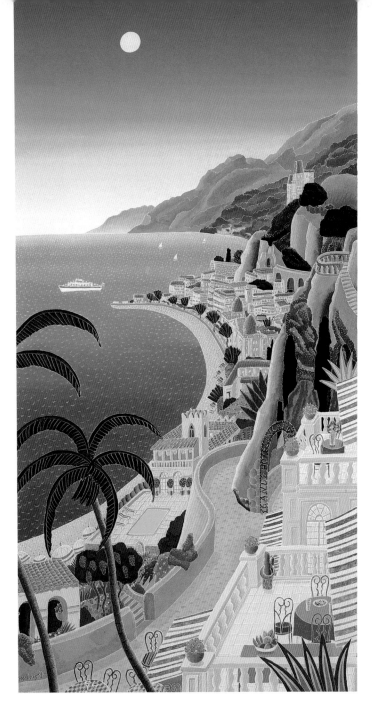

RIVIERA COAST

RIVIERA PARADISE

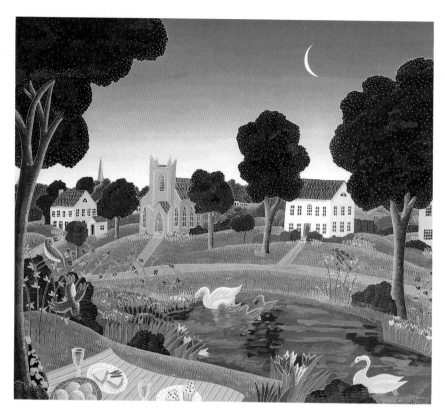

EASTHAMPTON

Going South

For historic reasons, and also because latitudes affect attitudes, North America's
dominant culture comes from Northern Europe. Here Atlas, a Titan king of
Atlantis—the legendary civilization said to lie beneath the Atlantic—bridges
the two Norths with his Southern body, graceful as a Renaissance Italian courtier,
solar red and gold and enlaced with flowering vines, a McKnight motif sug-
gesting sensuous pleasure. (Legend suggests that the north itself once en-
joyed a much balmier climate, and the tall, blond, blue-eyed Atlanteans
a culture of great beauty as well as power.) This Atlas is burdened by
the austere Protestant landscapes of the North, yet he also
supports and connects them, as the secret pagan under-
pinnings of our culture have kept pleasure from
being crushed by the moral granite
of the puritan church.

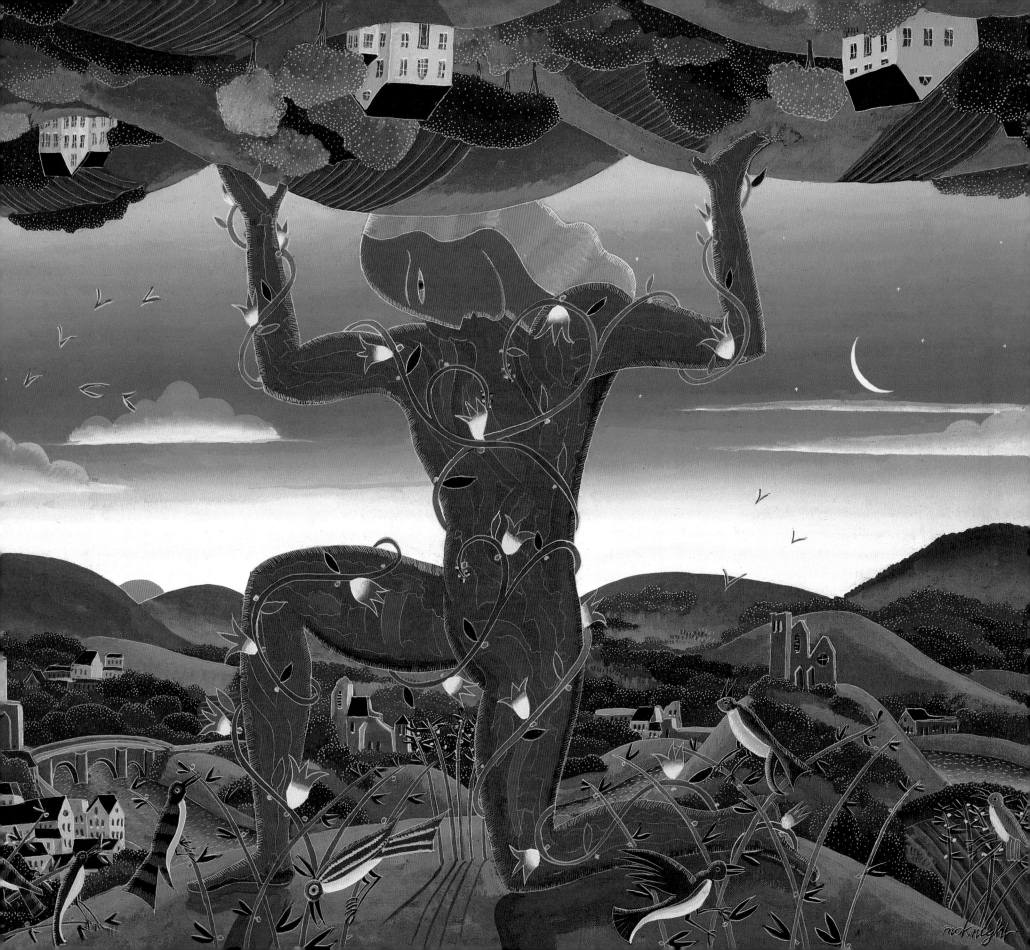

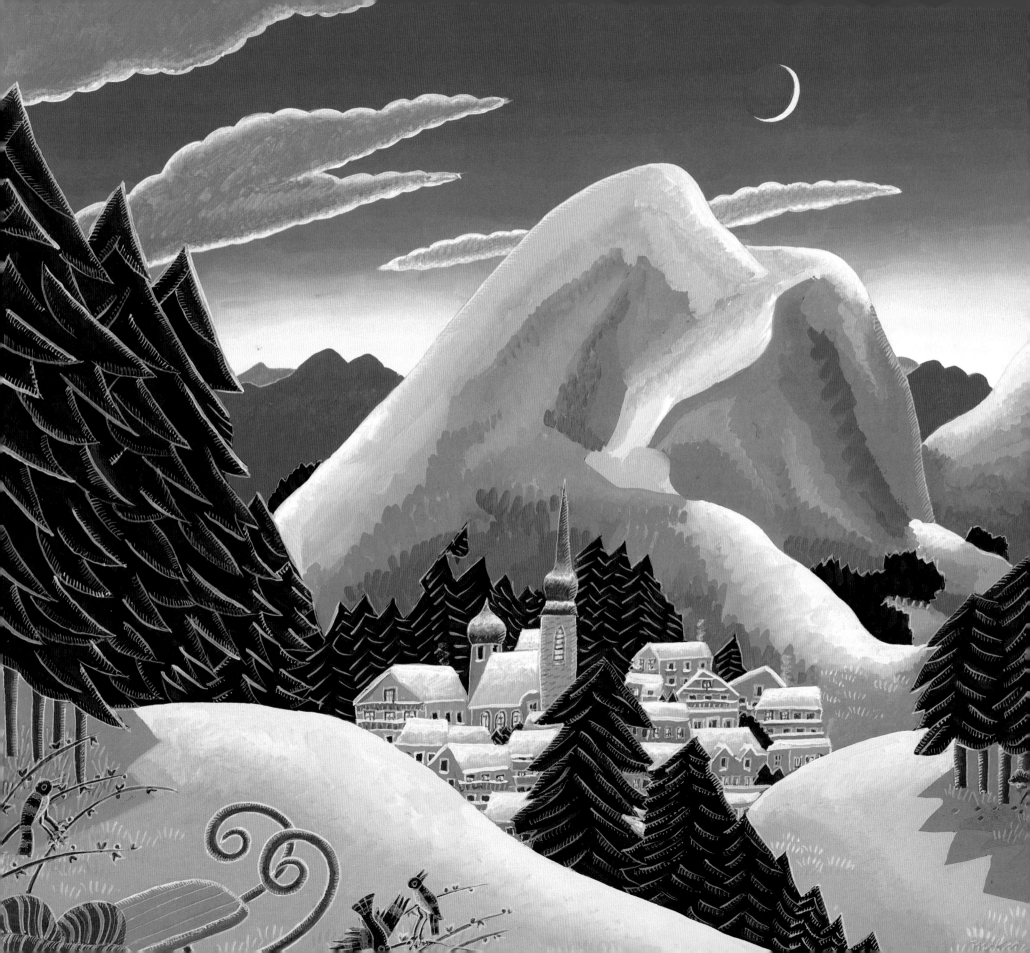

As James Hillman points out, Northern culture is monotheistic. There is only one right way, and that way is Up, away from the earth with its multiple temptations, toward the One God (or, after his death, toward the One Truth: scientific objectivity in its heaven, Progress). Every little village clusters around a church with its heaven-pointing spire. Every psyche clusters around a heroic ego, with its striving to rise above, control, unify, and improve the contrary impulses of human nature. To turn and go "down south," then, is a subversive move toward our ancient pre-Christian, polytheistic roots and their survival in our perversely diverse dream life.

"Venturing South is a journey for explorers," Hillman has written. And: "'South' is both an ethnic, cultural, geographic place and a symbolic one. It is both the Mediterranean culture . . . its sensual and concrete humanity, its Gods and Goddesses and their myths," and "the direction down into depth"—what Northern psychology has darkly called "the unconscious," but Hillman calls soul or imagination. For centuries, crossing the Alps has held both allure and danger for the Northern mind. Even the late great divers of the dream suffered "archetypal disorientation": "Once when Jung tried to venture beyond his psychic borders toward Rome, he fainted at the railroad station," according to Hillman. A similar "mysterious inhibition" kept Freud away from Rome for years, and he experienced a "disturbance" while visiting the Acropolis in Athens. "Now the old man went mad," wrote Lawrence Durrell, "for everything undressed and ran laughing into his arms." Perhaps today we are ready to venture deeper into that welcoming landscape, to experience subversion as seduction, disorientation as delight.

AUSTRIAN TOWN

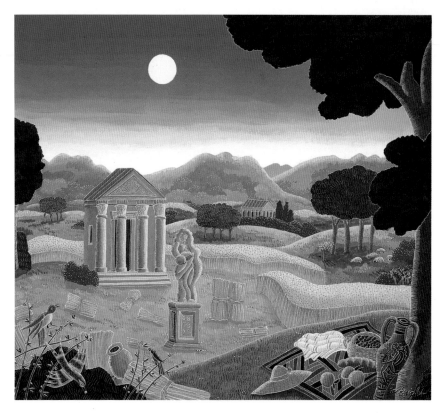

HARVEST IN SICILY

As we picnic our way south through these images, the world grows warmer, earthier, more brazen. (The picnic, to Thomas McKnight, is a little rite of classical leisure, an occasion to recline and savor the spirit of a place.) The landlocked prettiness of green and white gives way to russet roofs and golden apples by an azure sea. Gradually the church tower mutes its prominence, blunts its point, is absorbed into the tumbled community of daily life, as southern Catholicism settled comfortably on a bedrock of older beliefs, melding its many saints with local deities and the Virgin Mother with the Mother Goddess. Around the northern Mediterranean "the great bronze and marble statues of the pagan deities were destroyed," writes Jungian analyst Ean Begg, but "smaller household images or votive offerings, hidden in the earth, in cleft rocks or hollow trees, survived, especially in remote country places." Somewhere off the beaten path, between the south of France and Sicily, we might stumble on a rustic shrine.

It is literally "pagan"—"of the earth," right in the middle of a field, consecrating the fertility of the grain. It is a fragment of an animated world we can scarcely imagine, in which trees and streams, crossroads and thresholds all had their attending spirits, the hush of noon heralded the arrival of Pan, and every human action and passion was presided over by a god. In the industrialized North that archaic world is deeply submerged, plowed under by history. The further south we travel, the closer it rises to the surface, till the white bones of ruined temples break through the soil, and the Madonna dances frankly with snakes in the heel of Italy.

SAINT-TROPEZ

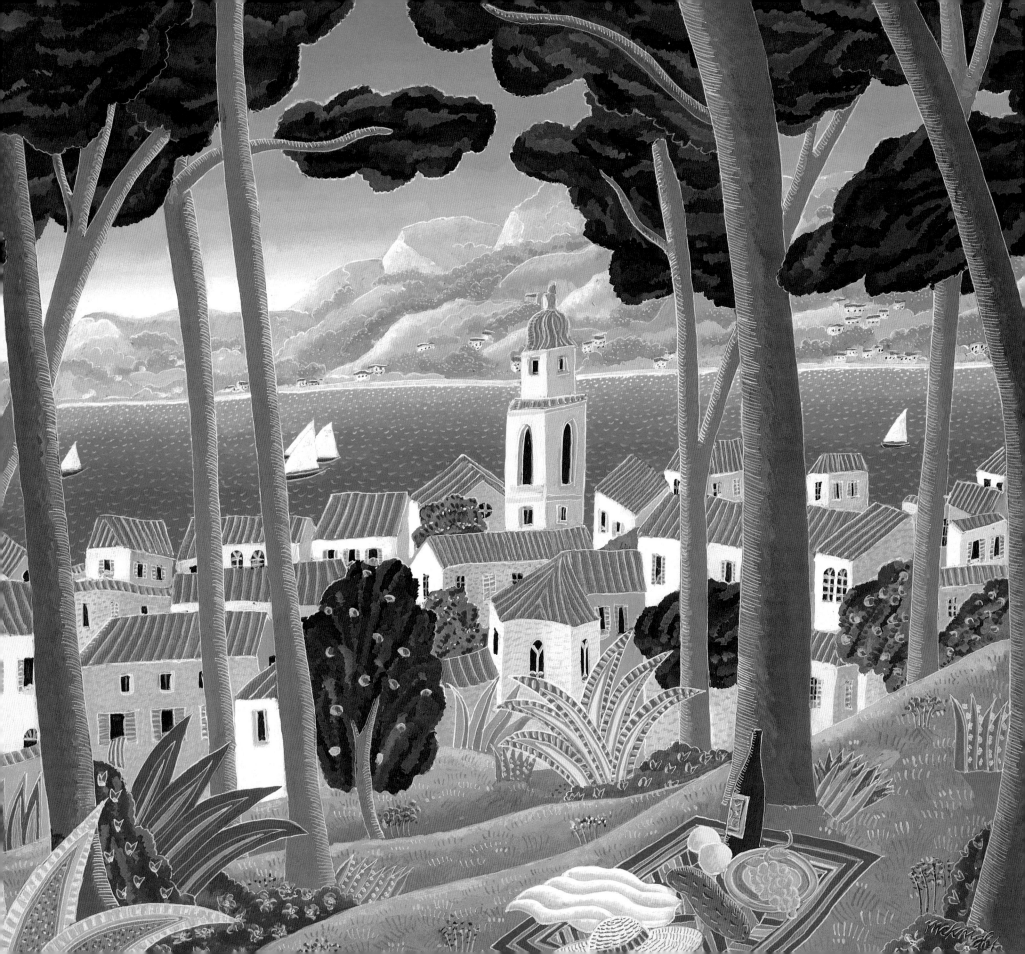

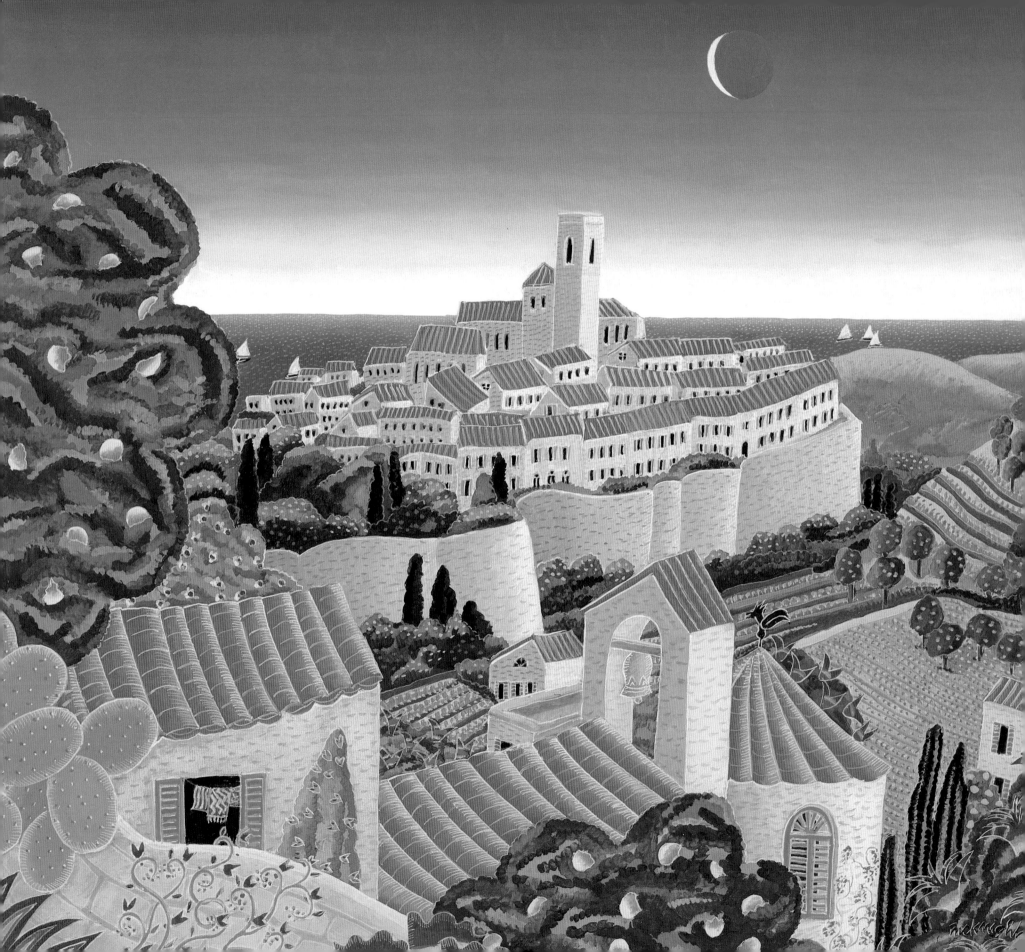

Italian Journey

At first, though, the change is subtle. We would panic if we met Pan; instead, we are stealthily possessed by a golden spirit that seeps in through our senses. "The purity of the sky, the tang of the sea air, the haze which, as it were, dissolved mountains, sky and sea into one element—all these were food for my thoughts," Goethe wrote on his 1786–1788 *Italian Journey.* "As I wandered about … between hedges and oleander, through orange trees and lemon trees heavy with fruit, and other trees and bushes unknown to me, I took this blessed strangeness to my heart." And into his mouth, for soon enough, like Persephone in the underworld, we can't resist eating something, and are lost. "What I enjoy most of all is the fruit," Goethe exulted with a sticky chin. "The figs and pears are delicious." Lawrence Durrell described "the little early grapes. . . .The sun has penetrated their shallow skins and has confused the sweetness with its own warmth; it is like eating something alive." In this country, meals are the same as sacraments— bread and wine and olive oil—and all grown and made right here, so that eating and drinking is direct communion with the local spirits of the earth. And this confusion or reunion of spirit and senses is what we came for.

MANAROLA, ITALIAN RIVIERA

47

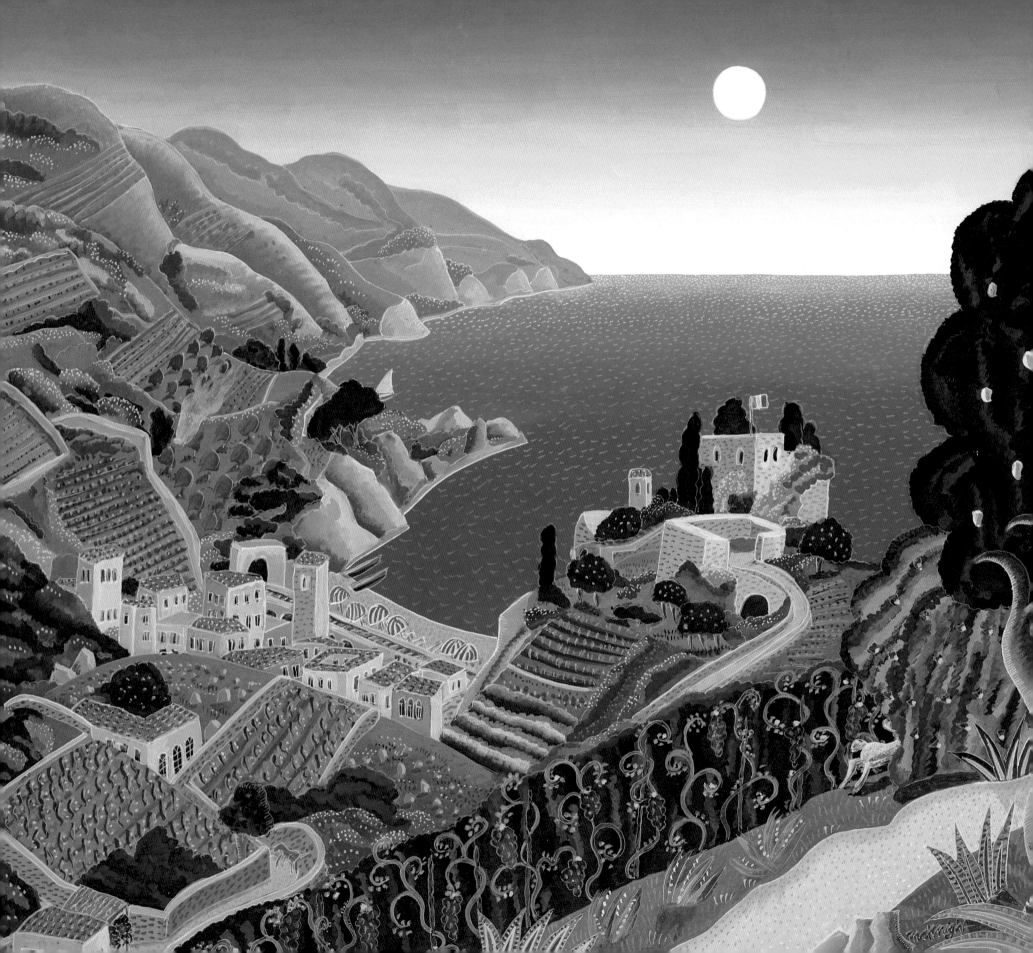

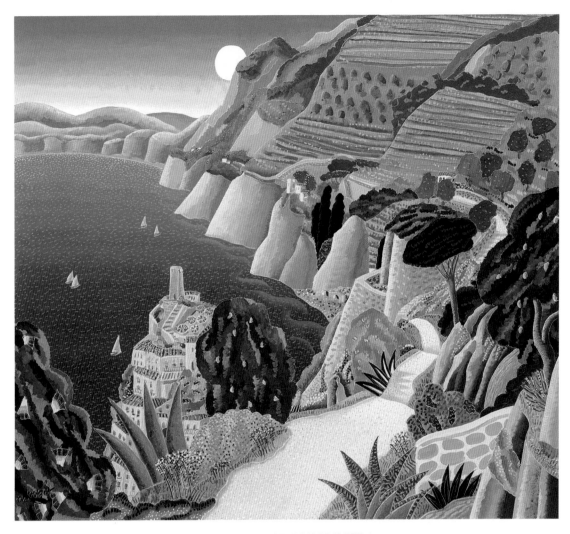

VERNAZZA, ITALIAN RIVIERA

Shelley and Byron came to this Ligurian coast of the Italian Riviera in flight from the ugliness of industrializing England. Not far from here, off Lerici, Shelley drowned, and his friends burned his body on the beach. And as in Brueghel's painting of Icarus falling from the sky, life went on in these hills as it had for centuries. But that was why Shelley had come. The dwellers in the Cinque Terre, five tiny cliff-clinging hamlets, are descendants of the Ligurians, among the earliest primitive inhabitants of Italy, once Provençal worshippers of the Goddess. Their precarious perch has made these little towns like islands, each isolated and unique, yet linked by a winding footpath above the sea, which Thomas McKnight paints as if it were the Yellow Brick Road, the Road that Goes Ever On, the restless ribbon of pilgrimage on which all our gemlike moments of arrival are strung. Are we there now? Is this Paradise?

MONTEROSSO, ITALIAN RIVIERA

Sheltered by
the Alps and Appenines, the climate
is "an eternal spring where bright blossoms
and bushes flower all year round." Yet "since time im-
memorial, life for the Ligurians has been a struggle. . . . To
grow vines and olives and basic crops, [they] literally had to
carry the soil by boat or on their backs and stick it to the rock
face, creating a style of terrace agriculture unique in Europe and
found elsewhere only in parts of China and Peru." Despite the
preying of pirates, the Ligurians were so deft at sea that the Greeks
called them dolphins; Portofino means "port of dolphins." They
still live by "fishing from the wooden boats moored in the tiny
ports and tending their pocket-handkerchief-sized vineyards
that stepladder down the hillsides to the sea. . . . Every-
thing Ligurians have achieved has been with blood, sweat,
and tears." This could be Paradise, if you like the
taste of salt. For Paradise may be won by
loving labor, not just found.*

*All quotations on this page are from *The Berlitz Travellers Guide to Northern Italy and Rome.*

RIOMAGGIORE, ITALIAN RIVIERA

"The eighteenth-century Neapolitan philosopher Vico thought that civilization passed through four ages—of gods, heroes, men, and chaos," Thomas McKnight has written. In Italy we have taken one step back in time, from our "Age of Chaos" into an "Age of Men," before labor was "alienated," as Marx said, when living was an art and work produced beauty. But there is another Italy, farther back in time, when the arts of magic flourished as well, conjuring an upsurge of richness in fantasy, art, architecture, and philosophy that could never have been summoned by labor alone.

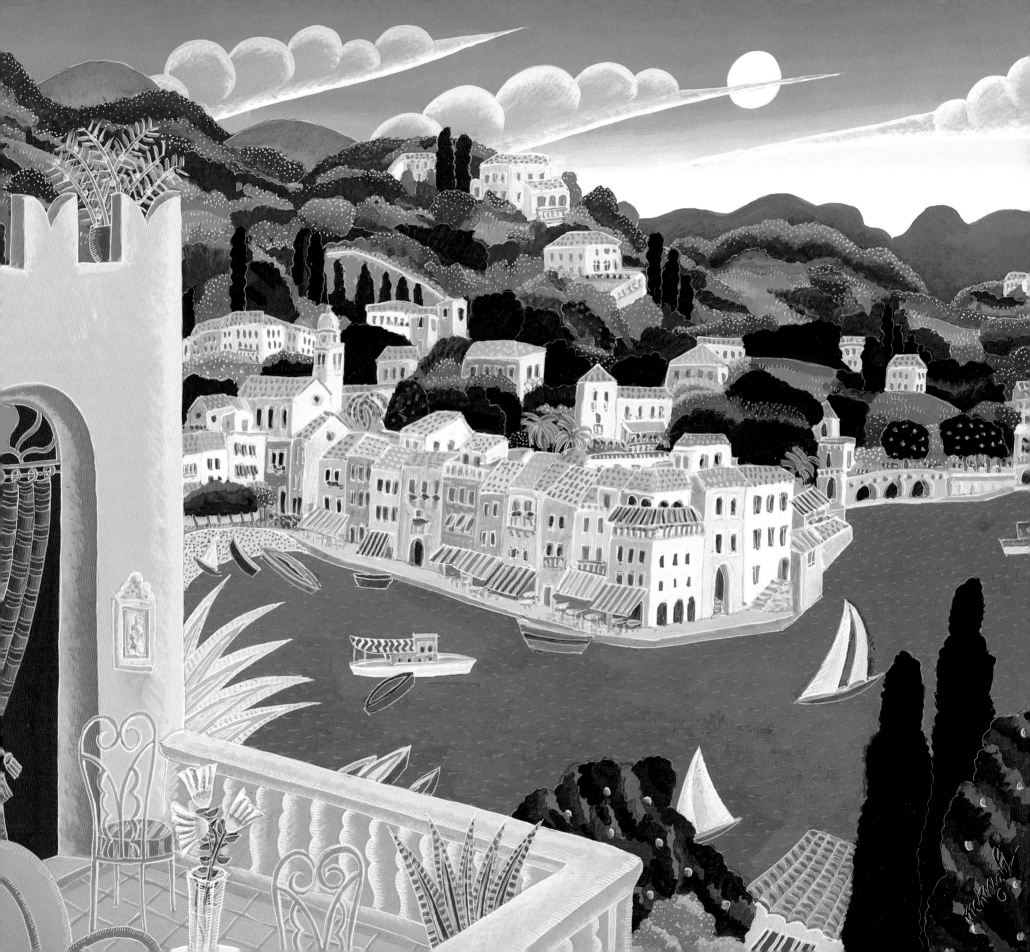

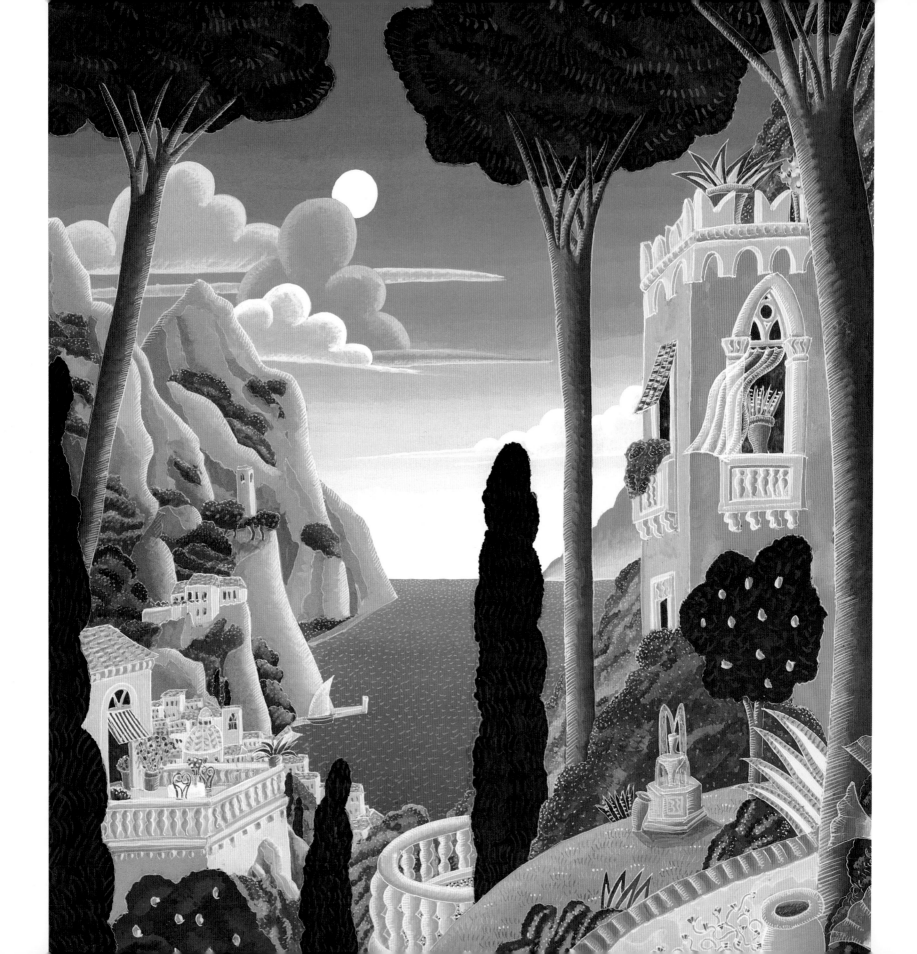

The Great Rebirth

The Renaissance of the Quattrocento—the flowering fourteenth and fifteenth centuries—is just around the corner of a time-warp in Italy. A filmy curtain in the window of a pink tower stirs with the passage of just-vanished ghosts, artists, thinkers, and statesmen whose names resound like great bells: Dante, Petrarch, Michelangelo, Leonardo, Ficino, the Medici. (There was also a Tommaso de' Cavalieri, a friend of Michelangelo whose name, translated, is Thomas McKnight.) The Renaissance could be called an Age of Heroes—and Heretics—for these men bestrode their world like colossi, and some risked their lives in a renewed romance with pagan antiquity that helped to make "medieval conceptions of good and evil . . . no longer valid" and led to "a dangerous liberation of feeling," according to Jungian scholar Linda Fierz-David. (The Church was well aware of the threat: the Inquisition burned Giordano Bruno at the stake in 1600 for his work on esoteric magic. He had written of himself, "We see how this man . . . a child of Father Sun and Mother Earth, because he loves the world too much, must be hated, censured, persecuted and extinguished by it.") Alchemists, astrologers, and magi, the "Renaissance men" revived the ancient Greek pantheon, not as deities to be worshiped, but as allegorical figures invoking the full range of powers of nature and the soul. Cracking open the narrow vertical piety of the Middle Ages, they almost midwifed a new Age of the Gods.

Instead, our culture chose the straight and narrow. Over the next two centuries, Science replaced Religion as the guardian of what Blake called "single vision and Newton's Sleep," once more banishing myth's fantastic cast of characters to a cultural under-

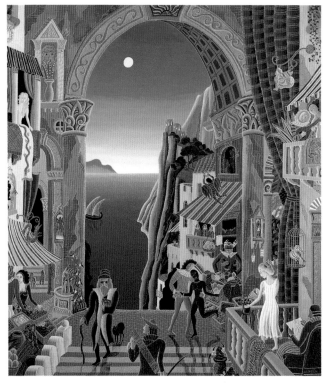

warriors seem to us a strange breed of sea-animal who left behind them the pink, convoluted shell they grew to protect them, which is Venice.") To enter these corridors and chambers is to hear whispers and echoes of the imagination that secreted them. It

world. In Italy, though, the living Renaissance left monuments, as a mollusk leaves its castled shell. (Quattrocento architecture seems to demand this image. Robert Harbison writes of "ideas hardened like the shells of sea animals . . . in shapes fantastical but firm." So does Mary McCarthy: "Those hale old doges and is easy to envision, as Thomas McKnight does, the intricate architecture repopulated by maidens, courtiers, lutenists, mages, Moors, and mummers. Not again until the Haight-Ashbury of the 1960s would the pageantry of dreams so boldly occupy everyday city streets.

For our century is another Renaissance, as Jung said, "a transition between two eras." Again, "single vision" is failing, and we feel "the hunger for myth." We feed it by reading Joseph Campbell's journeys through all of world mythology. Renaissance Italians fed that hunger with illustrated journeys through an imagined classical past or its ruins, like *The Dream of Poliphilo*, a strange and influential work by a fifteenth-century Dominican monk of Venice, Francesco Colonna. Titled in Greek *Hypnerotomachia*—an untranslatable amalgam of "dream," "love," and "strife"— the story accompanied the lover Poliphilo's pursuit of his beloved (a rather unmonkish theme) through a classical landscape of architectural fantasies and idealized ruins, depicted in woodcuts that would strongly influence later Renaissance art. Five hundred years later, they would also strongly influence Thomas McKnight, who found a dusty volume of the 1499 *Dream* in an antiquarian bookshop when he was fourteen. Like Poliphilo's dream, this book you are holding in your hands is an "autobiography of the soul" in the form of a "journey through many regions," in Linda Fierz-David's words. McKnight's own initiatory journey—often in pursuit of an elusive nymph—has led back through Renaissance Venice into a revitalizing fantasy of ancient Greece.

Gateway of Dreams

Venice, then, is a gateway to all that follows in this book, a gateway between actual travel and the journeys of the imagination. A seasoned traveler in both dimensions, McKnight says that whenever he arrives in that city "I feel like I'm coming home." Venice has always been a gateway in many ways. From the twelfth through fifteenth centuries, it was the conquest, crusade, and trade gateway between East and West, which accounts for "the unmistakable, fascinating Oriental look of the city" as well as its crumbling artistic magnificence and wealth. As a city founded by refugees from Attila on eighty flat lagoon islands, described by Cassiodorus as "spread like the Cyclades over the surface of the waters," it is also a gateway between land and sea. And thanks to its "carnival that lasted half a year" Venice is also a venerable gateway between the worlds of reality and fantasy, life and theater, the living and the dead.

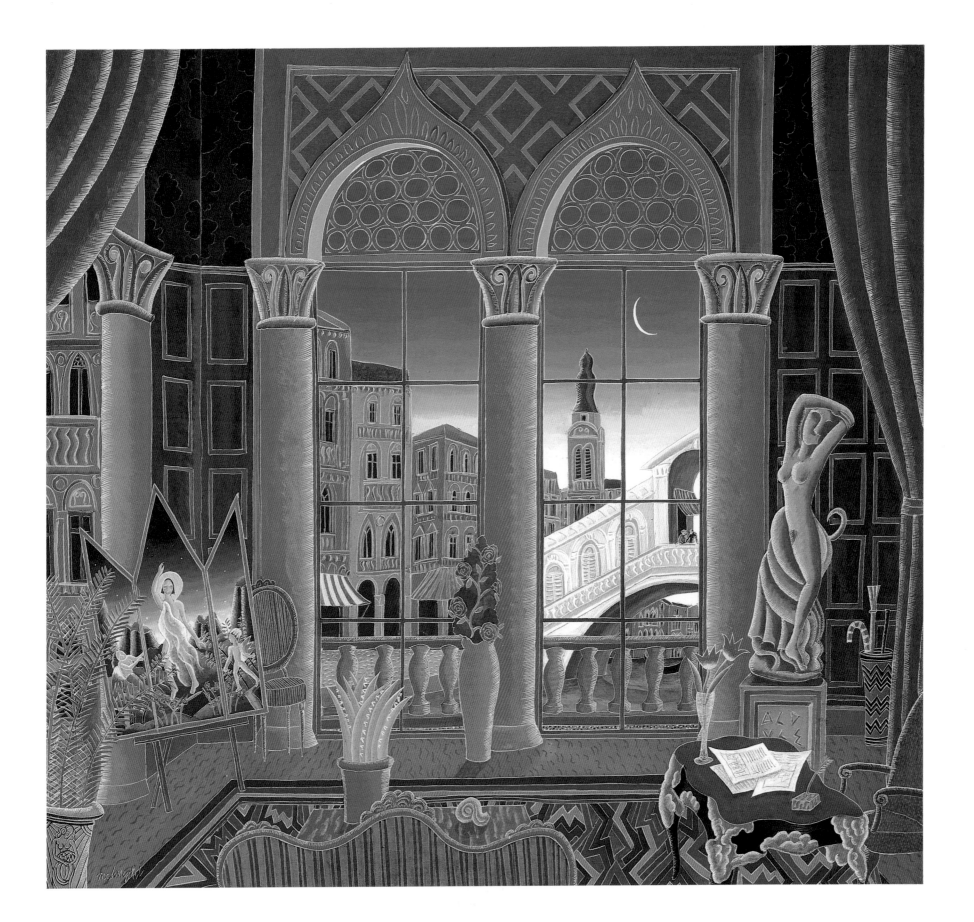

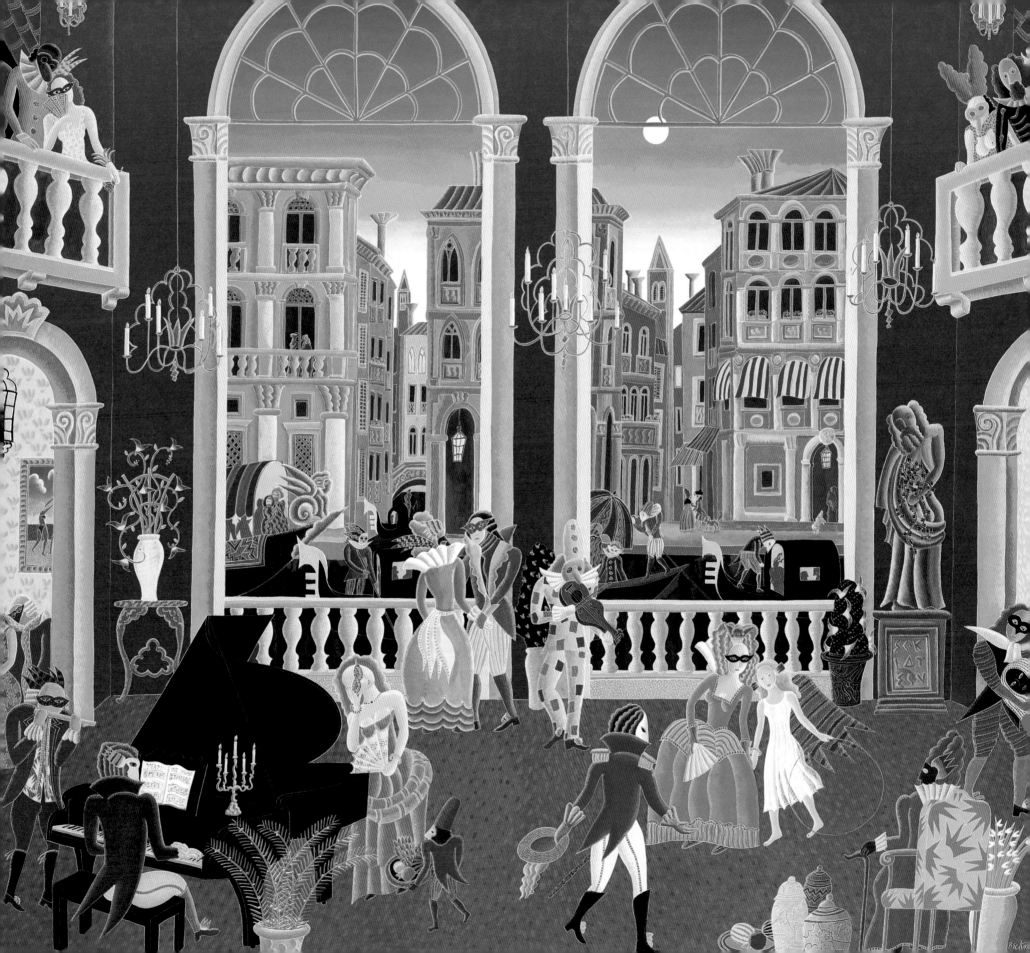

Goethe wrote in 1786:

During the daytime, squares, canals, gondolas and palazzi are full of life as the buyer and the seller, the beggar and the boatman, the housewife and the lawyer offer something for sale, sing and gamble, shout and swear. In the evening, these same people go to the theater to behold their actual life, presented with greater economy as make-believe interwoven with fairy stories and removed from reality by masks. . . .

Masks, which in our country have as little life and meaning for us as mummies, here seem sympathetic and characteristic of the country: every age, character, type and profession is embodied in some extraordinary costume, and since people run around in fancy dress for the greater part of the year, nothing seems more natural than to see faces in dominoes on the stage as well.

But this is a scene of
mystery as well as merriment.

Marie-Louise von Franz, in
The Golden Ass of Apuleius, reminds
us that in antiquity "a carnival
belonged to the cult of
the dead":

Those masked people, clowns and Columbines and whomever one meets in the streets, are really ghosts. The dead come along in that form and you meet them halfway, you wear their masks. It is really a festival in which the underworld, the ancestral spirits, come back and you unite with them. . . . There takes place therefore a mystical union of the Beyond and the here and now. . . . The underworld is wide and open and the masked ghosts go around, and the laughter has therefore a strange double aspect of being close to the gruesomeness of the ghost world and death.

VENETIAN TALE

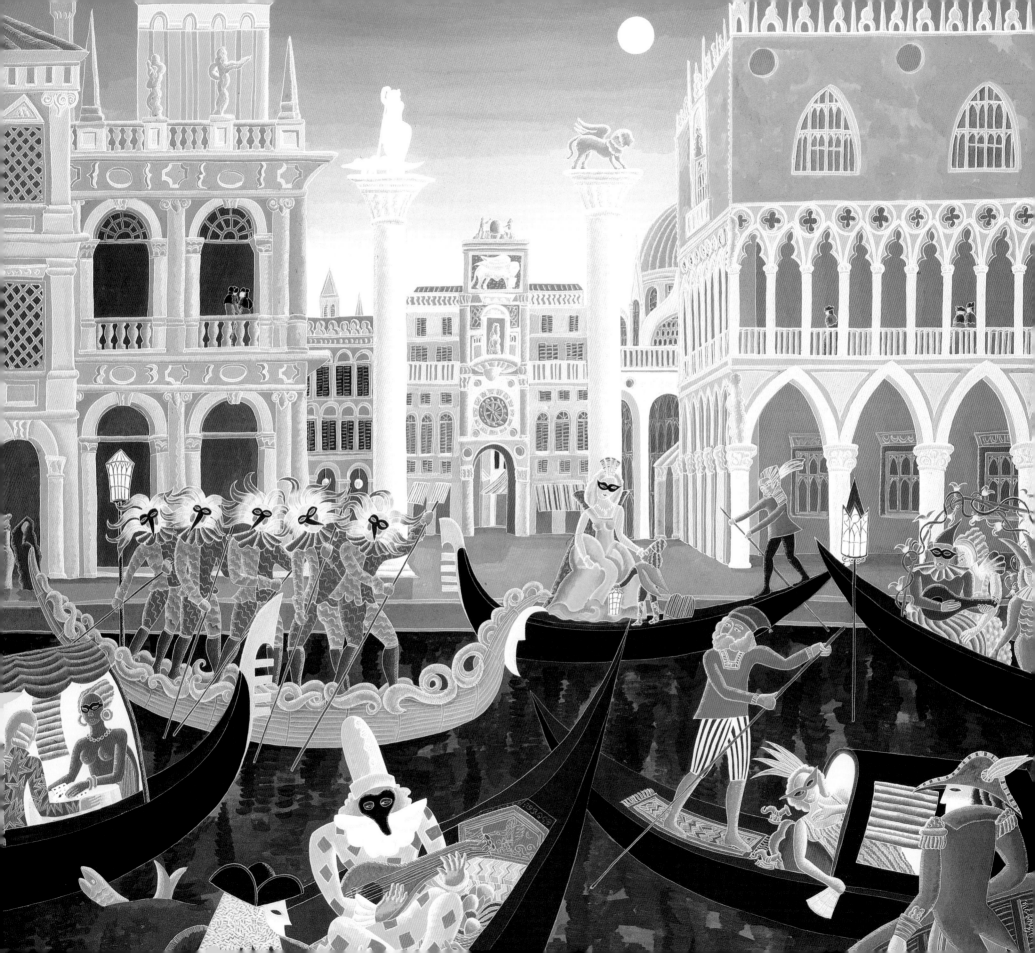

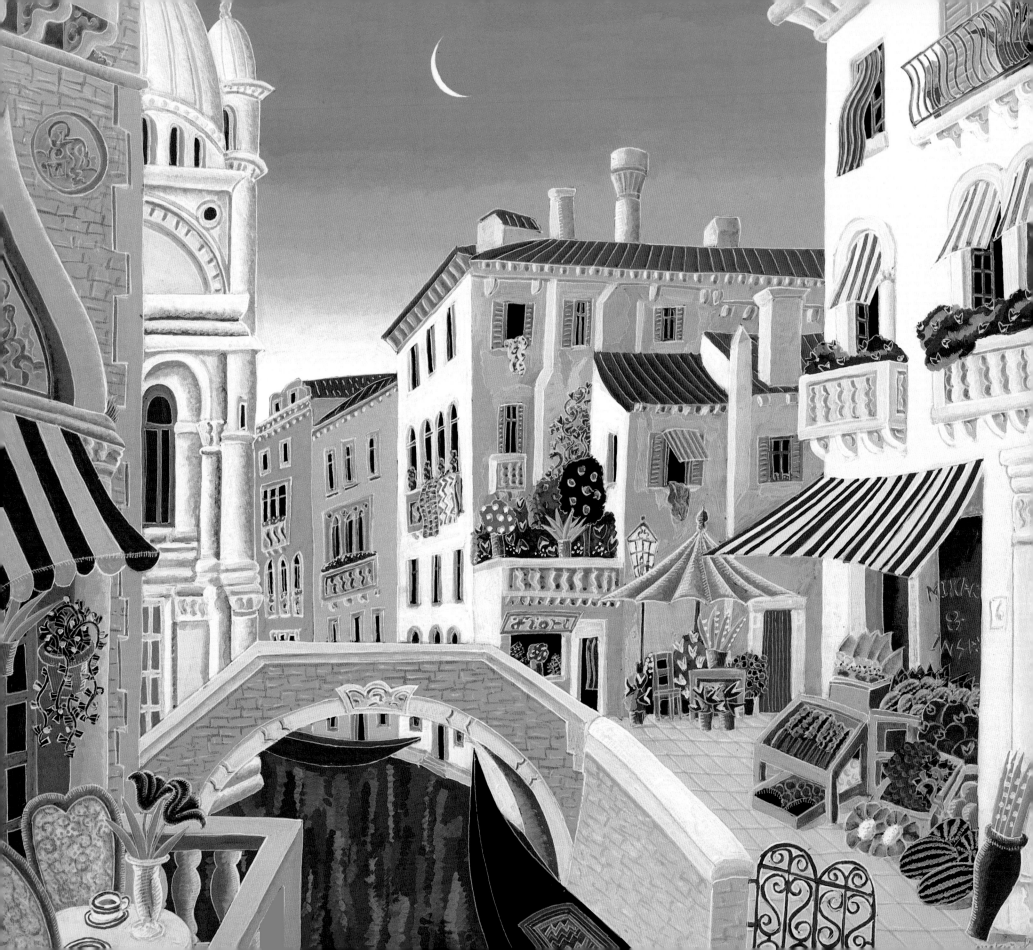

Even today, Venice is haunted, not only by those eminences who lived here—McKnight passed a "moldering palace" where Casanova had supposedly lived, simply boarded up as if its inhabitant might return—but by all the great spirits of Europe who have made the obligatory pilgrimage: Mozart spent the carnival season of 1771 here. And talk about echoes, so many of these visitors painted or described the city that, in Mary McCarthy's words, "Nothing can be said here (including this statement) that has not been said before. . . . [A] friend observes that the gondolas are like hearses; I was struck by the novelty of the fancy until I found it, two days later, in Shelley: 'that funereal bark.' Now I find it everywhere." (Thomas McKnight has composed these images so that you, the passenger in a gondola, join the procession of Venice's future ghosts.) "[A newcomer] has found a 'little' church— has he?—quite off the beaten track, a real gem, with inlaid coloured marbles on a soft dove gray, like a jewel box. He means Santa Maria dei Miracoli. As you name it his face falls. It is so well known, then?"

All the clichés about Venice, McCarthy says, are true: that "it is an endless succession of reflections and echoes . . . a mirror held up to its own shimmering image"; that "St. Mark's . . . looks like a painted stage flat." Architectural critic Robert Harbison adds, "The light is so continuously making an effect . . . that it must be done on purpose, an enhancement of theatrical illusion, lighting, not just light." Having absorbed Venice's lesson that imagination is real and the "real" the intensely imagined, we are ready to pass through the gateway. Looking back, we say goodbye to what Thomas McKnight calls "one of the great magic cities of humanity."

SANTA MARIA DELLE SALUTE, VENICE

VENETIAN LAGOON *(overleaf)*

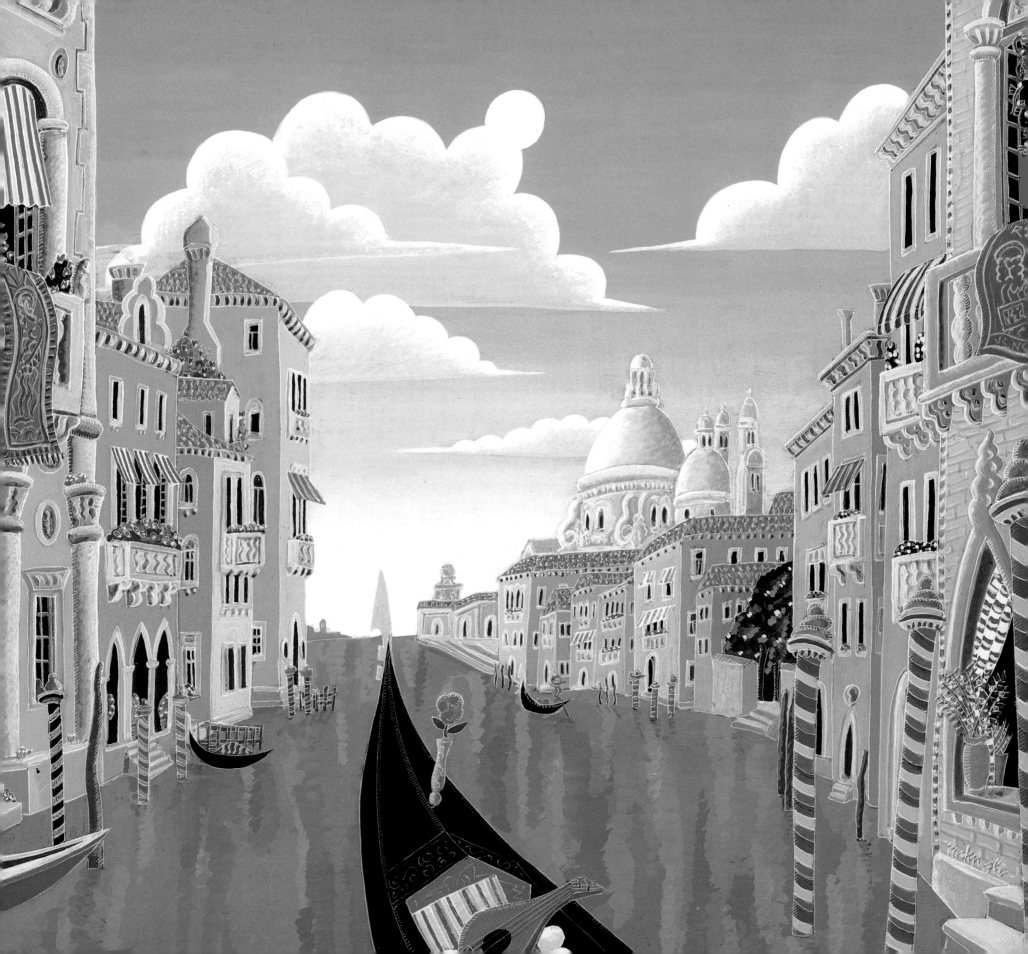

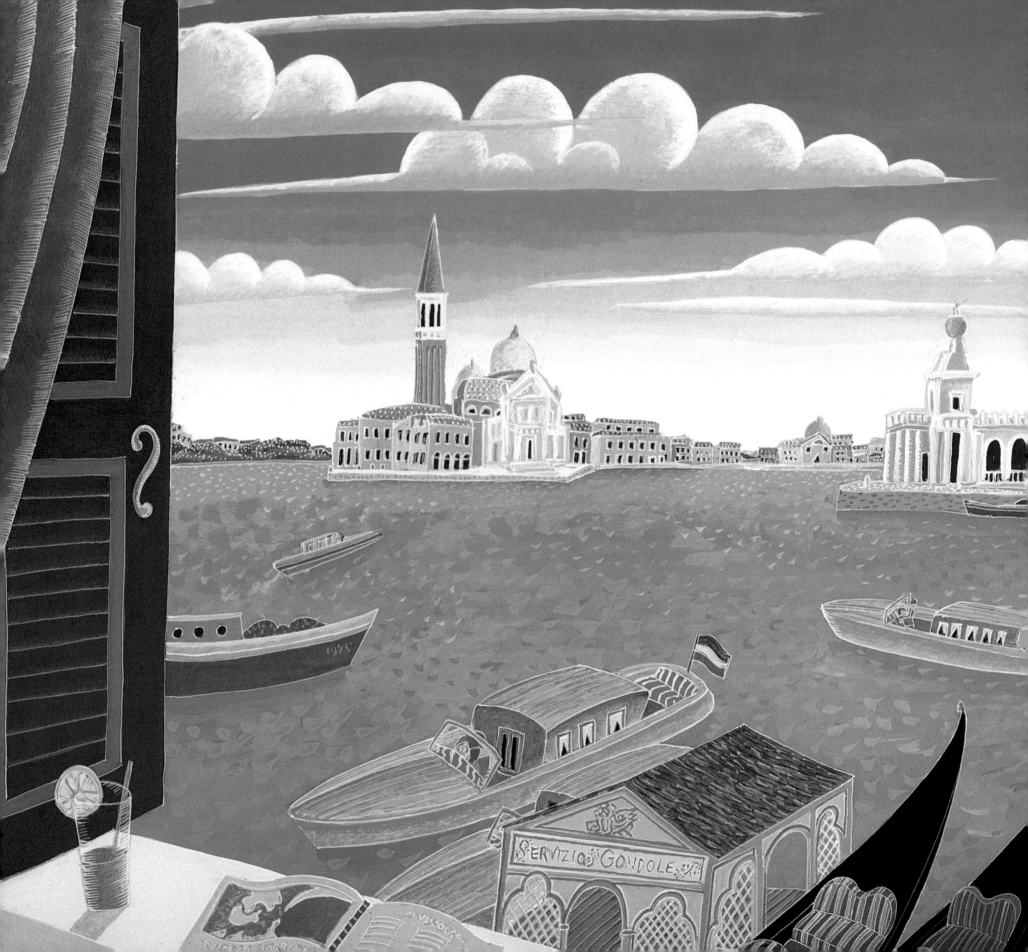

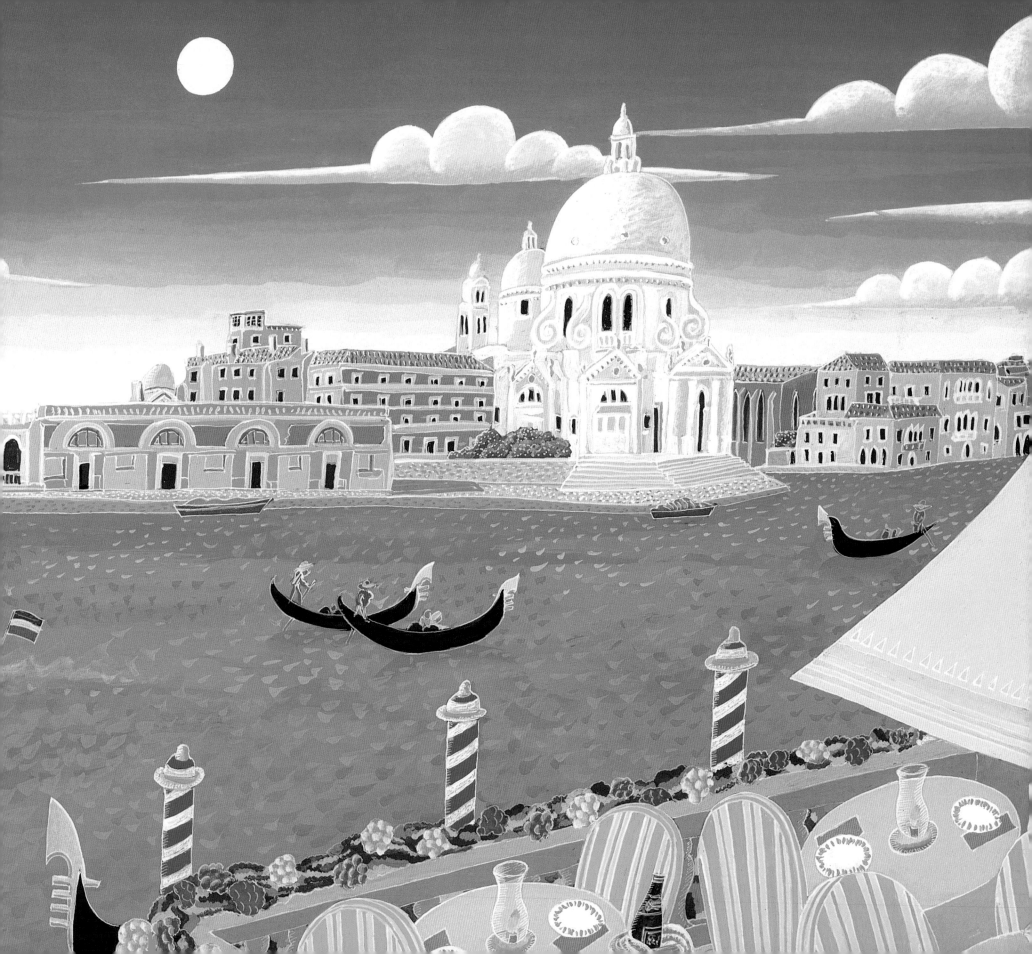

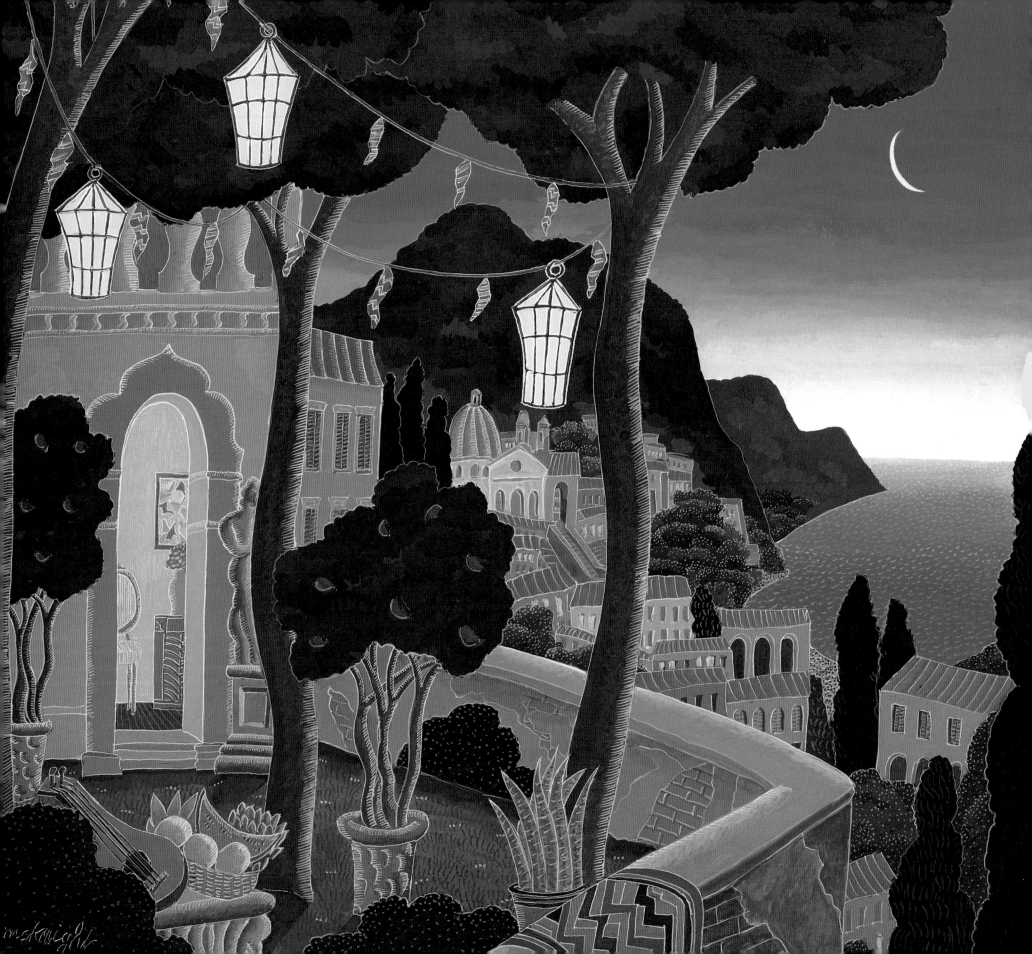

Magna Graecia

Good night! *We northerners say this at any*
time after sundown when we take leave of each
other; the Italian says "Felicissima notte!"
only once, to wit, when the lamp is brought into
the room at the moment that separates day from
night. . . .

—Goethe, *Italian Journey*

Felicissima notte! We are taking lingering leave of Italy by way of its southern coast, and no expression could more felicitously evoke the soft bliss of dusk along the Amalfi Drive, where towns are "pastel sweet by day and as magic as a Christmas village by night." In Amalfi your hotel's rooms "open onto terraces above lush gardens and lemon groves, with only the sea beyond." (The denizen of this coast, Goethe noted, "firmly believes that he lives in Paradise.") You look south toward the ancient Greek city of Paestum and toward Sicily, once part of Magna Graecia; already, on Amalfi's hillside, you see (or dream?) the pillars of a classical temple right beside the cathedral's dome. Thomas McKnight says that as he travels down the Italian coast his feelings quicken, as in that child's game, "You are getting warmer." In Sicily, again he is struck by a sense of homecoming. "These are places we had reincarnations in."

"Sicily is mysterious . . . a region apart, a seductive puzzle"; the island reveals a tangle of prehistoric, Greek, Arab, African and Norman influences. Here, following a town's "Medieval maze of steep streets and alleys . . . lined with gateways that look in on [flowering] courtyards," you may find yourself in an ancient amphitheater that, "situated with the Greek genius for capturing the best possible view from the *cavea*, or seating area . . . looks out on sea and mountains." But instead of the stark bone white we have come to expect in Greece, the temples and theaters here are tawny, giving their classical forms a sensuous leniency that is still Italian. Here cults and religions have grown riotously over each other, like vines entwining the pillars of trees: in Agrigento, the ancient fertility goddess Astarte was worshiped first, and earth-goddess shrines of the seventh century B.C. still stand among the later temples of Zeus and Hera; the Temple of Athena in Siracusa had a Norman and then a Baroque church built right on top of it, so that the original pillars are still visible in the walls.

Here, among the temples, science was born:

Empedocles of Akragas [Agrigento] developed the theory of the four elements: that all things are compounded of earth, air, fire, and water, with love and strife acting as alternating currents. . . . Empedocles insisted that the senses, not just the mind, if properly used, were routes to knowledge. His On Nature *covers subjects from astronomy to zoology, and his work in physics is basic to the field today. In later years he apparently believed himself a god, having already been a bush, a bird, and a fish. To die a death worthy of a god he is supposed to have leaped into the crater at Etna.*

—Barbara Coeyman Hults,
in *Berlitz Travellers Guide to Southern Italy and Rome*

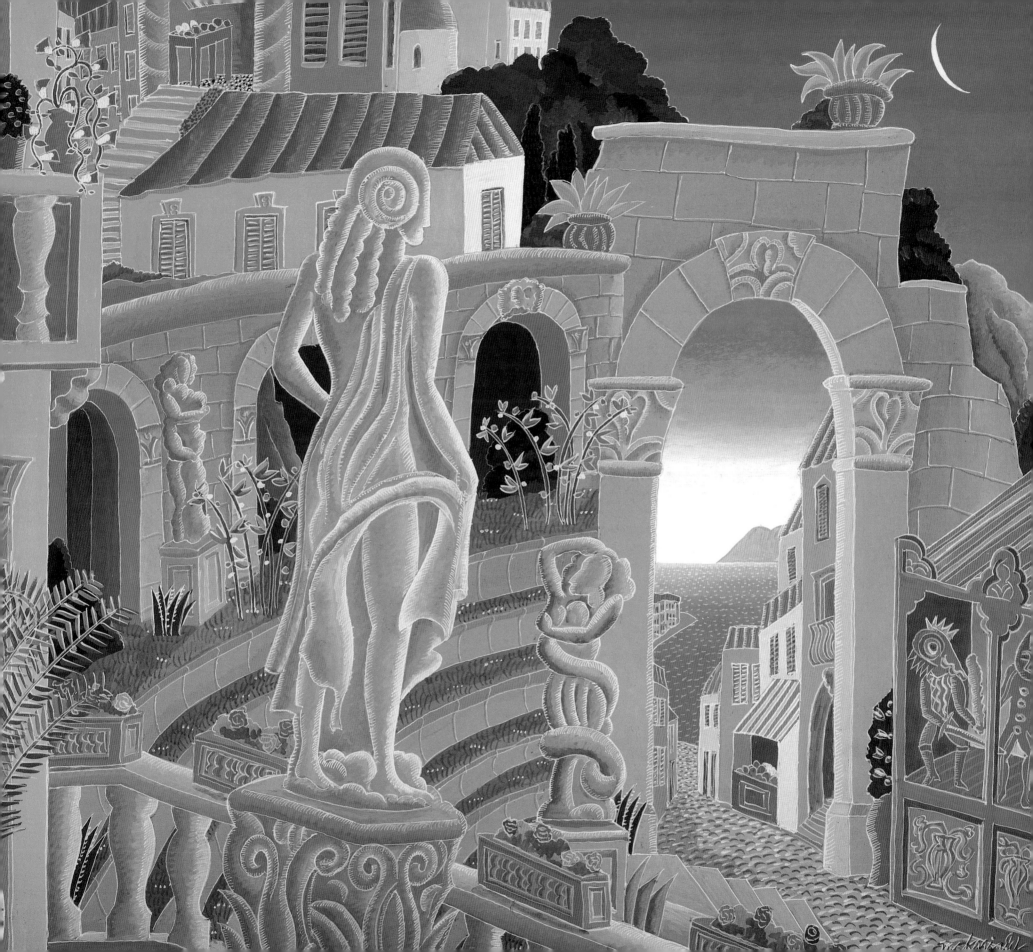

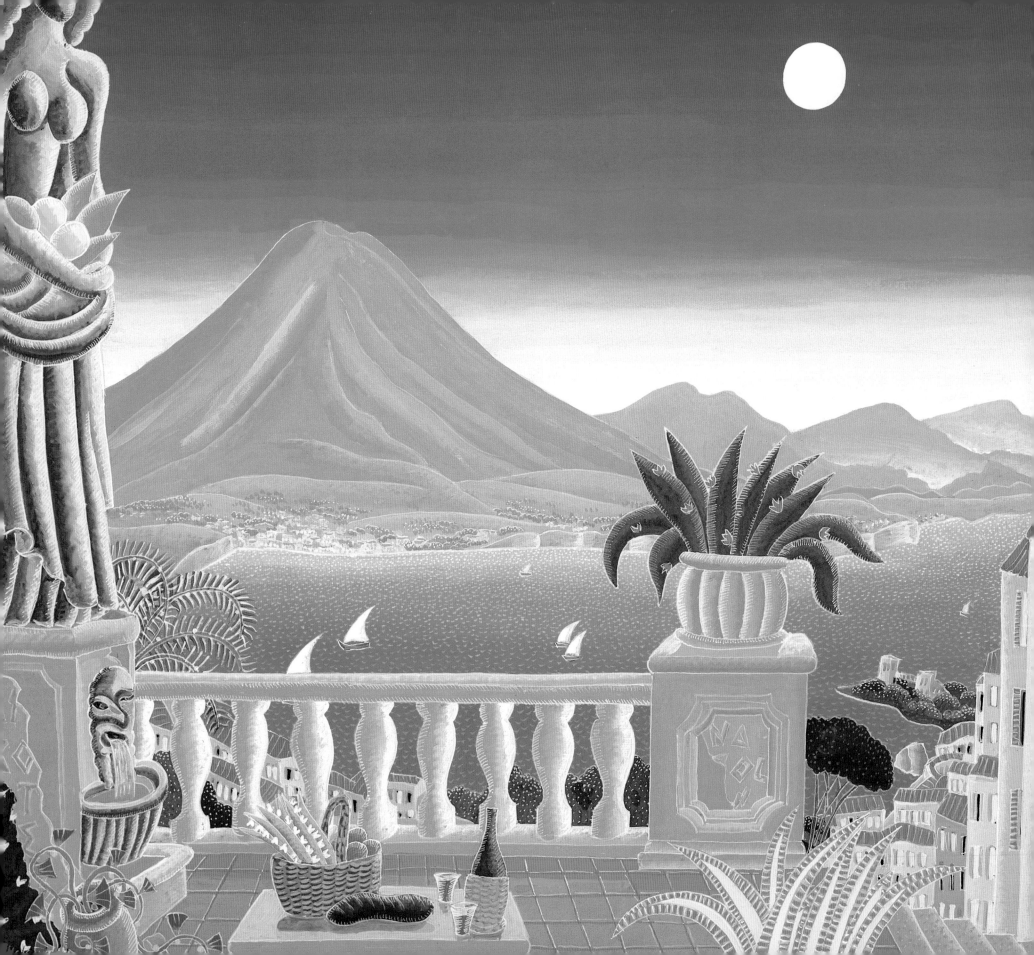

And here, myth was—and is—alive, just as it is in the Australian desert, where aborigines can tell you what quarrel among the ancestor gods is commemorated by each landform. The flowery meadow where Hades burst through the earth and dragged Persephone down to the underworld is on Sicily, near Lago di Pergusa.

It may be no coincidence that here volcanoes, too, are alive—or have been and may be again at any time. Goethe noted that Sicily's Mount Etna erupted four months after he had climbed it; Vesuvius near Naples, the destroyer and preserver of Pompeii, had also erupted the previous year. "This natural phenomenon has something of the irresistible fascination of a rattlesnake," Goethe wrote, hoping to lay hands on its primal power in the form of a frozen chunk of lava flow. The zone of seismic turbulence corresponds closely to the homeland of the Greeks and their gods, stretching eastward to the Aegean, where an eruption around 1500 B.C. sank most of the island of Thera, thought by some to be Atlantis. Our civilization was born out of an experience of Earth alive, shuddering in creation and destruction, "love and strife." The mountains are quiescent now, like the gods biding their time; but assume at your peril that they are dead. Frozen in stone, a goddess watches calmly as we sail eastward toward Greece, the heart of the caldron.

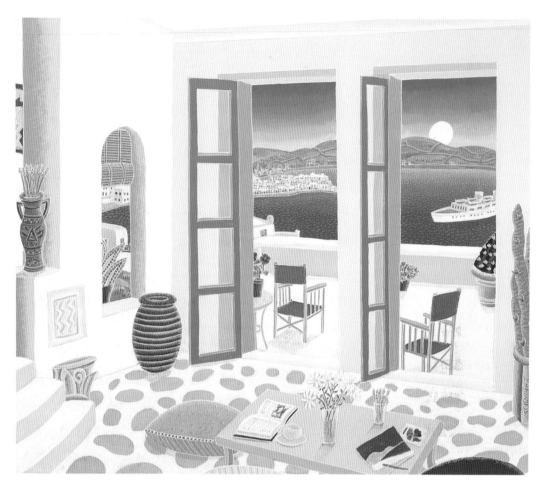

AEGEAN PARADISE

Aegean Blue

*Somewhere between Calabria and Corfu the blue really begins. . . . You are aware
of a change in the heart of things: aware of the horizon beginning to stain at the rim
of the world: aware of* islands *coming out of the darkness to meet you.*
—Lawrence Durrell, *Prospero's Cell*

PATMOS: BEDROOM IN CHORA

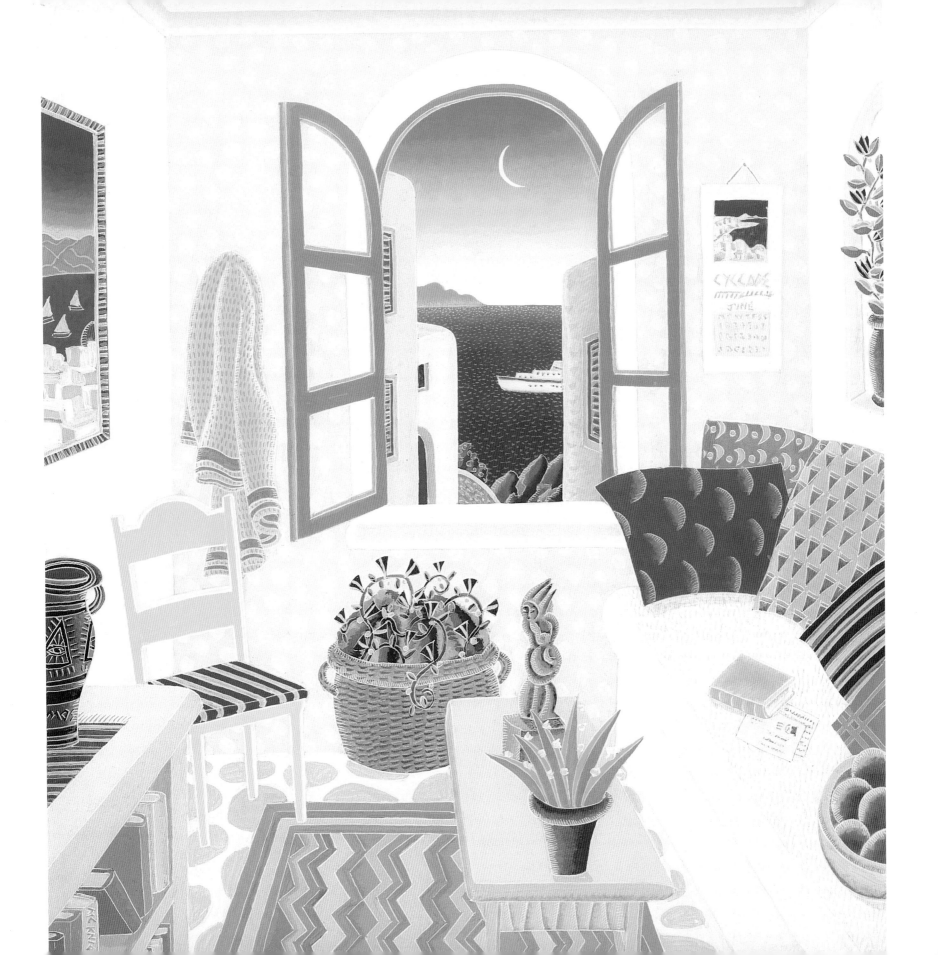

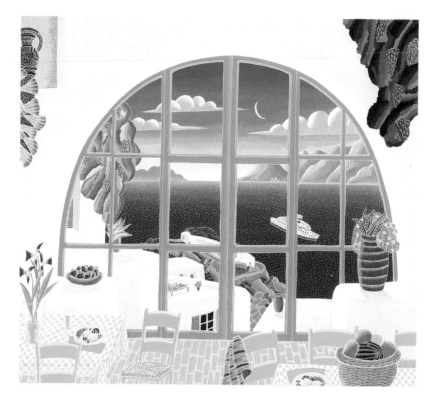

PATMOS: TAVERNA WITH ARCH

So many who have stood on a ship and watched islands rise out of "the prismatic heart of the Greek sea" have felt compelled to capture that sight, in paint or words. Henry Miller wrote, "Out of the sea, as if Homer himself had arranged it for me, the islands bobbed up, lonely, deserted, mysterious in the fading light." "The presence of so many famous islands so near to you, softly girdling the confines of the seen world, has a cradling effect—your imagination feels rocked and cherished by the present and the past alike," wrote Lawrence Durrell. Thomas McKnight paints the islands at dawn, and though we know this is a very old world, it appears new-born: "The subliminal threshold of innocence," wrote Henry Miller, "naked and fully revealed . . . made of earth, air, fire and water."

AEGEAN NYMPH

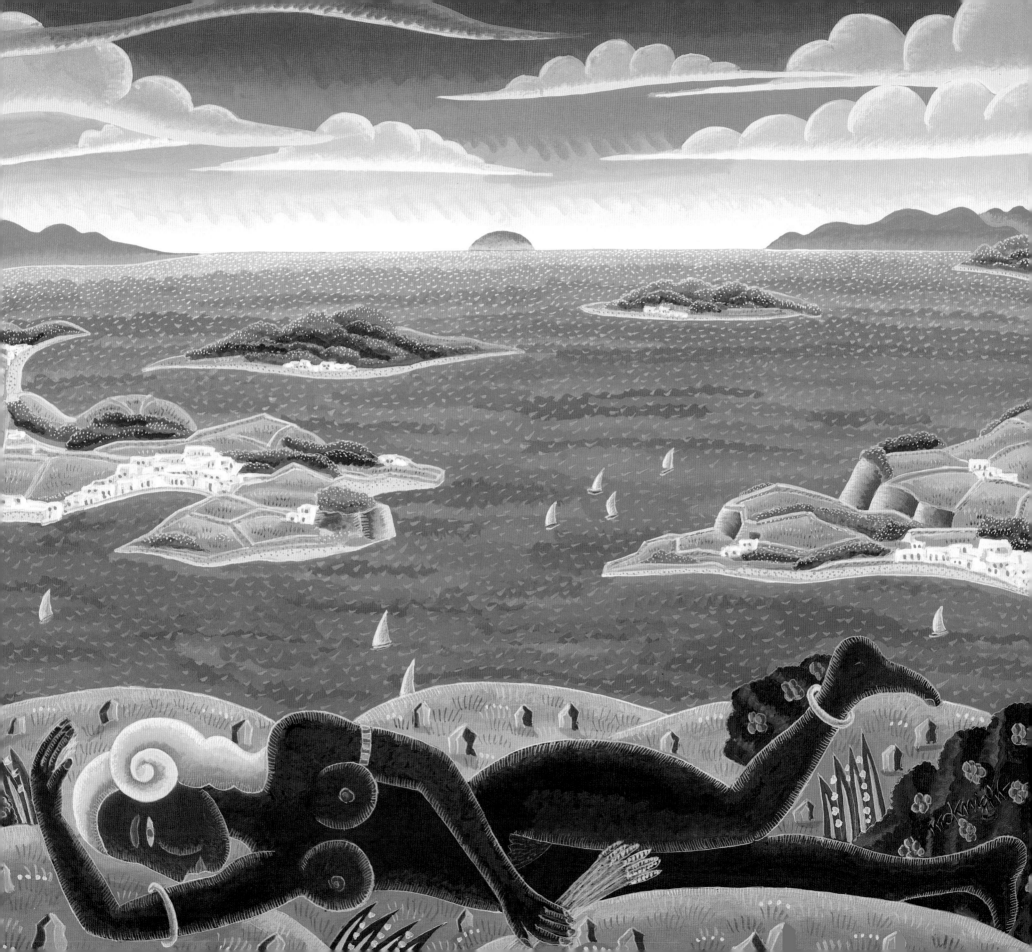

For many travelers, the sense of arrival is stronger here than in any other land on earth. "Greece is now, bare and lean as a wolf though she be, the only Paradise in Europe," said Miller. And "the island Greece" is, for Durrell—and for McKnight—"the heart of the Greek experience." A friend of Durrell's had a theory that "people . . . who find islands somehow irresistible" are "the direct descendants of the Atlanteans, and it is towards the lost Atlantis that their subconscious yearns." And one speculation is that Atlantis lies right here on the sea floor, the sunken heart of the island of Thera,

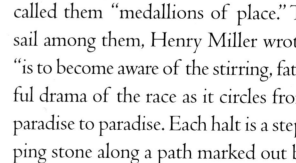

or Santorini. Certainly the Cyclades, "smoke-grey volcanic turtle-backs lying low against the ceiling of heaven," are scattered like lost, eccentric pieces of a once much larger puzzle. Naxos, Paros, Delos, Mykonos: McKnight compares the islands to Italo Calvino's *Invisible Cities*, self-enclosed worlds each with its own atmosphere and theme. Durrell called them "medallions of place." To sail among them, Henry Miller wrote, "is to become aware of the stirring, fateful drama of the race as it circles from paradise to paradise. Each halt is a stepping stone along a path marked out by the gods."

PATMOS: SKALA AT NIGHT

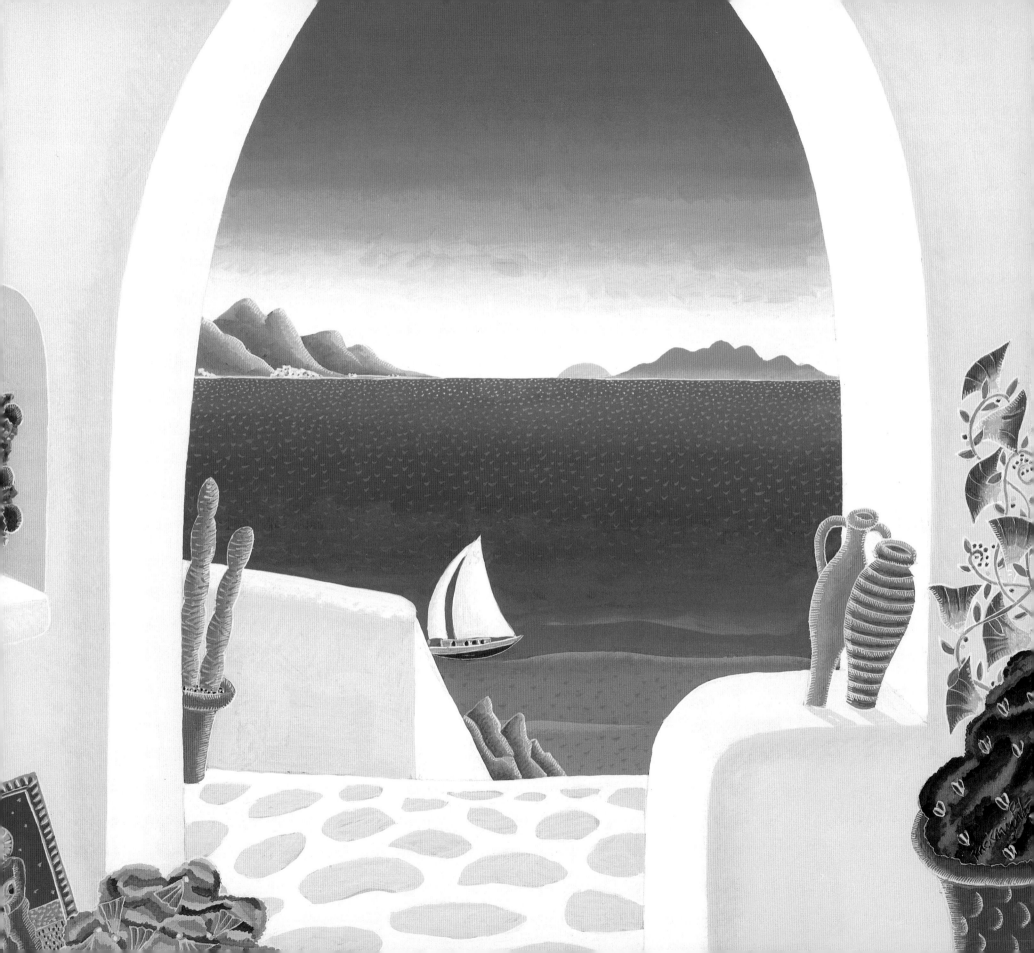

For "Greece is the home of the gods; they may have died, but their presence still makes itself felt." Each island has been favored by a different god or gods. Dionysos magically hijacked a pirate ship (grapevine and ivy snaked up the mast to bind the sails, while the oars turned into serpents) and made green Naxos his own, rescuing Ariadne, who'd been abandoned there by Theseus after she had helped him in and out of the Minotaur's labyrinth. On desert Delos, Apollo and Artemis were born to a mortal mother, after Zeus anchored the wandering island for her as a refuge from Hera's jealous rage. "Then Leto clasped a palm tree in her arms, pressed the soft ground with her knees, and the earth beneath her smiled and the child leaped into the light," says the Homeric hymn to Apollo. The characters are as familiar as our own personal ancestors, and we can't help telling these tales as if they really happened: Greece turns every Westerner back into an aborigine, released from the factual shackles of history into the garden of myth. This bowl of islands is an archipelago of stories, a contour map of our collective psyche, in which every principle of human life finds its place, and all their balance: "Reason (Apollo) is as important as emotion (Dionysos) . . . war (Ares) is as ever-present as love (Aphrodite) . . . stability (Hestia) is as crucial as change (Hermes) . . . the sun (Apollo) needs his sister the moon (Artemis)."

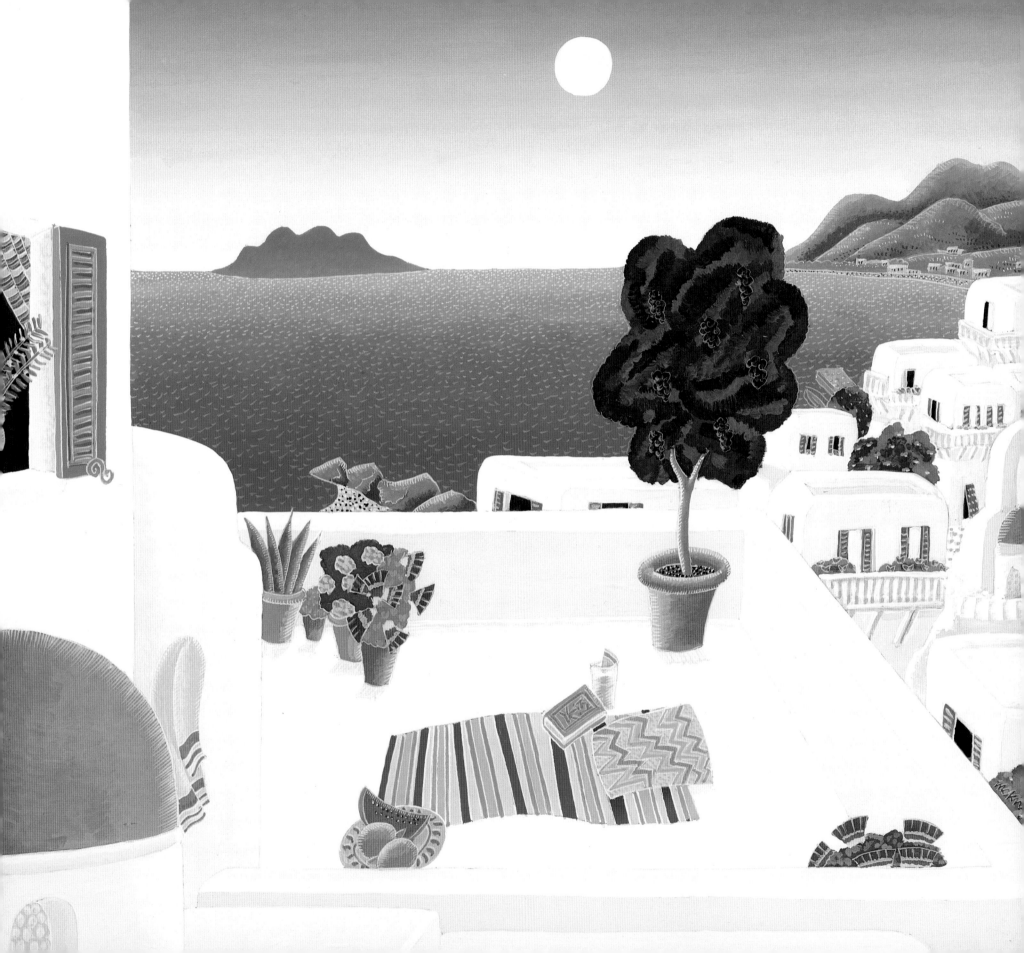

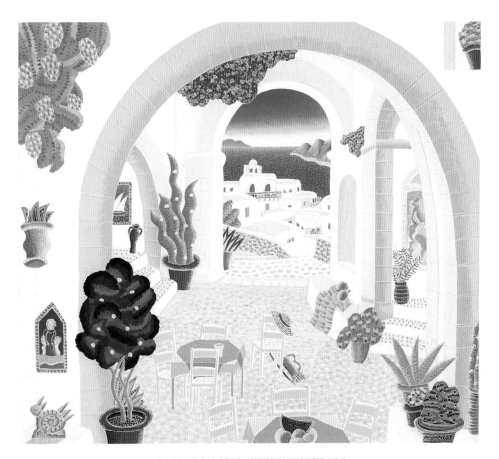

PATMOS: MONASTERY INTERIOR

Even Christ, who came late, found his place among these islands. Unable to subjugate or evict the ancient gods, he and his mother coexist with them in an uneasy peace—as they do in our cultural psyche. Sometimes harmony prevails. Thomas McKnight lets us look through an airy pleasure dome—a place of straw hats, beach towels, bright fruits—to a cameo monastery, set in a gem of blue distance. Spirit shines from the background, discreetly blessing the joys of the senses; an icon and a sphinx lie down together like lion and lamb. On the island of Tinos, a pagan, masculine energy has passed the torch to a feminine and Christian one: once the site of a wonder-working shrine to Poseidon, it is now "the Lourdes of Greece" thanks to a miraculous healing icon of the Virgin, discovered here in 1822. "Power to her arm, and Poseidon be with her!" salutes Durrell.

PLATY GIALOS, MYKONOS

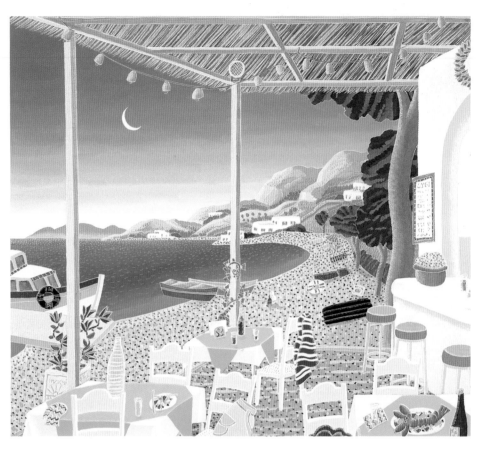

PATMOS: LAMBI BEACH

On Patmos, the sexual polarity is reversed, the contrast harsher. Overlooking the embracing curves of its coast, the island is crowned by a stern monastery built over the cave where the exiled St. John wrote his Apocalypse after A.D. 95. "The monastery is very masculine, the bays very feminine," Thomas McKnight told me.

PATMOS: MONASTERY VIEW

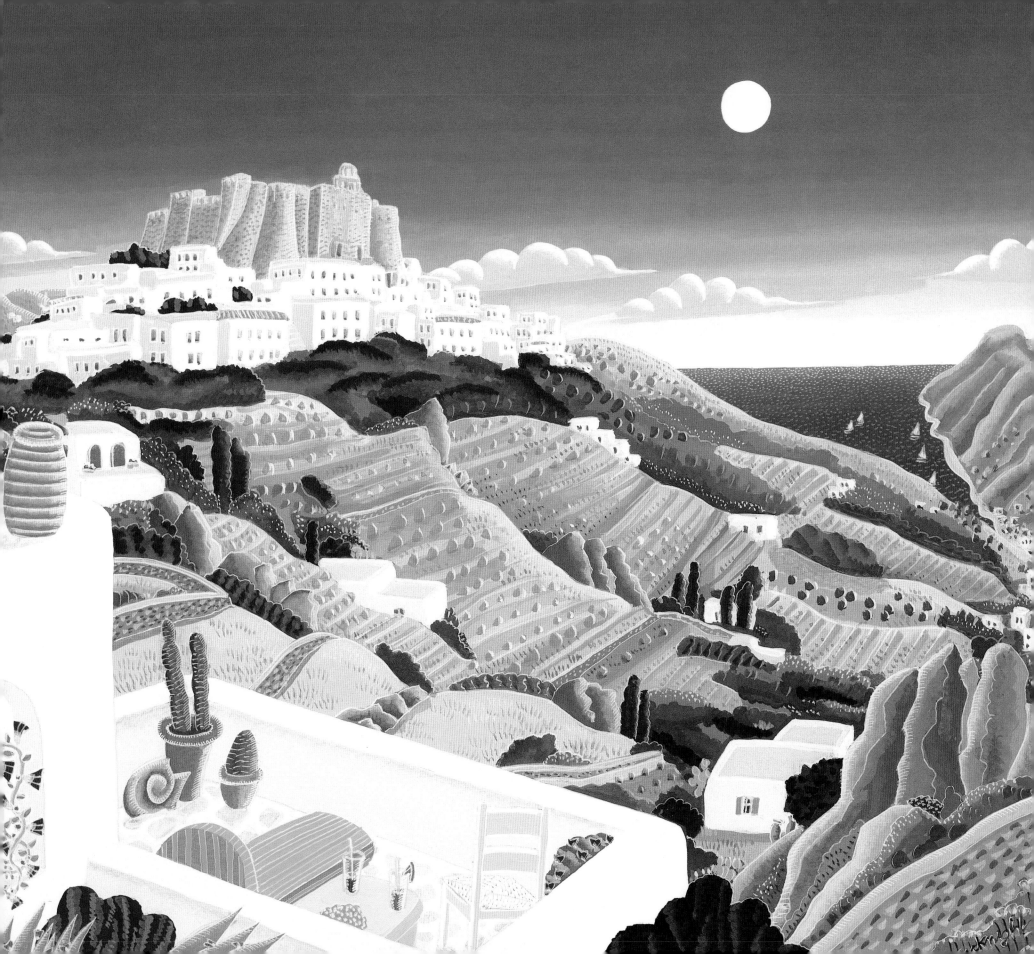

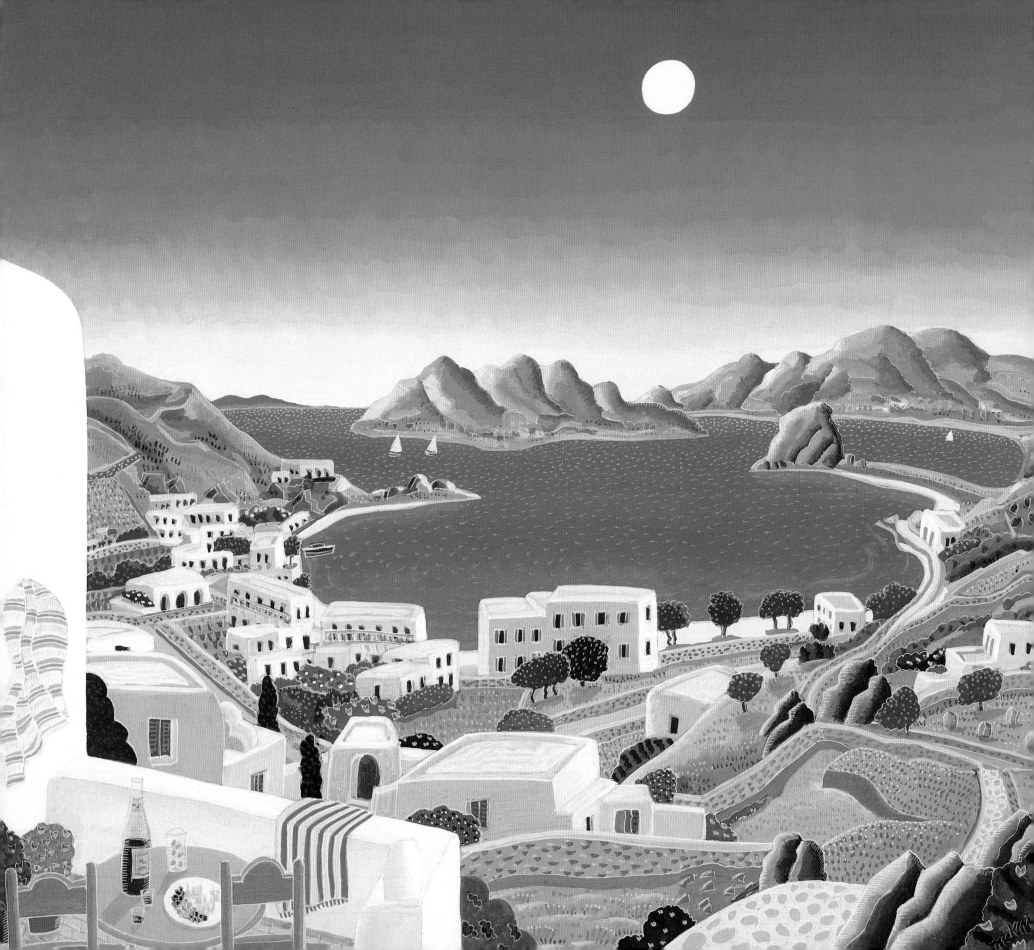

And high in a rock on a peninsula jutting into the bay is a cave sacred to Aphrodite, goddess of love, which he and his wife, Renate, walked and climbed to. "It was a hard climb up a little cliff, and then we turned around and it almost took our breath away. We were scared. You look down and you only see water." You are in that cave now, feeling the giddiness of height, so much like love—Aphrodite energy, pure and undaunted by the frowning monastery above.

"There's another cave on Delos," McKnight told me, "that's extremely powerful, where Aeneas received the oracle that he should found Rome. A priest I've heard of wouldn't cross the threshold. The energies of the gods are too strong." In us, too, there are lairs of primal energies that the priests of conscience don't dare enter. The earth, we begin to remember, is also a living body with a soul, and it is at sacred sites like Delos, the hub of the Cyclades, that her energies gather. Strung along ley lines, the earth's energy meridians—

PATMOS: APHRODITE'S CAVE

Delos is linked to Palestine in the east and Stonehenge in the west—these places of pilgrimage are magnets and transformers: those who are drawn to them find mystical experiences, life-changing insights, portentous dreams. "Delos" means "the revealed" (it's the root in "psychedelic"), and the island's ground is "permeated with dreams": his first time there, sleeping in a tumbledown guest house near the temple ruins, McKnight dreamt of being passed the torch of art by a woman mentor, who would die the following year. The night before, asleep on nearby Mykonos, he had flown over Delos in a dream and seen it exactly as it was.

89

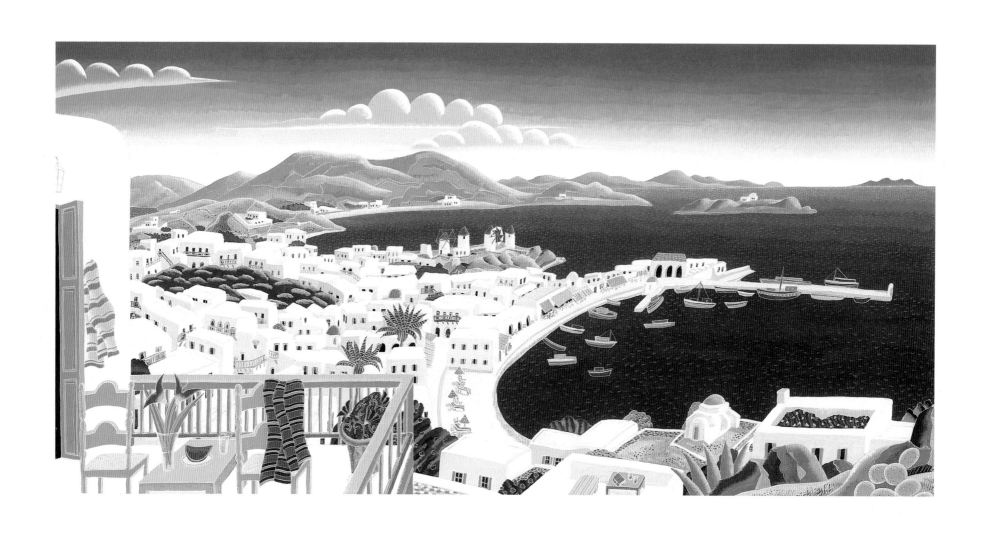

MYKONOS DOUBLE PANORAMA LEFT

Pagan Isle

Today Delos has been consecrated to eternity and tourism; only a handful of caretakers live there, guarding the archaeological sites. By contrast, Mykonos is all for the living, a welcome island of mere humanity in the midst of these rookeries of the gods. "Mykonos is pagan in the sensual, physical, fleshly sense," says McKnight. He should know: he lived here, summer after summer, as a rather shy, young, single artist who lived "a very solitary life" in Manhattan the rest of the year. "I knew I could meet people on Mykonos. I would go there to live my life." The island has been absorbed into his bones as only a place where one has really lived can be: "I've been happy there, I've been sick there, I've been in triumph, I've been in despair, I've been in love and out of love." He met his wife, Renate, there (her name means "rebirth"), not long after his dream of being passed the torch of art. "After our first dinner together, we spent the whole night wandering the white moonlit labyrinth of Mykonos." That "white labyrinth," which he calls "a metaphor for life, in a way," has been central to McKnight's art as well as to his heart.

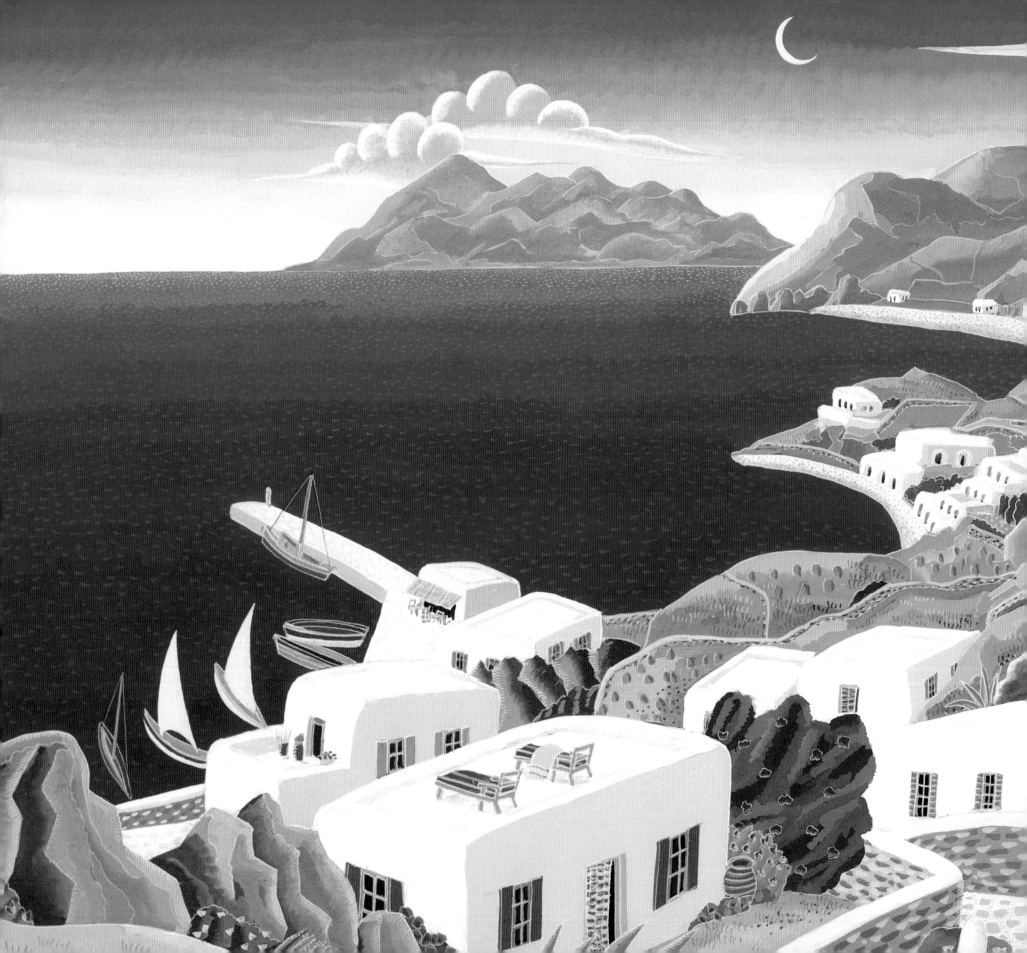

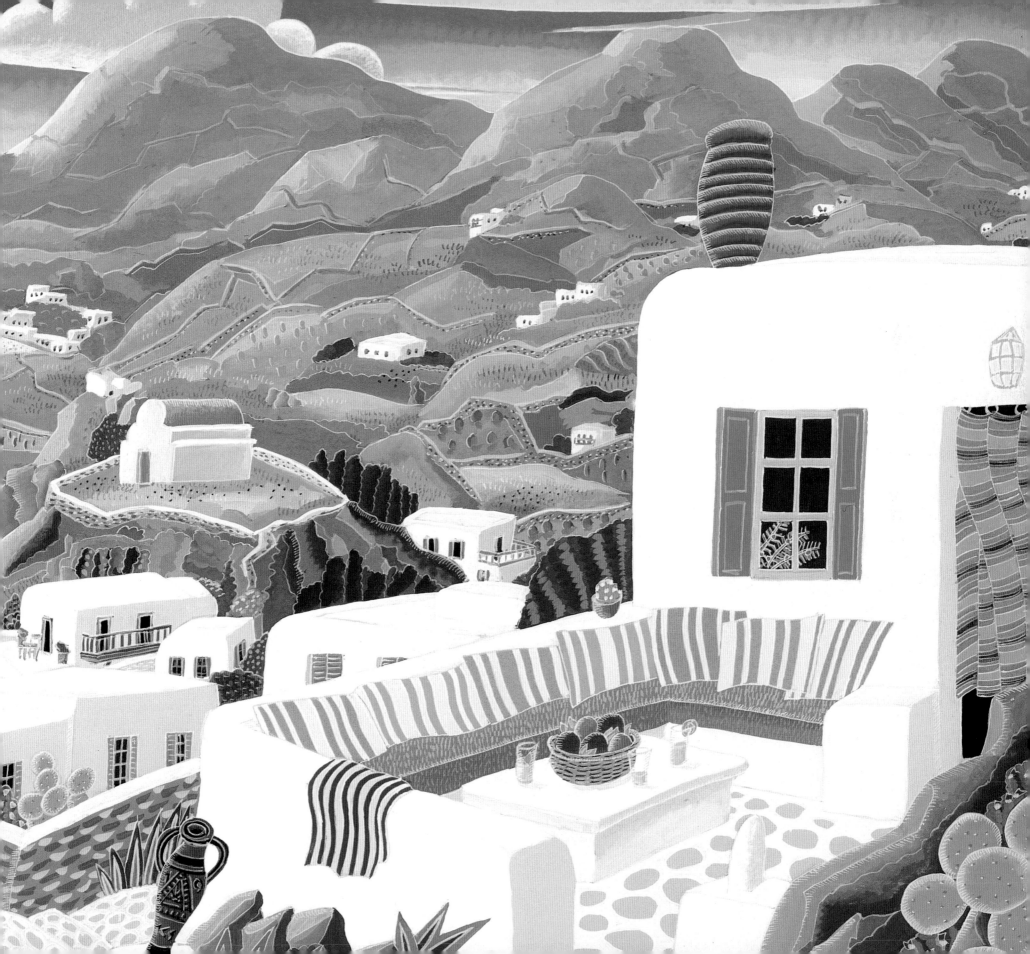

There is nothing quite like this extraordinary cubist village, with its flittering, dancing shadows, and its flaring nightmare of whiteness, which haunts its noons and hence your siestas. Its colonnades and curling streets, with their kennel-like houses, sprouting extravagant balconies of tottering painted wood, lead on and on, turning slowly upon themselves to form labyrinths, hazing-in all sense of direction until one surrenders to the knowledge that one is irremediably lost in a village hardly bigger than Hampstead.

Everywhere the white arcades and chapels repeat themselves in an obsessive rhythm of originality and congruence. . . . Everything is as newly-minted as a new-laid Easter egg, and just as beautiful. . . . Take Picasso, Brancusi and Gaudi, knock their heads together, and you might get something like Mykonos . . . only paradise could be composed like this, so haphazardly and yet so harmoniously.

—Lawrence Durrell, *The Greek Islands*

An identifying characteristic of paradise—whether it's a moment or a place—is an enfolding of the human back into nature: not that we abandon culture, but that its severed limb is grafted back onto the great tree, so that our acts and arts become as inevitable and spontaneous as natural forms unfolding. Durrell finds this trait in Mykonos—along with a fusion of body and spirit, "the voluptuous shapes of breasts translated into cupolas and apses."

The architecture is of no special time or merit; the Greek islander has built himself a home, that is all, and like a sea-animal the shell he constructs prefigures the contours of his nature with its extremes of mysticism and rationalism, asceticism and voluptuousness. . . . If you are a painter or a poet, you will feel, when you walk here . . . part of the extraordinary natural forces which have shaped a peach, have ensured the exact calibration of a starfish or an orange or an octopus.

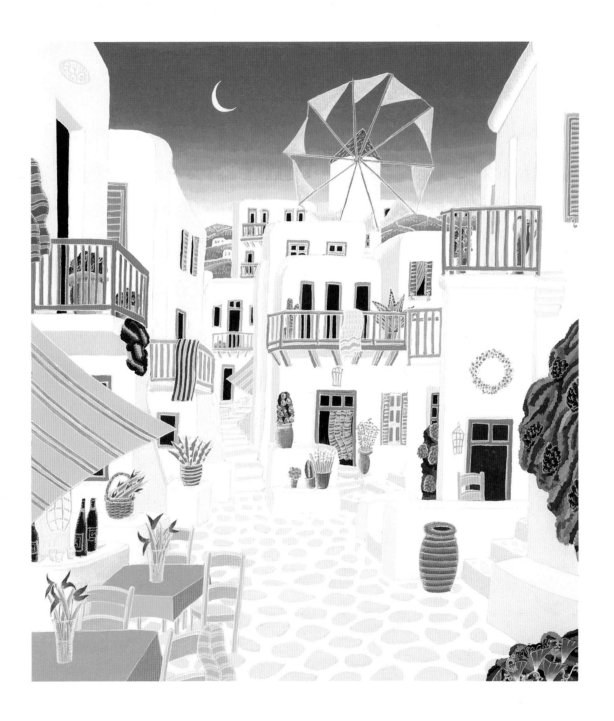

ANNA'S TAVERNA, MYKONOS

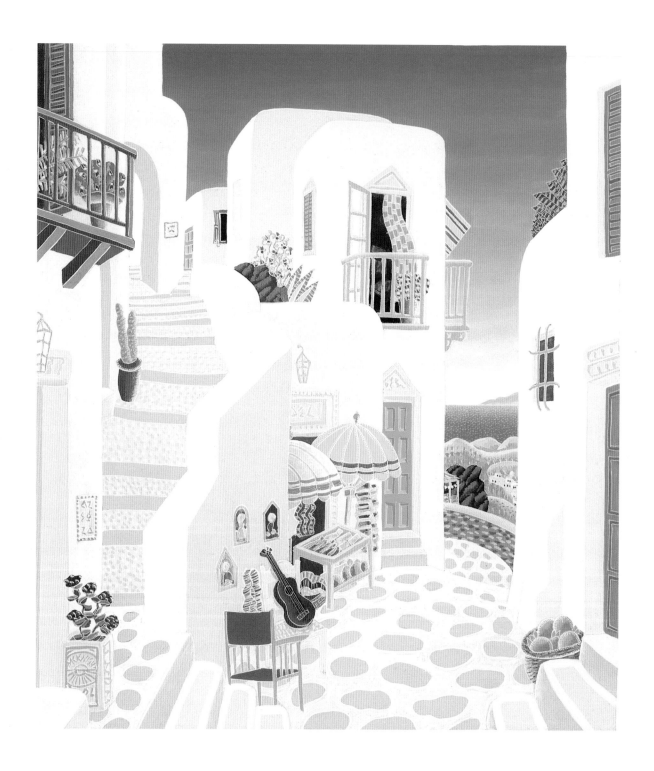

PATMOS: CHORA SOUVENIR SHOPS

Our conscious reasons for what we do often guide us unknowingly into such a larger design. Locals say that the builders of Mykonos made it a labyrinth "to confuse pirates," but more likely what they really meant to baffle was the wind: the *meltemi*, that dry, incessant late-summer wind that Thomas McKnight actually succeeds in painting. (Look at the lifting curtain on a Patmos bedroom balcony, and you feel it.) On a windy day, when the high sails of the Mykonos windmills are spinning, "you walk inside two or three streets and there's a nice calm," he says. The brilliant whiteness, often refreshed, is lime, which—as in Spain—may have been washed over adobe-colored buildings only since the eighteenth century, as a sanitation measure. If so, it was an "accidental" stroke of visual genius—cleanliness being next to godliness—and it has had a major influence on the way Thomas McKnight paints.

"It makes everything look more particular, surrounded by this beautiful white frame," he says. "You can *see* everything. Things don't blend into a continuum, the way they do in the north. Here everything *is* a continuum, but done piece by piece, the colors of tables and chairs and things separated by white streets and white walls. One of the technical ways I've been able to use bright colors without making them look jangled is to surround them in white. I think that what it does is allow the colors to breathe." In all of McKnight's images, not just the Greek ones, white is used to separate areas of color, even if it is no more than the thinnest "whitish ochre lines that further delineate detail," which he adds as the finishing touch to each painting. Think of it as a fine line of Greek light that now travels everywhere in this artist's eye, importing into very different scenes that supernatural clarity Henry Miller praised: *Everything is delineated, sculptured, etched. . . . You see everything in its uniqueness—a man sitting on a road under a tree: a donkey climbing a path near a mountain: a ship in a harbor in a sea of turquoise: a table on a terrace beneath a cloud. And so on. Whatever you look at you see as if for the first time. . . . Every individual thing that exists, whether made by God or man, whether fortuitous or planned, stands out like a nut in an aureole of light, of time and of space. The shrub is the equal of the donkey; a wall is as valid as a belfry; a melon is as good as a man.*

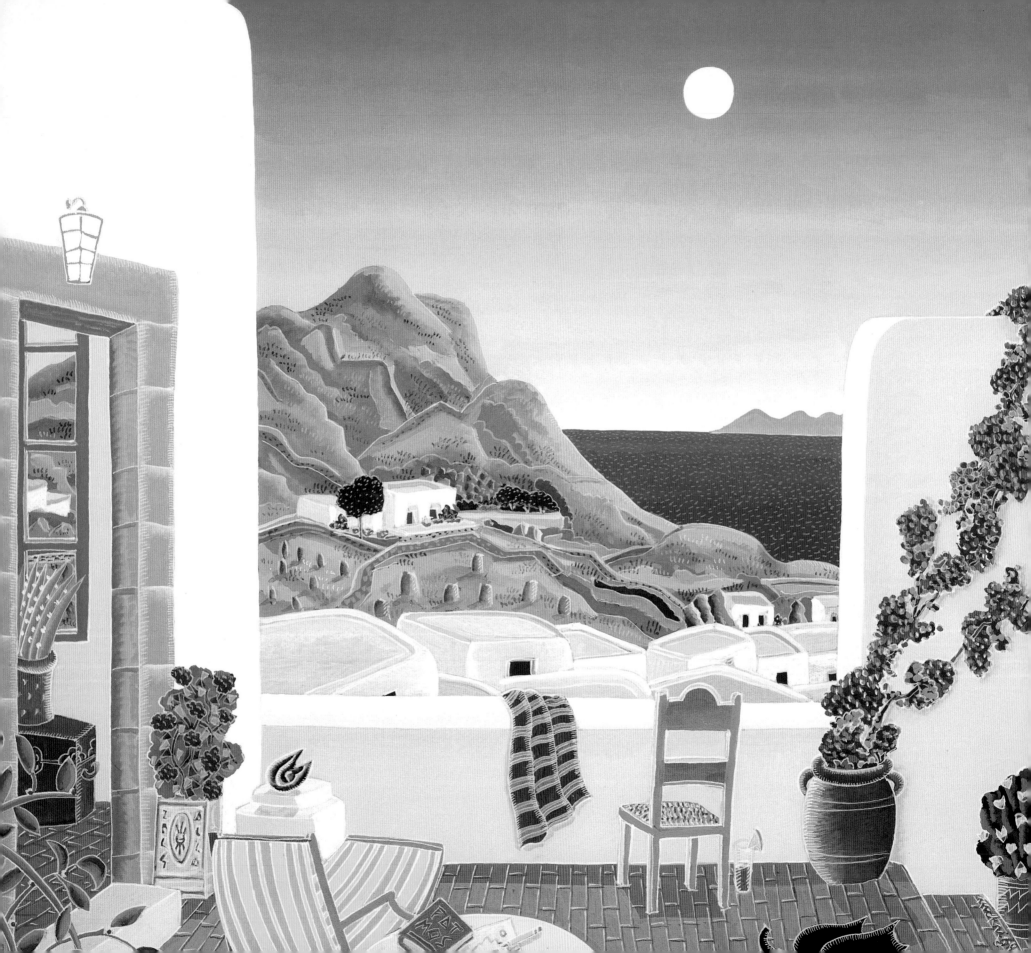

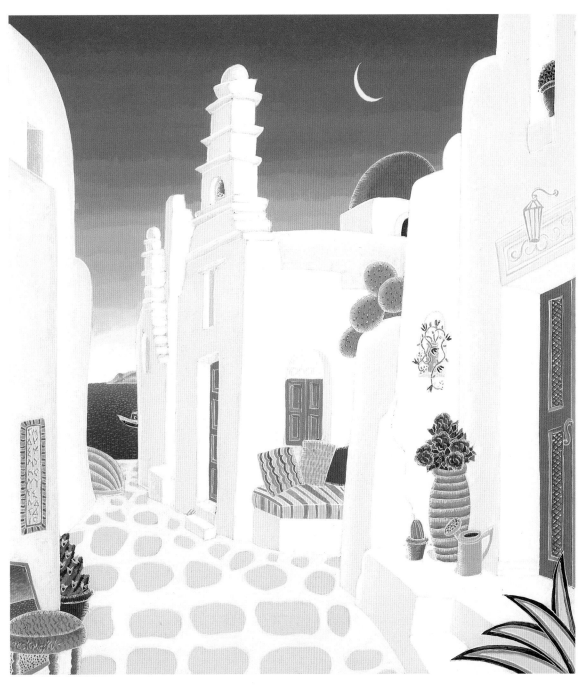

AEGEAN CHAPEL

PATMOS: TERRACE AT CHORA

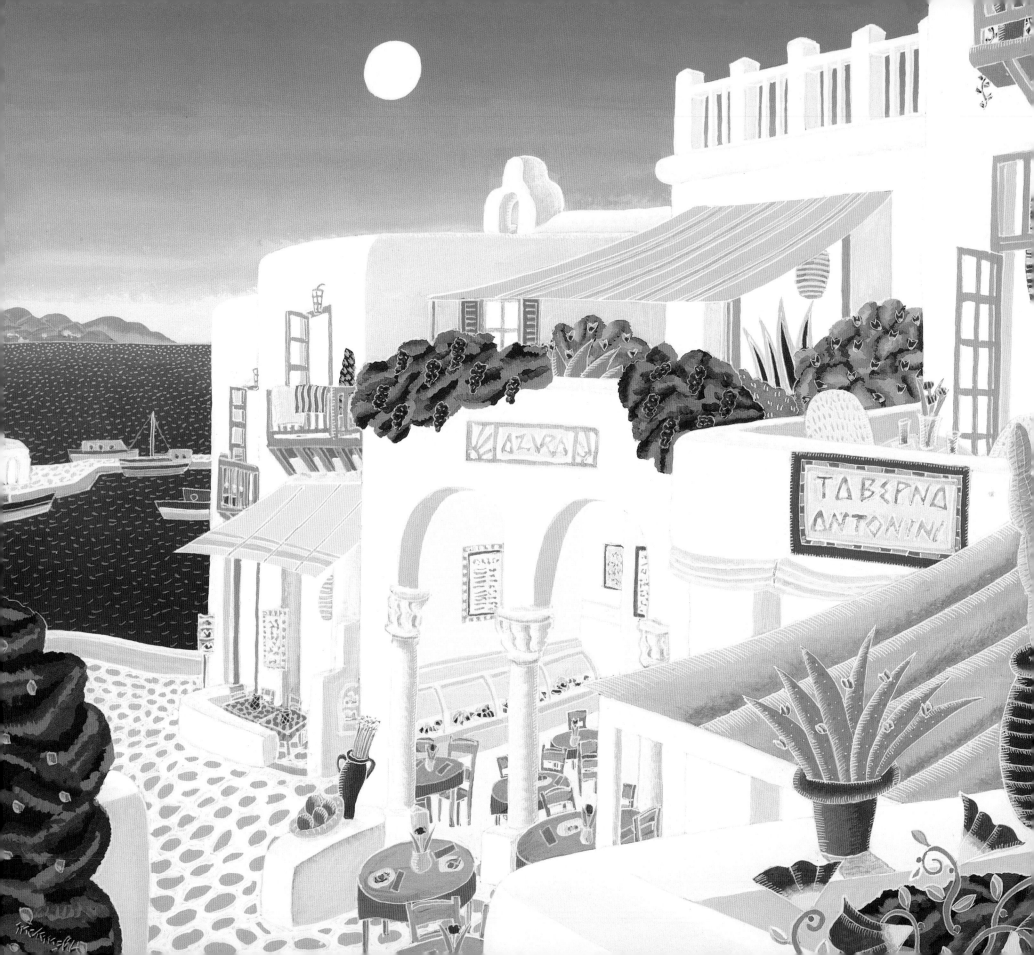

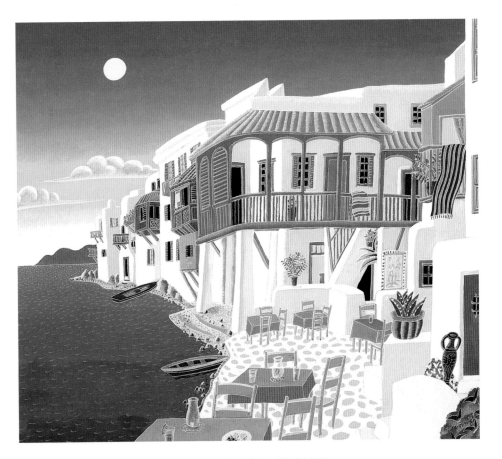

LITTLE VENICE, MYKONOS

As the day ends, that white light is prismed into its component parts and then fades to ultra-violet. Emerging from the labyrinth, you sit and drink to its sea-change:

At the end of every gyre or whorl (you are inside a sea shell) you suddenly plunge out upon the harbour with its welcoming lines of cafes and chop-houses, set out under brilliant awnings or in some places shaded by tall mulberries. . . . Night-fall is the time, ouzo-time, after an exhausting day of doing nothing purposefully (the opposite of killing time), when you feel the need of these cafes. The violets, pinks, rose, and grey, of the sinking sun on the walls—just before the wink of the green ray that says goodnight—are all the more haunting for being reproduced in little in the cloudy glass of ouzo before you on the table. It is like inhabiting a rainbow.

—Lawrence Durrell, *The Greek Islands*

MYKONOS: ANTONINI'S

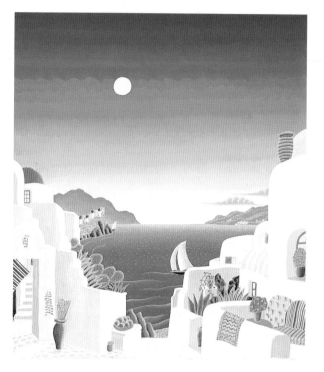

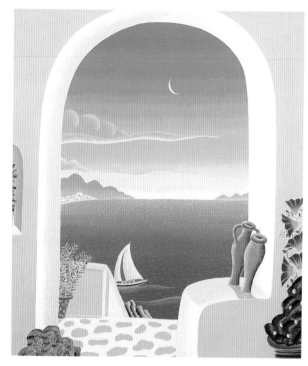

MYKONOS CAPRICCIO DUSK AEGEAN ARCH

Then you walk home through "the trembling amethyst . . . the violet whiteness of the falling dusk." And then, Durrell says, "You sleep in a cocoon of wind. . . . Never will you go to sleep so soundly as you will in Mykonos—and it is the deep sleep of early infancy. In the morning, when you push back your shutters, the whiteness comes up to meet you again like the caress of wet eyelashes."

This is the "lotus-eating" life Thomas McKnight lived, and still revisits, on Mykonos: days on a nude beach or a whitewashed terrace, imbibing the light to paint with; nights in the island's fleshpots—the tavernas, vivid with candlelight, color, and gossip, "the small change of the gods." It's a timeless life, another trait of paradise: you are in an eternal present of pleasure. But time is tricky here, because there is so much of it, lying in layers like an archaeological palimpsest. You may glide horizontally from day to day with no change, like that passing sail, but the smallest vertical slip—during a nap on your terrace, perhaps—and you might wake to see a sail of barbaric red. Unsurprised, you rise, slip on your tunic of fluted linen, and walk into the labyrinth of Mykonos's past.

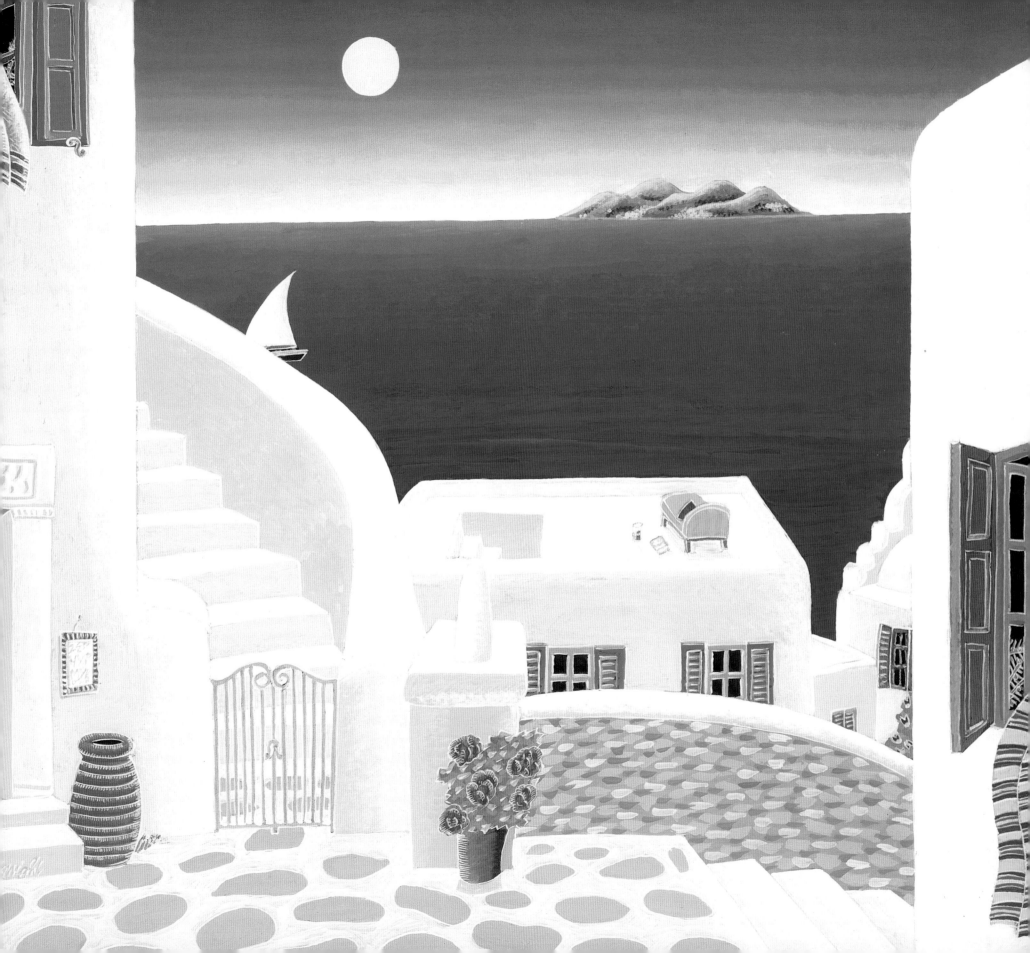

· III ·

The Voyage Back

AEGEAN COVE

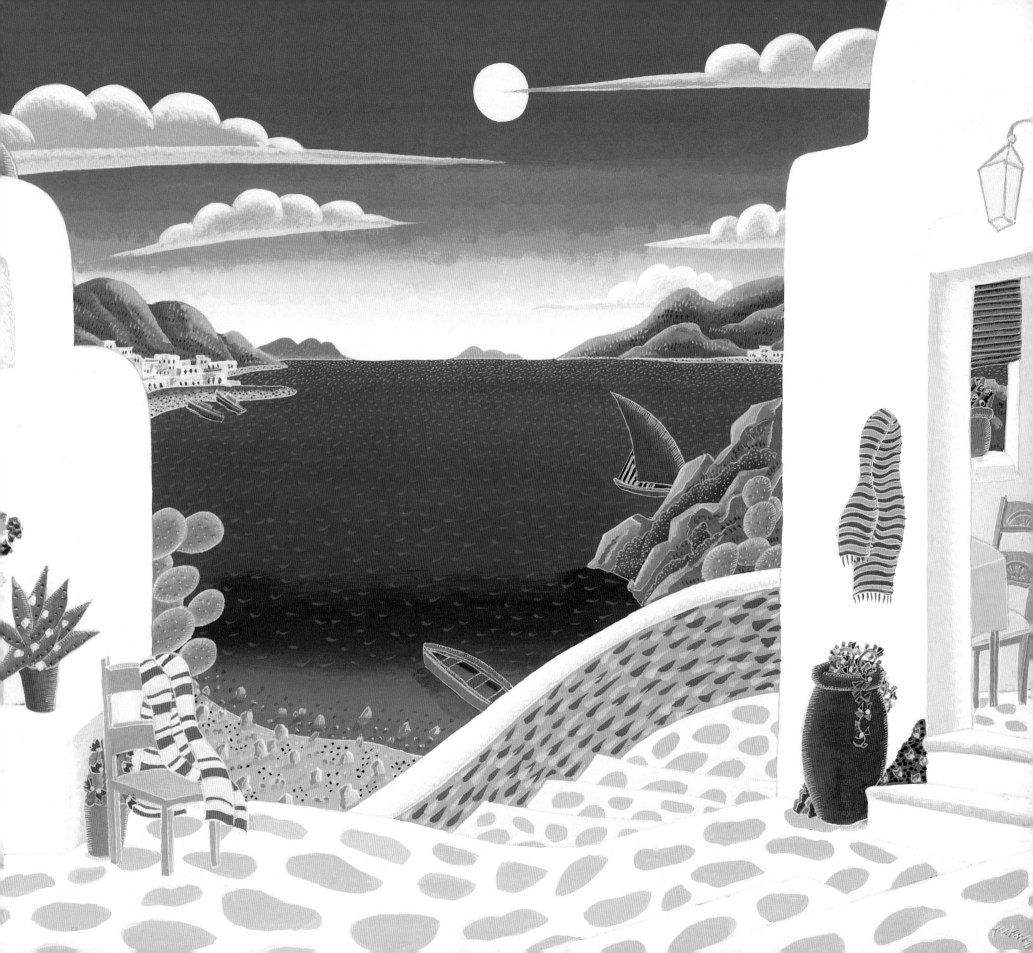

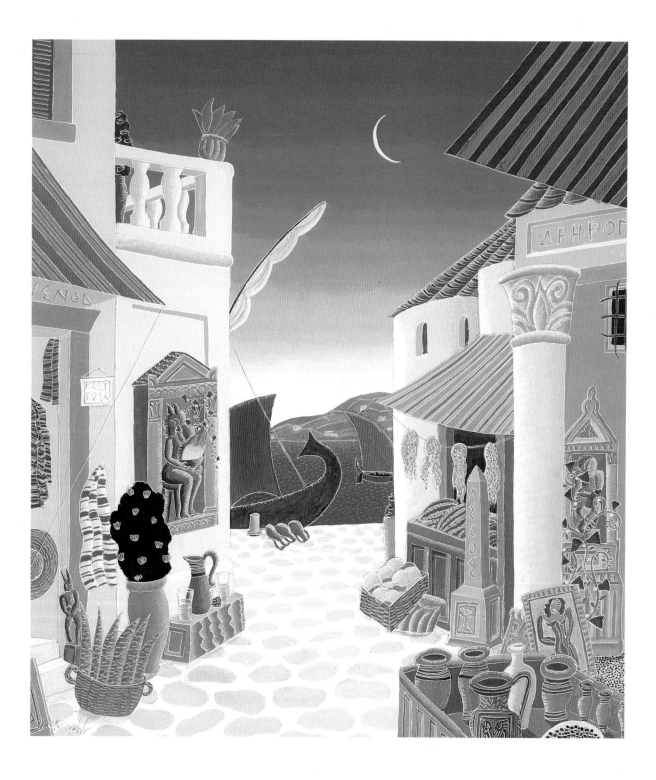

ANCIENT DELOS HARBOR

Archaic Grace

The first thing you notice is that the colors are fiercer, deeper, as if the blood of Greece ran redder, its flame burned brighter. The Christian chapels with their snowy curves are gone; in their place, the columns of classical temples stand straight and proud. And while the chapels were enclosed as Easter eggs, incubating man to hatch into the next world, the temple porticos surrounding the inmost sanctuary are open to everyday life and commerce. They stand right in the marketplace, sheltering craft workshops and merchants' stalls. You can drop by a god's front porch and leave an offering between buying melons and octopus—as you can today in parts of Japan. These gods aren't absentee landlords; they've got their feet on the ground. Hephaestos is right there in the smith's fire, Hermes in the fishmonger's slipperiness (for he is the god of trade, guile, and silver-tongued persuasion). Mama Demeter runs the bakery, Dionysos the wineshop, Athena spins the potter's wheel—her invention—and Daedalus gives sculptors the godlike power to breathe life into their creations.

This is a paradise we dream of today: a time and place where civilization is still handmade and human-scale, and still has a ruddy health, like someone who's just come into town from the country. Both the people and their gods have scraped the rustic mud off their shoes and learned refinement, but not abstraction; the town with all its arts is a flower still firmly attached to its roots in the olive groves, goat pastures, and unpolluted blue sea. Honey and wool, grain, fruit, and fish are brought in fresh; the town responds in bronze and cloth and clay. Is Thomas McKnight imagining these scenes, or remembering them? While some are based on actual present-day sites, "I've just done them out of my head," he says. "I have a book of *National Geographic* pictures of reconstructions of classical antiquity, and it doesn't look anything like what I've done. But their pictures aren't necessarily right, either."

Perhaps he was there.

ANCIENT MYKONOS WITH PELICAN

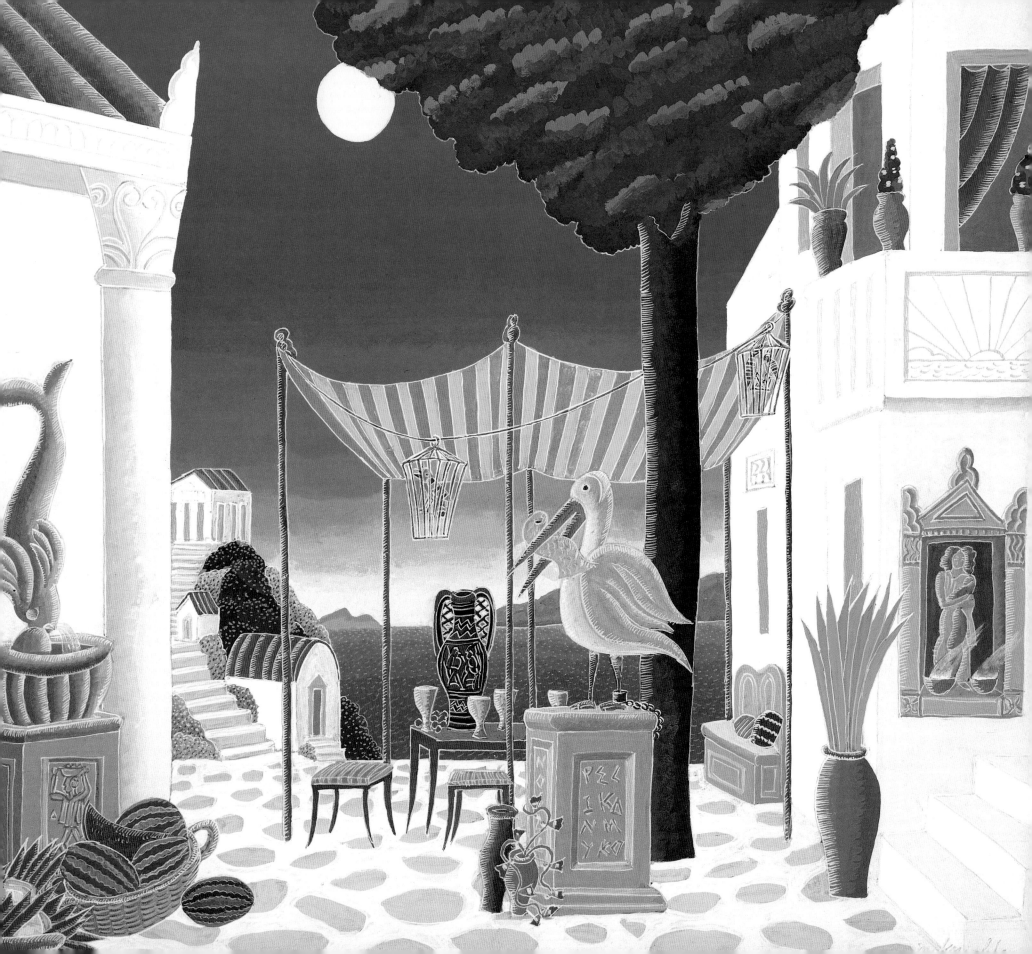

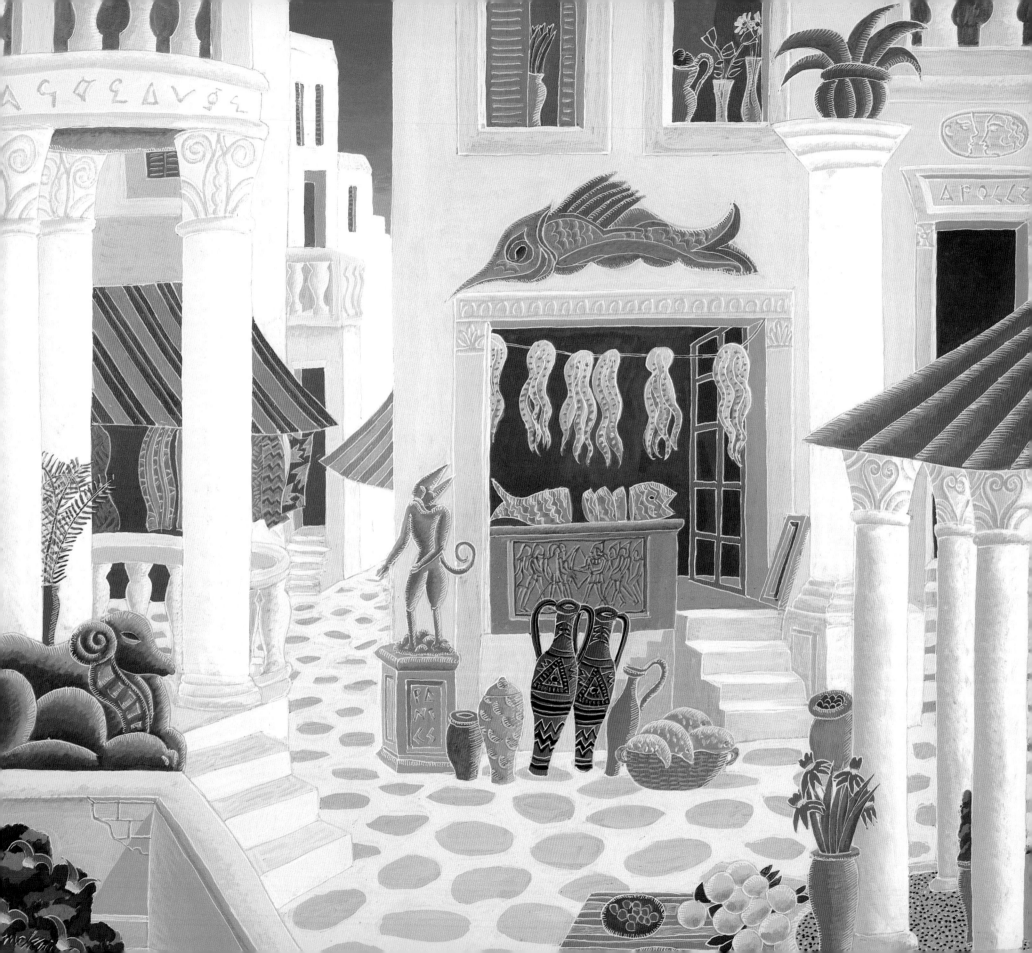

McKnight's painting technique has a secret affinity with ancient Greek pottery. Looking at his luminous blue and white, you would never suspect that hidden underneath is a wash of Venetian red, an earthy brick color much like the terracotta of classical vases. "It warms the colors and enriches them," he explains. "It also forces me to keep painting over and over until I cover the ground, and you get more of a texture that way. If you painted a white wall on a white piece of paper, it wouldn't have the depth." First, though, he sketches a composition on the red ground in charcoal, and when he is satisfied, "I fix it with a pencil sketch. I use a fairly soft paper, so the pencil actually digs in, and you can hold it against the light and see the lines deep into the paper. It's almost like what the Greeks did on those vases: they would incise the line into the wet clay with the other end of their brush, so they'd actually have a line-drawing first, which would then be painted." Maybe McKnight himself is like his paintings, an archaic Greek lifetime glowing through and warming the plain white of his Midwestern birth. Each of us is more than meets the eye.

The culture of this time and place—Greece in the middle of the first millennium B.C.—is the offspring of a marriage that began in rape over a thousand years before. Semi-nomadic Indo-European warriors, wheat-growers, cattle-herders, and metal-workers, pressed down into the Balkan peninsula. They knew nothing about the sea; but on the shores of the Aegean they found a civilization that had mastery of the sea and dominated trade from Italy to Egypt: the peaceful, feminine, and graceful Aegean or Minoan civilization that reached its peak in the palace of King Minos in Knossos, Crete. After "a brutal invasion," wrote historian Jean Hatzfeld, "the northern conquerors wedded the daughters of the great native families," a development mirrored on Olympus by "the marriage of Zeus, the chief celestial deity and Indo-European by his name and nature with Hera, the goddess worshipped by the original peoples of the Peloponnese. . . ."

111

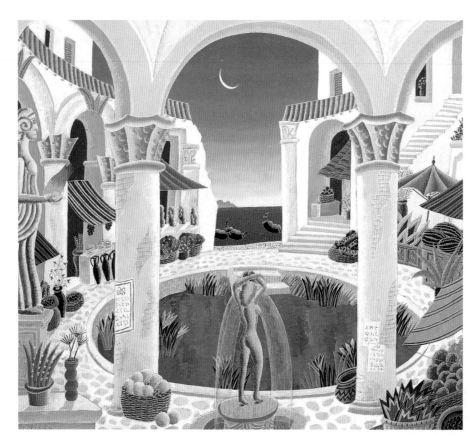

CLASSICAL CITY MARKET

The result was a potent marriage of war and art, force and grace: Greek architecture probably got its grandeur from the fortification-building skills of the warriors and its exquisite proportions from the artistic eye of Crete. It was also a marriage of the elements: the warriors' thundering hoofs brought earth and fire, the Aegean dowry was water and air, prime movers of the silent sail. Their descendants spoke a landlocked language (born on the Central Asian steppes) but lived a sea-girt life; within a few centuries, the Egyptians were calling the Greeks the "People of the Sea."

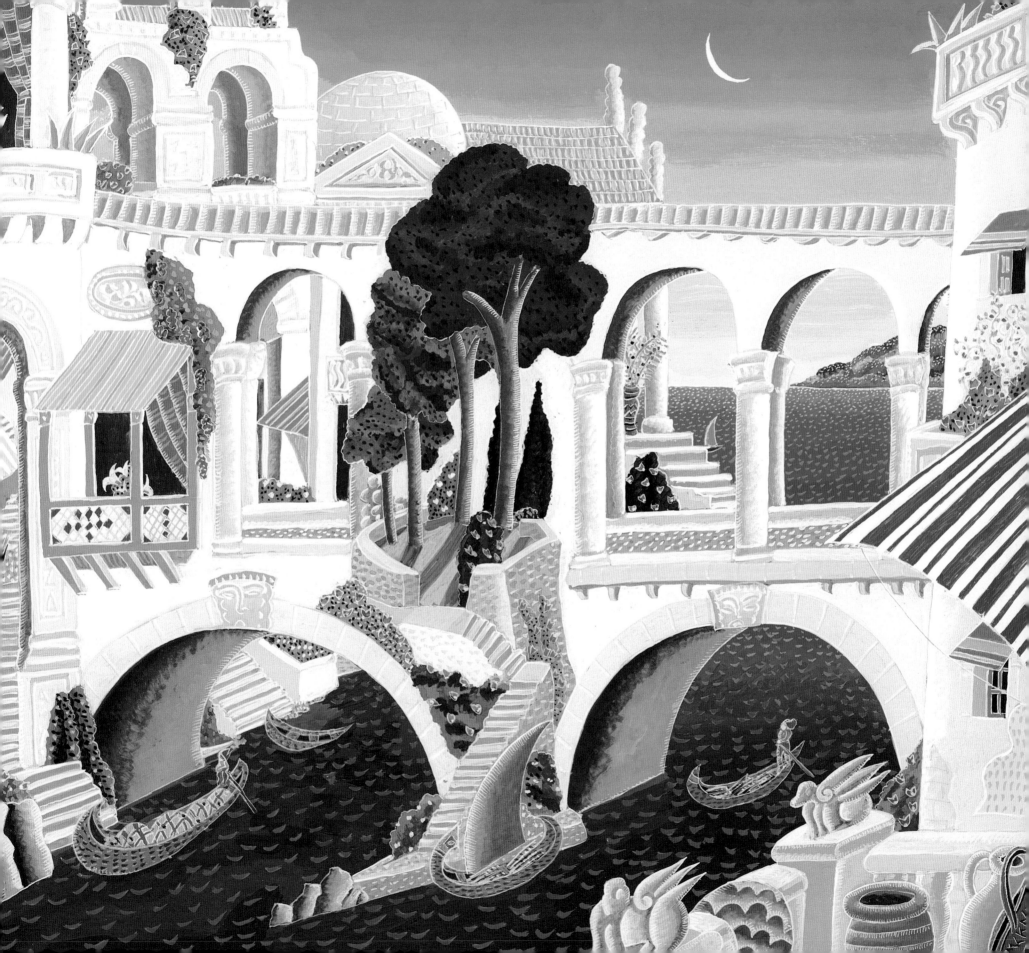

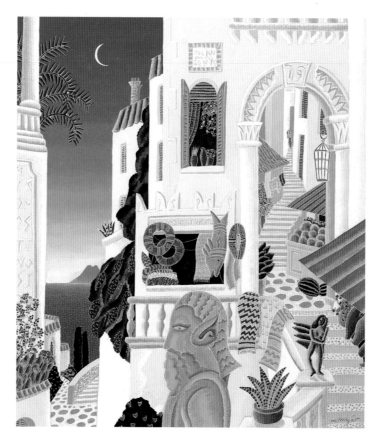

CLASSICAL CITY WITH POSEIDON

They owed special fealty to Poseidon, god of the sea and Earth-Shaker, who periodically remade their world; also to Aeolus, god of the wind, who took an earthbound race and set them as free to roam as the clouds. I think of *Temple Precinct* as a temple to Aeolus, where there is no image of any kind, just an airy space offering hospitality to the god and a banner to announce his entrance.

For the most part, though, the Greek gods had "human shape and passions"—only larger. And that is how the Greeks portrayed them: as human beings writ large.

TEMPLE PRECINCT

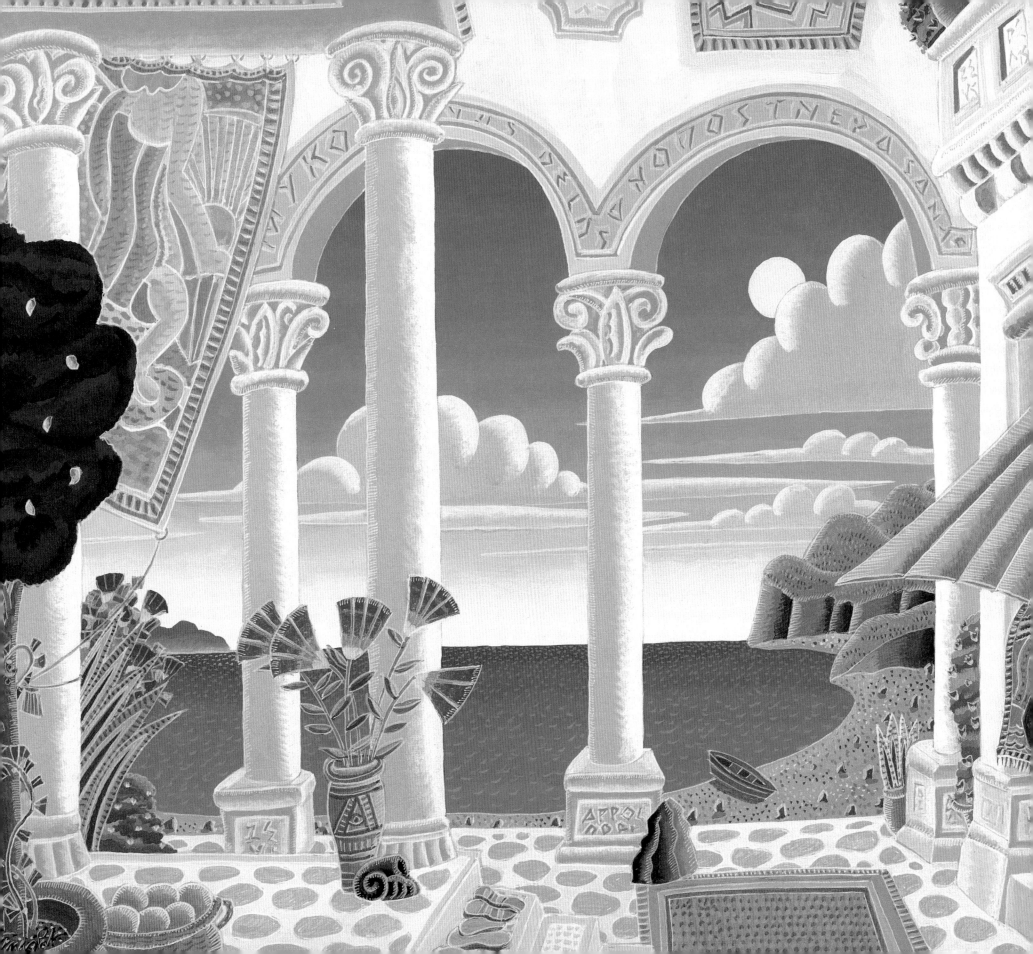

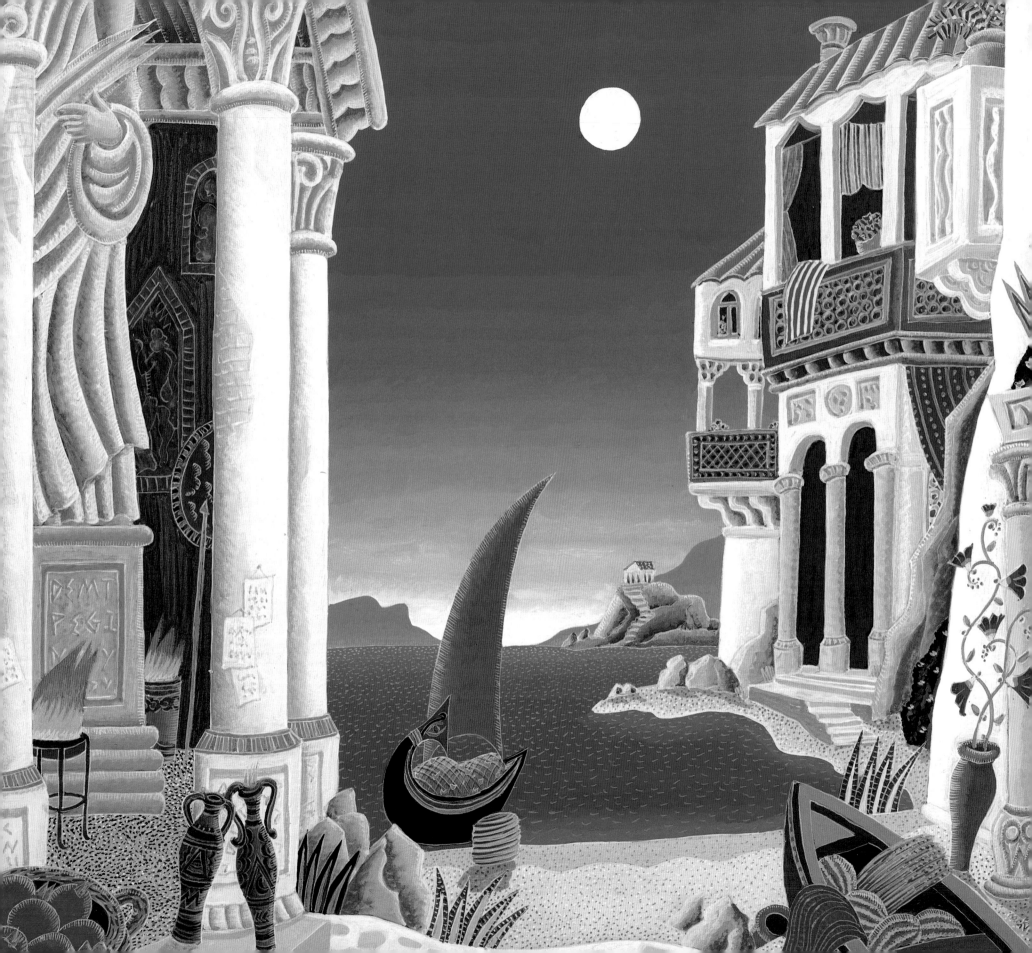

Inside the Colossus

Colossal sculpture became an obsession and a glory during the sixth and fifth centuries B.C., when Greek civilization was at its peak. In the same period in which Sophocles was writing his tragedies, the sculptor Phidias erected in the Parthenon a statue of Athena over forty feet high, made of bronze, marble, ivory, and gold over a wooden framework. His equally imposing statue of Zeus debuted in Olympia a few years later. The later Colossus of Rhodes is better known: a bronze-plated statue of the sun god Helios, 105 feet high and built to commemorate a third-century military victory. (His crown of spikes,

CLASSICAL CITY WITH STATUE

or sun's rays, inspired those on the Statue of Liberty.) Less well known is that Rhodes was a city of colossi even before the famous one was built: "A hundred statues of the Sun, 100 feet high, were dotted round the isle like the monoliths of Easter Island." To some extent, the same was true of every Greek *polis*. "Each city had its acropolis to shelter the temple of her tutelary God," and each temple housed an awe-exacting image of that god, half-concealed, half-revealed to the worshipers outside. "In the sacred precincts of Delphi and Olympus, temples were erected one beside another," and so were their great, grave images.

One can only imagine, as Thomas McKnight does, the impact that these massive yet mysterious figures must have had on the imagination. They appear here as adults do to a toddler: both reassuring and intimidating, protective and inaccessible, their heads too far away for us to see the expression on their faces and know their dread judgment of us—if they notice us at all. Like parents, their lighthouse gaze over our heads suggests a life far beyond our small horizons. But the human form of the gods hints tantalizingly that their greater life is not forever out of reach; we could someday grow into their powers and graces, taste their delights.

This sense of the attainability of the divine must have been strengthened for the Greeks by their many myths of mortals lifted up to Olympus by impressed or smitten or pitying gods. Their cult of hero-worship, too, enlarged the founding hero of a city—or an art—into a demigod with a colossus of his own. "Each city and each district venerated its mighty dead. Each guild and corporation had its guardian. . . . The poets not only chose as tutors legendary Heroes such as Linos and Orpheus, but they also worshipped Pindar, Aeschylus, and Sophocles. The philosophic sects 'heroized' the great philosophers who had founded them. Anaxagoras, Plato, Aristotle, and Epicurus himself became veritable objects of worship." For us today, this humanizing of the gods and deifying of the human foreshadows the anthropocentric arrogance that has been the tragic flaw of Western culture. But imagined from the point of view of the Greeks, it expresses a nearly limitless sense of possibility, and of human *power* in its innocent root meaning of *potere*: "I can!"—the delighted crow of a baby god taking his first steps.

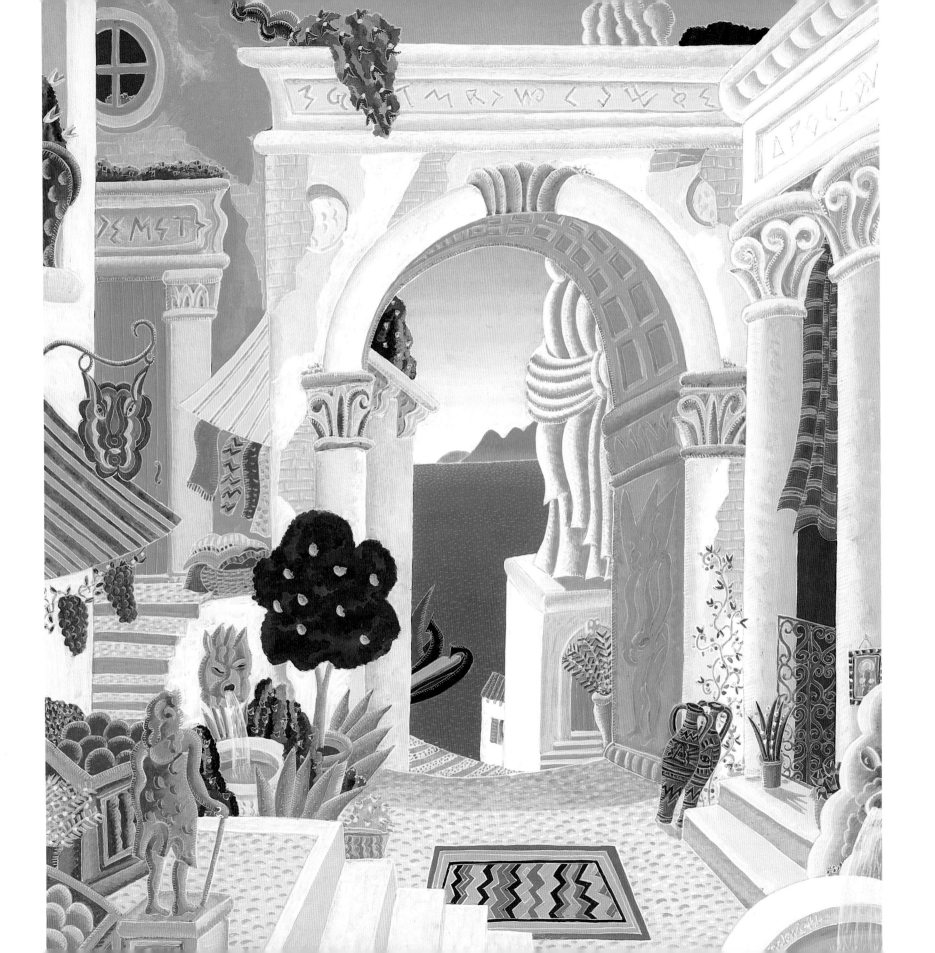

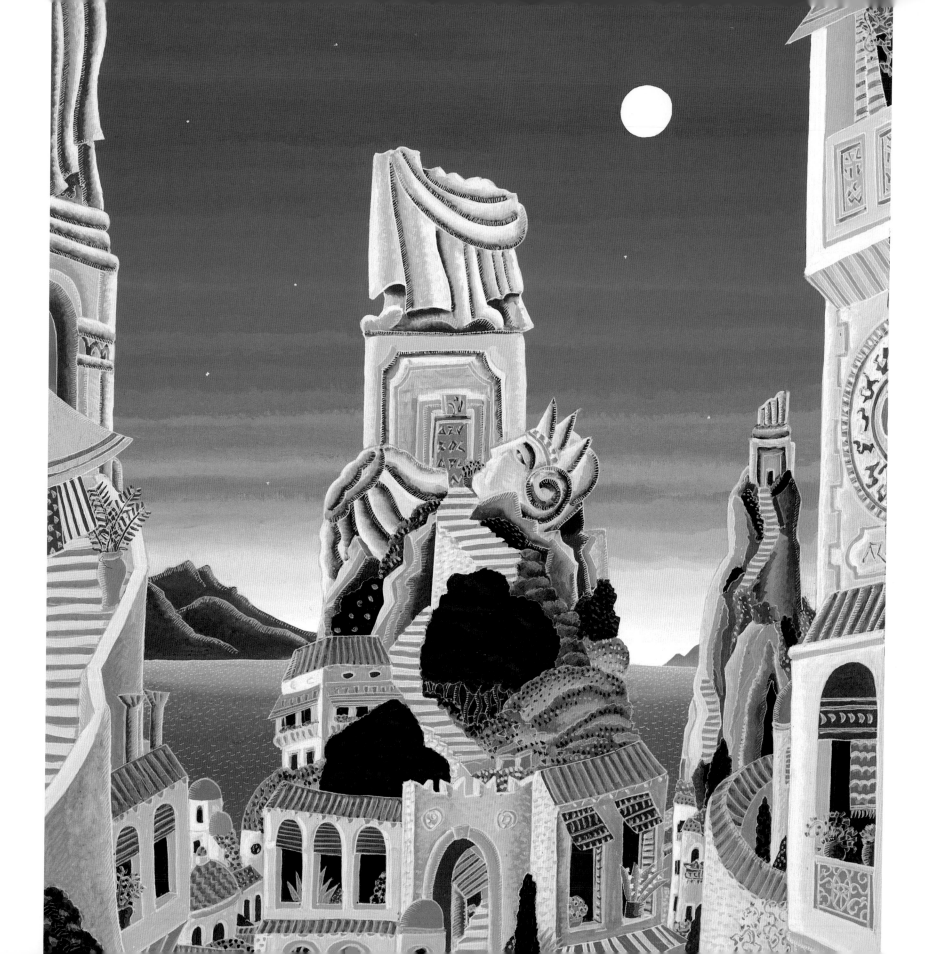

"But even gods fall." Like an American flush with cholesterol, the Colossus of Rhodes stood for only fifty-six years. Then, in 227 B.C., there struck "one of those sudden earthquakes to which much of the Aegean area is still subject." (Durrell is narrating now.) "The town was shaken to its foundations. The temples, the arches, the statues—in the space of a day they had been swallowed up. And in the forest of falling statuary the Colossus was only one of a number of casualties. . . . For nine centuries the figure of the Sun-God was to lie prostrate in the town it had adorned." Three hundred years after the quake, the Roman historian Pliny saw the ruin: "Its very finger was larger than many of the statues. . . . The gaping rents in it, the cavities and fractures, revealed the masses of rock and iron" that had anchored the giant's base, what another writer called "his entrails of rock." Many centuries later, Renaissance readers of *The Dream of Poliphilo* would be fascinated by the image of wandering around inside the body of a fallen colossus, as if somewhere within its winding bronze intestines lingered that Greek experience of human grandeur and its loss.

The nineteenth and twentieth centuries have been unique in that we place our Paradise in the future. The theory of evolution, the religion of scientific progress, and "Star Trek"'s visions of sailing through space have led us to believe that our godlike days are yet to come—though that faith has begun to falter. Until us, every civilization, even the Greek, has looked yearningly backward in time, imagining a lost Golden Age when people were larger in body and spirit and still possessed the secret of life. Even Socrates spoke of "the men of old, who were better than ourselves and dwelt nearer the gods." This sense of loss—lost knowledge, power, wisdom, bliss—has lain close to the bone of being human for as long as we know. As the Renaissance looked back to the Greeks, the Greeks looked over their shoulder to Egypt, in classical times considered "the country of magic par excellence and at the same time the country of the greatest religiosity" (M. L. von Franz). "Al-khem," the Arabic name for Egypt, gave us the word *alchemy*.

The Rustling of a Sphinx's Wings

Egypt's ancestral influence on Greece runs deeper than we knew. "Go to the Metropolitan Museum and look at the older Greek statues," Thomas McKnight told me. "The *kouroi*, the young males, have an Egyptian feeling." Straight and stiff, wearing smiles of blank elation, these life-sized figures of Apollo or his acolytes are formal, like gods not yet at ease in human shape. The very notion of 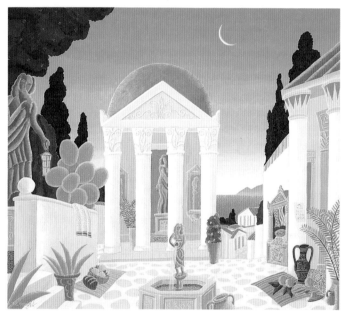 making free-standing human sculptures may have come to Greece from Egypt. Farther back, Egypt was intimately related to the Greeks' Minoan predecessors. Egyptian and Cretan objects have been found in each other's tombs, and the painting styles of wall murals are strikingly similar. In the Cretan religion, as in the Egyptian, burial in tombs and sarcophagi suggested belief in an existence after death—and many features of the Greek gods can be traced to their Cretan origin. As the Greek gods have been folded into our cultural unconscious, we can imagine Egypt as an everpresent underworld to sunny Olympus, a stratum of mystery that took only nightfall to expose. On Delos, "when evening comes," wrote Durrell, "the strange Pharaonic bronze and green lights seem to play about the site of the ancient Serapeion, reminding one, not of Cycladean blue and white, but of the exhausted colors of the Nile valley." Dusk, and you hear the rustle of a sphinx's wings.

ANCIENT MYKONOS TEMPLE WITH DIOGENES

Thomas McKnight's way of imagining the Greek-Egyptian link is to set obelisks and stone sphinxes in classical temple courtyards, and wild Oriental-looking boats in Cycladean harbors.

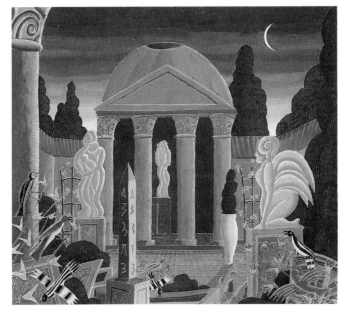

He admits the obelisks are a fib: "As far as I know, I made them up. But there *were* things around the Greek countryside called 'herms,' like an obelisk with a head on top": pillarlike, phallic representations of the god Hermes, which stood at crossroads to guide travelers and invoke fertility.

The name "Hermes" recalls another imaginative fib linking Greece and Egypt: a Greek Neoplatonist, writing in the early Christian era as "Hermes Trismegistus"— the Thrice-Great—put on the persona of an ancient Egyptian sage, and with it the mantle of esoteric truth. His occult work, the *Corpus Hermeticum*, became a cornerstone of Islamic and medieval alchemy, and then ignited the Renaissance with its heady blend of Greek chutzpah and "Egyptian" mystery. "O what a miracle is man," wrote Hermes (the Renaissance credo we hear echoed in *Hamlet* and set to music in *Hair*). "Man ascends even to heaven and measures it . . . to so vast a distance can he put forth his power. We must not shrink then from saying that a man on earth is a mortal god, and that a god in heaven is an immortal man." The rigidly hierarchical Egyptians had no such merit system for ascending to be a god, and only their pharaohs were descended from one. It is pure Greek, this intoxicating, almost blasphemous sense of human power, and it was reborn in the Renaissance.

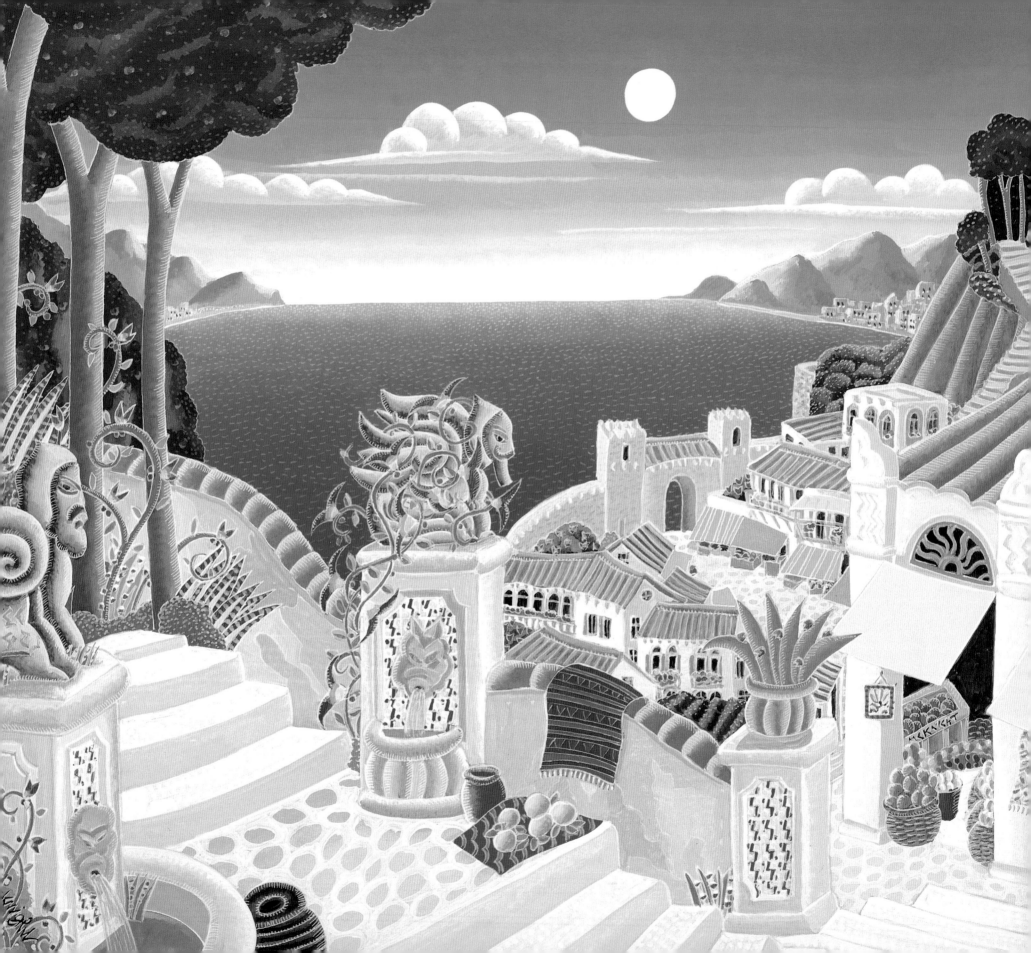

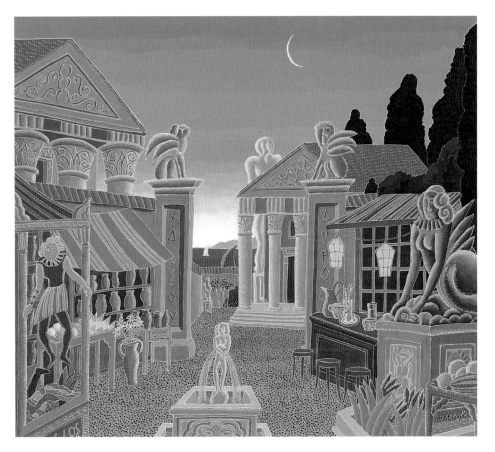

TEMPLE OF APOLLO, DELOS

The obelisks may not belong, but the lion-bodied, woman-breasted sphinx did migrate to Greece from Egypt. The island of Naxos donated to Delphi "a sphinx over six feet long with marble plumage and wings in the shape of a sickle." And whether or not the crouched stone lions of Delos had sphinxes' wings, as Thomas McKnight imagines, Delos did have—among all its temples of the Greek gods—a temple to Isis, the dark, all-encompassing mother goddess of the Egyptian cosmos.

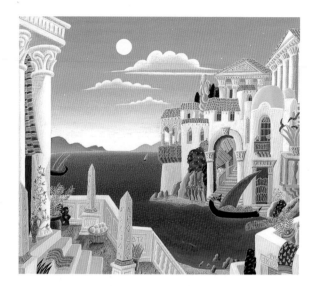

BYZANTINE CITY

Greek and Egyptian sailboats resemble each other to this day; the fierce, exotic boats McKnight paints could be the black Barque of Isis, on which she tended the dead on their night-sea journey. But Isis was also (like Aphrodite) the protectress of living sailors, and we can imagine boats like these plying the entire ancient Mediterranean, one species of wild sea bird alighting on the coasts of Italy, Greece, Asia Minor, and North Africa alike, weaving bright strands of Greek, Egyptian, and Phoenician culture into their coastal nests.

I am at Corinth in a rose light, the sun battling the moon, the earth turning slowly with its fat ruins, wheeling in light like a water-wheel reflected in a still pond. . . . First touch of red; something distinctly Egyptian about the Corinth canal . . . there is something rich, sensuous and rosy about Corinth. . . . The pillars of the Roman temple . . . are almost Oriental in their proportions, heavy, squat, rooted to the earth. . . . Everywhere this lush, overgrown, over-ripe quality manifests itself, heightened by a rose-colored light flush from the setting sun. We wander down to the spring, set deep in the earth like a hidden temple, a mysterious place suggesting affinities with India and Arabia.

—Henry Miller, *The Colossus of Maroussi*

ANCIENT MOTYA, SICILY

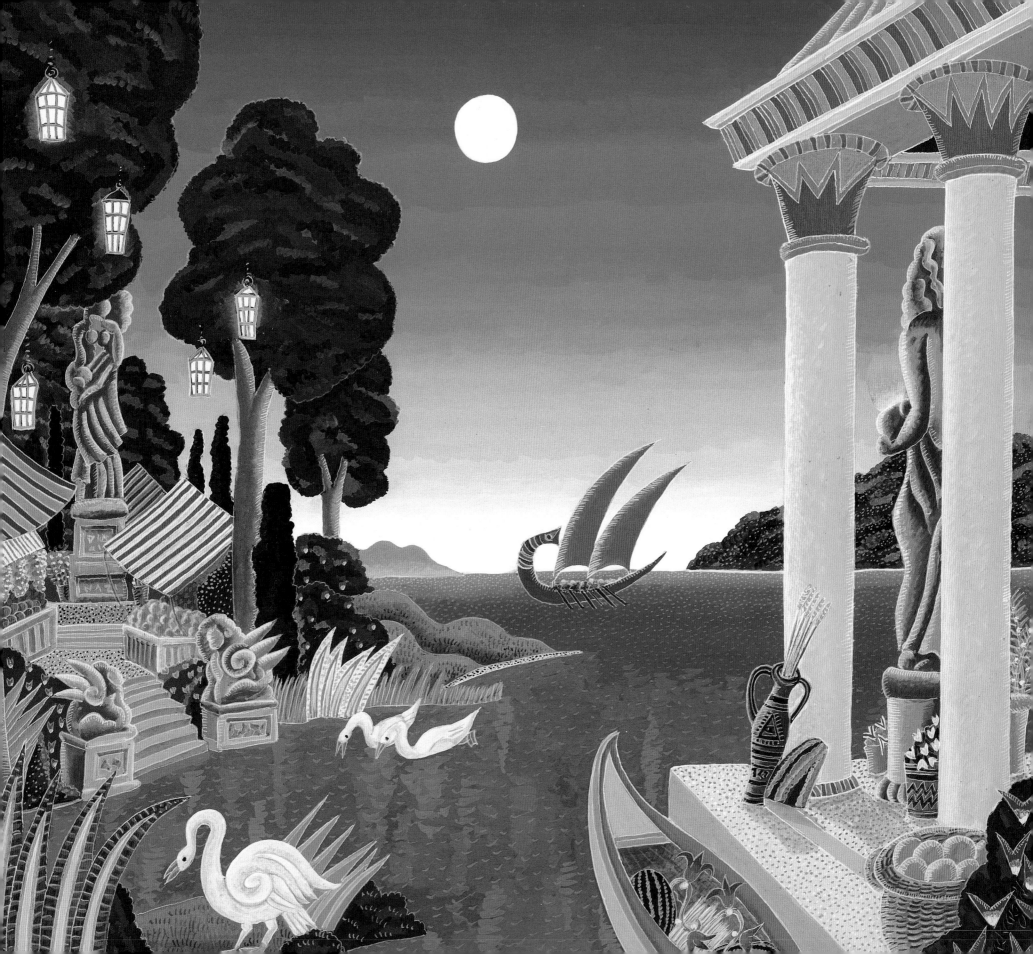

So each paradise
we visit sends us on, with
refreshments and rumors of the
greater wonders that await us still
deeper in the past. Do you marvel that
the pillars of Greek temples were pat-
terned on the ideal proportions of male and
female bodies? Go back to Egypt, where (ac-
cording to R. A. Schwaller de Lubicz) the
Temple of Luxor *was* a human body, and the hu-
man body a temple whose altar was the heart. An
Egyptian temple, in this view, was not a "house of
worship," where you dutifully visited your deity
like a parent in a nursing home; it was a living
spiritual colossus, which you entered in order to
evolve and be reborn. And both temple and body
were images of the universe, with its intelligent
heart that seeks to become one with our own. By
passing through the gateway of this temple's heart
and womb—in McKnight's vision she looks more
Indian than Egyptian—we might at last "recover
the lost 'intelligence of the heart,'" and find our-
selves "in harmony with nature and able to
understand life and living things."

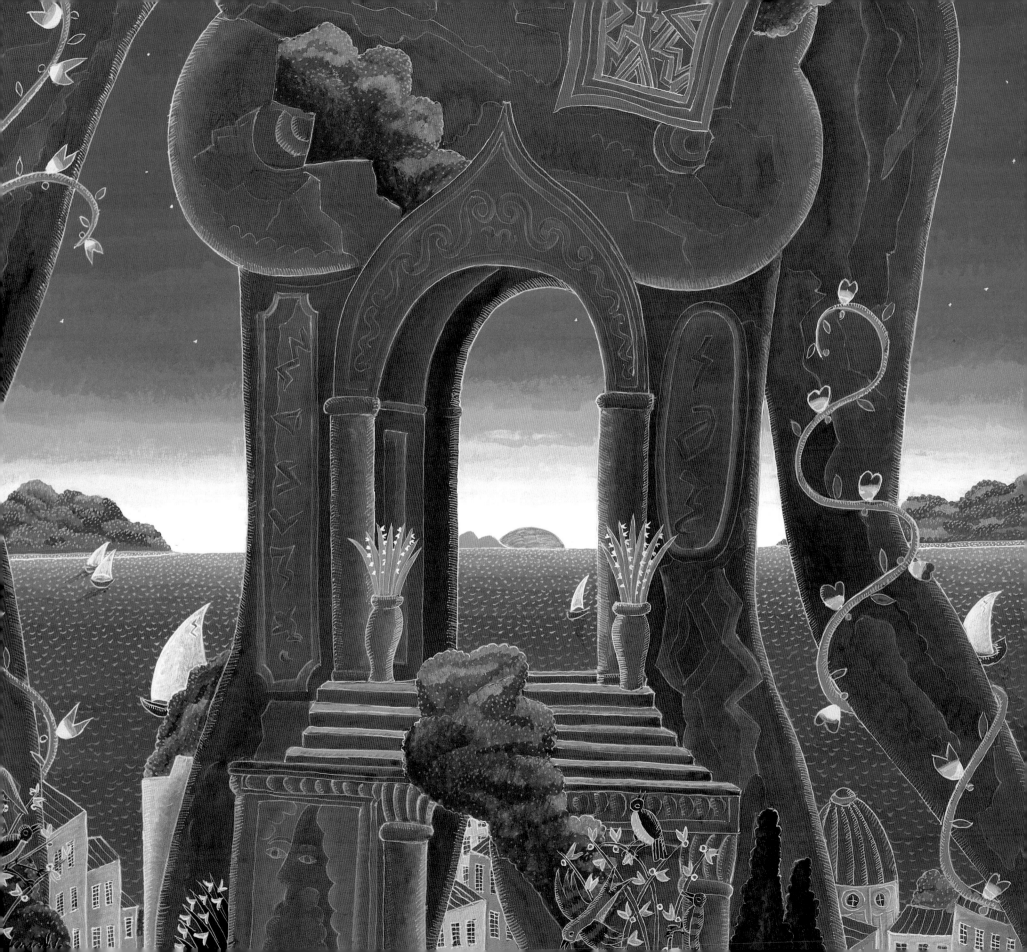

But our journey does not
end here. There is another gateway
to pass through before we can be en-
folded back into the community of "life
and living things." We have to go beyond
the human form, back to a time before the
powers of the universe were imagined as
magnified human beings. That now seems
like an immensely seductive mistake, one
that reaped great power and beauty, but
set us against our world. The human form
must once have seemed like the image of divinity
emerging out of nature's chaos. Now we recognize
divinity and order in nature, and man as a broken-
off fragment run amok. "The human form divine,"
as Blake called it, has been spoiled for us the
way Hitler spoiled the gorgeous German lan-
guage, turning it into the sign of the despoiler.
In art, the human figure went mad between
the two World Wars and then disappeared
altogether after World War II. Thomas
McKnight doesn't work in the mainstream of
the avant-garde, but his signature image is a beau-
tiful, empty room. We may be returning, in a
great circle, to a time before our long self-
infatuation, when we saw power and
beauty in the world,
not in the mirror.

The way leads through the Gate of the Sphinx.

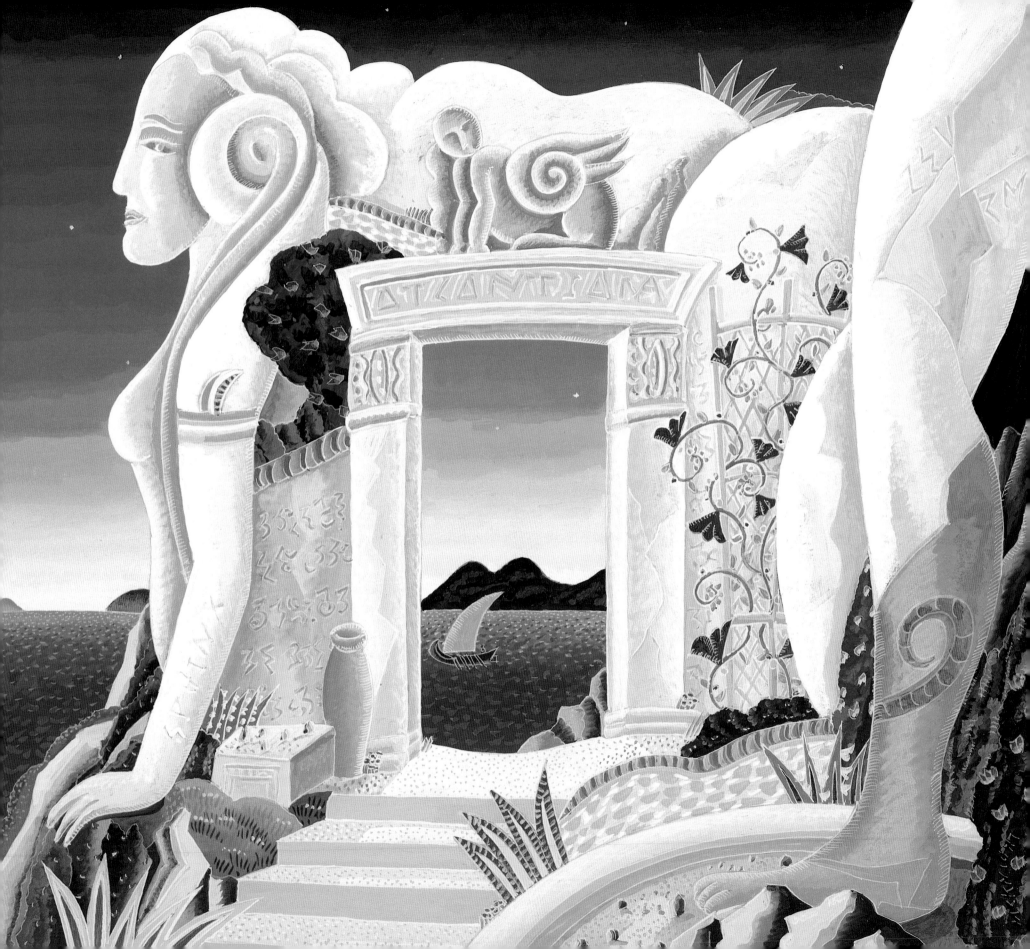

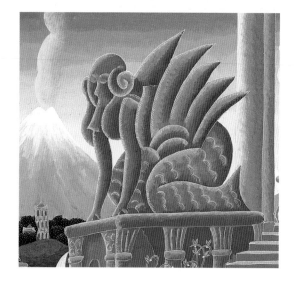

The sphinx was a terrifying monster. Like life, she posed the inescapable riddle of human nature and killed you if you didn't "know thyself." Her name meant "strangler," from the same root as "asphyxiate." Yet she was portrayed in stone over and over again, a talisman of might and mystery, like other composite gods and monsters of the ancient world: the winged bull of Assyria, which sometimes had a human face; the Minotaur, the man with a bull's head; the Chimera (which McKnight's sphinx may actually be), a lion-goat in front and a dragon behind; and the Egyptian gods with falcon or baboon or crocodile heads. "The Homeric vocabulary includes words which recall a time when Hera had the face of a cow, and Athena that of an owl." What did they mean, these splicings of human and animal nature, like prodigies of genetic engineering? They may be denizens of a twilight zone between shamanic culture, with its animal gods, and human-centered civilization. There is a legend that the Greek gods, in their battle with the Titans, once fled to Egypt and hid in animal form: Zeus became a ram, Hera a cow, Apollo a crow, Dionysos a goat, Aphrodite a fish. This was probably an evolutionary regression to their original forms, not so different from the gods of the Native Americans. The sphinx is a middle term between ceding all power to the lion's loins and eagle's wings, and arrogating all power to the human warrior. She is a diagram of the universe as awesome and partly alien, combining the pitiless vitality of nature with the awakening of wisdom. *That's* Egyptian.

SPHINX WITH BURNING TOWER

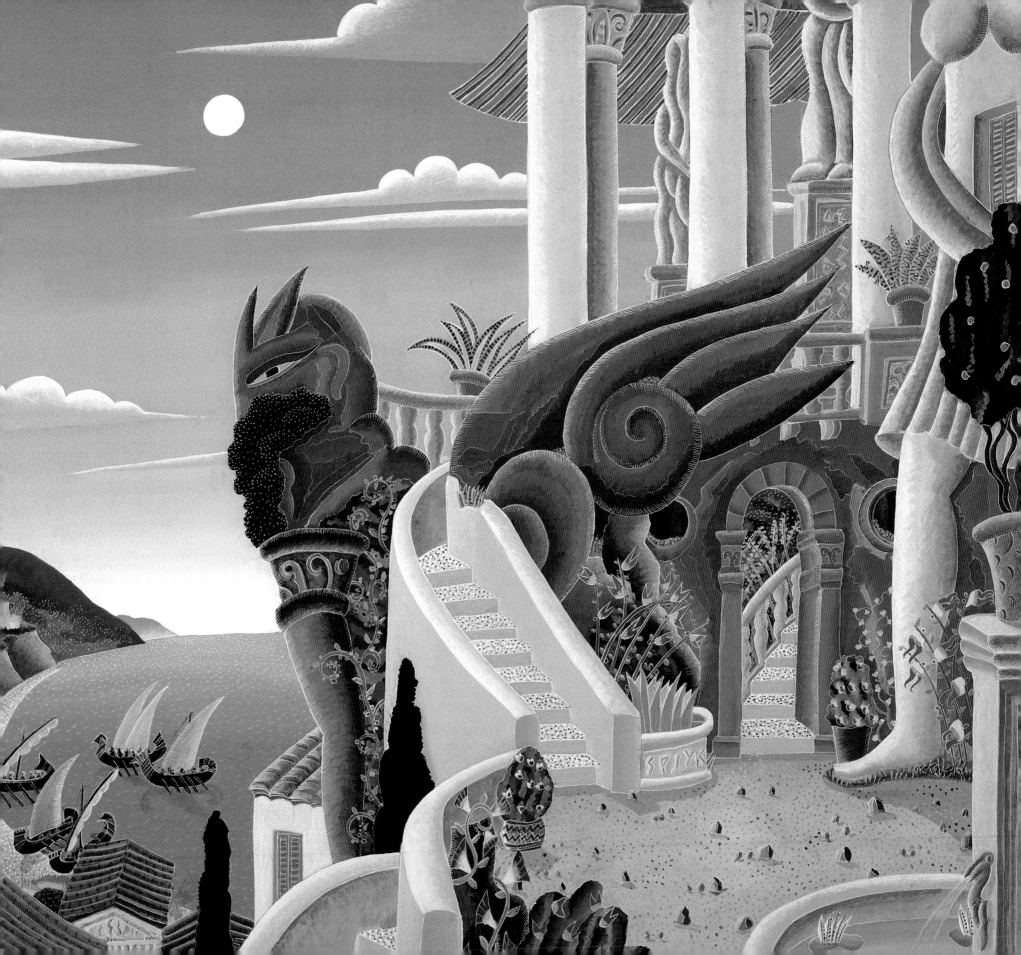

This
vision of Egypt
could be Hesiod's Golden Age,
when people lived on goat's milk and
honey, mastered music and magic, never grew old, and
"rejoiced in continual festivity"
till they died in their sleep.
Yet even the Egyptians
looked back,
as Plato
tells us—
to
Atlantis.

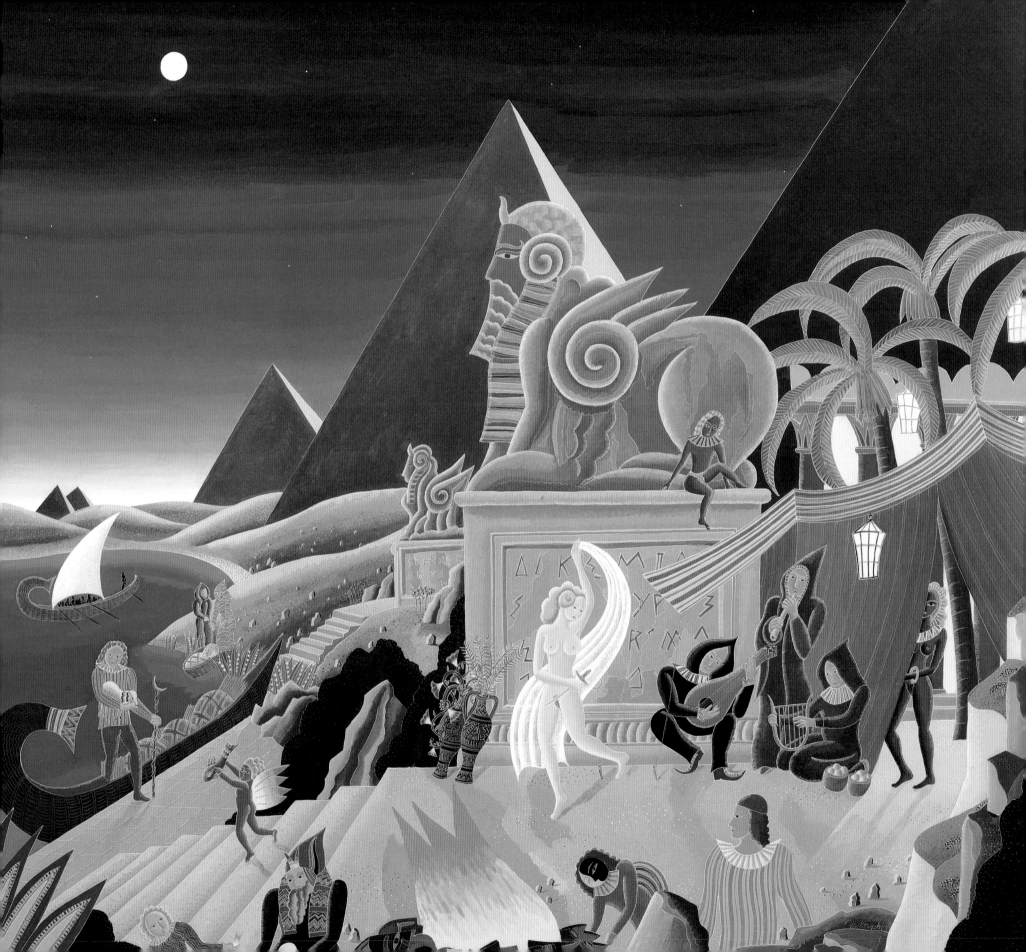

The Lost Continent

The rumor of Atlantis is, with the Garden of Eden, one of our two most precious and stubborn visions of Paradise. A flickering torch passed from one human voice to another across windy gulfs of time, it has never quite gone out. Plato (427–347 B.C.) heard it from Socrates (470–399 B.C.), who heard it from Critias (ca. 460–403 B.C.), who heard it from his grandfather, who heard it from the widely traveled Solon (639–559 B.C.), who heard it from an Egyptian priest, who claimed that his culture's memory spanned more than nine thousand years. Whatever that apocryphal Egyptian said, by the time it reached Plato, it had become a typical Greek myth. When the gods divided up the earth, the sea-god Poseidon was given the rich continent "beyond the pillars of Hercules" (in the Atlantic); Atlas, his half-mortal son, became king; he built a civilization of "barbaric splendor," with mighty fortifications, wise laws, bloody sacrifices, a puissant navy, walls and statues of gold, many temples, palaces and baths, and "most beautiful azure robes" for the nobles—in short, a glorified Greece. Poseidon's half-breeds lived in magnanimous peace until, with "too much of the mortal ad-

mixture," they fell into the familiar quarreling and greed. Zeus resolved to chasten them: "There occurred violent earthquakes and floods, and in a single day and night of rain . . . the island of Atlantis . . . was sunk beneath the sea."

Like the Greeks, we make Paradise in the image of our wishes, and the Fall in the image of our guilt. Our Atlantis is a typical New-Age myth: the Atlanteans must have constructed the great pyramids and the Sphinx, for that advanced knowledge of astronomy, mathematics, and engineering apparently sprang out of nowhere; they knew how to use "crystal power" and to move huge blocks of stone with sound, and the abuse of these mystic sciences brought their destruction; they were adept in the use of the right brain hemisphere—"Nowadays man thinks in concepts," wrote Rudolf Steiner, "the Atlantean thought in images"—and they knew how to move outside of time. The myth even reflects our weary readiness to admit we may not be the ultimate life-form: some say the Atlanteans were, or learned from, a race of superior lion-beings from the star Sirius, and the Sphinx is a self-portrait.

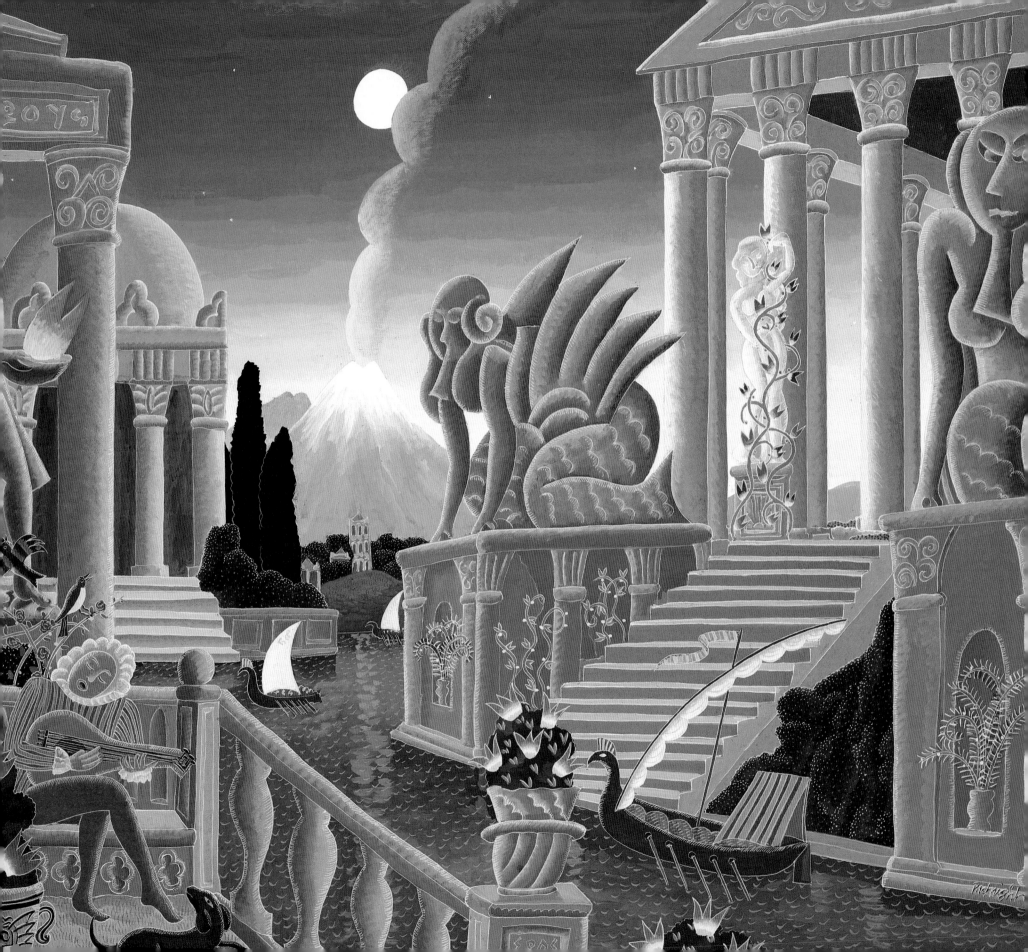

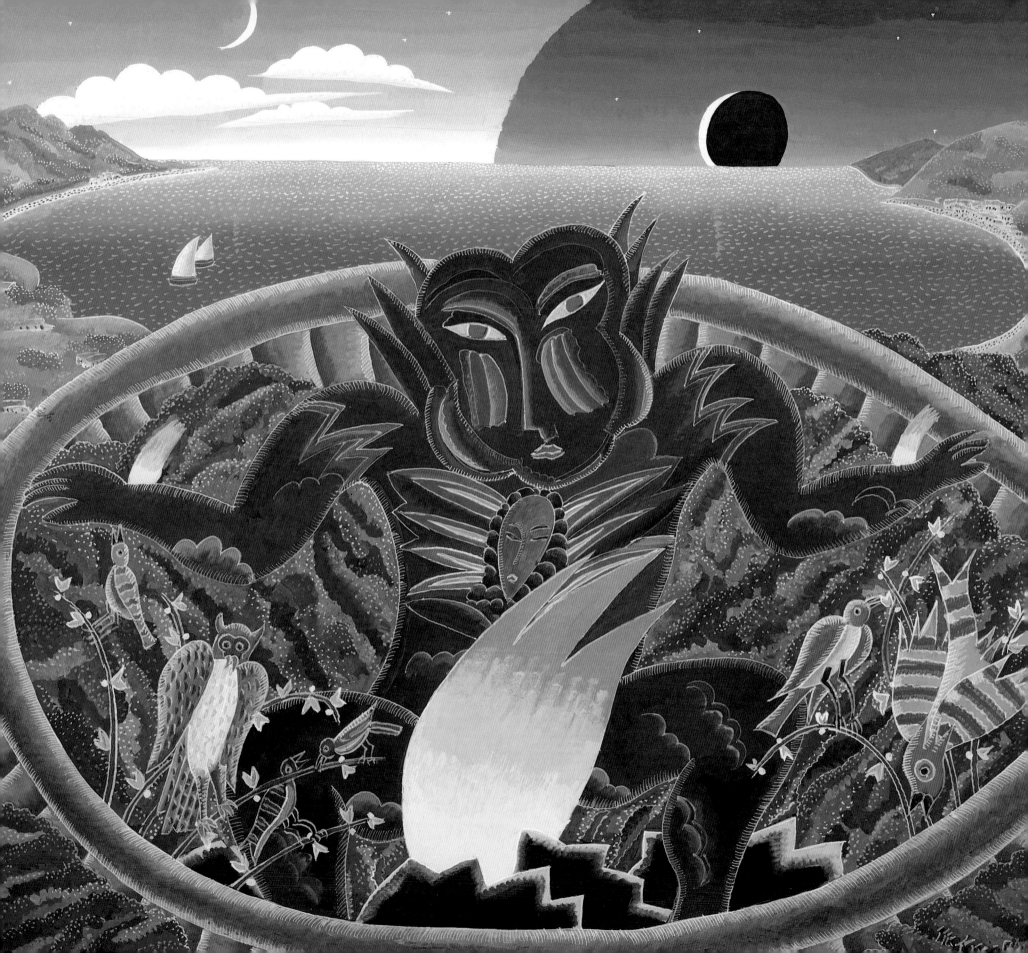

Maybe there
was a radiant civilization that is now
under the sea. But we may never separate the
strands of memory and fantasy in this myth. For Atlantis
also suggests the sunken continents of our own brains, the
85 percent that lies so mysteriously fallow, the spellbound pow-
ers we have but cannot use. Have we lost the key, or are we still
evolving? Is "Atlantis" a memory or a prophecy? As we travel farther
and farther back, the straight road of history curves into myth, until
time comes full circle and the story begins again. The earth moves,
the volcanoes awaken. Atlantis rises from the sea, her fish-tailed
sphinxes glistening, with the slow, tectonic grating of a stone roll-
ing away from the mouth of a tomb. We are at the moment of
creation or birth, when the portals between the worlds are
wide open, and evolution's current flows though us from
the base of the spine to the crown of the head.
A telluric imp of brimstone, steam,
and flame crawls out of the
earth's core;

we walk into the eternal sky through a doorway
carved of his stone.

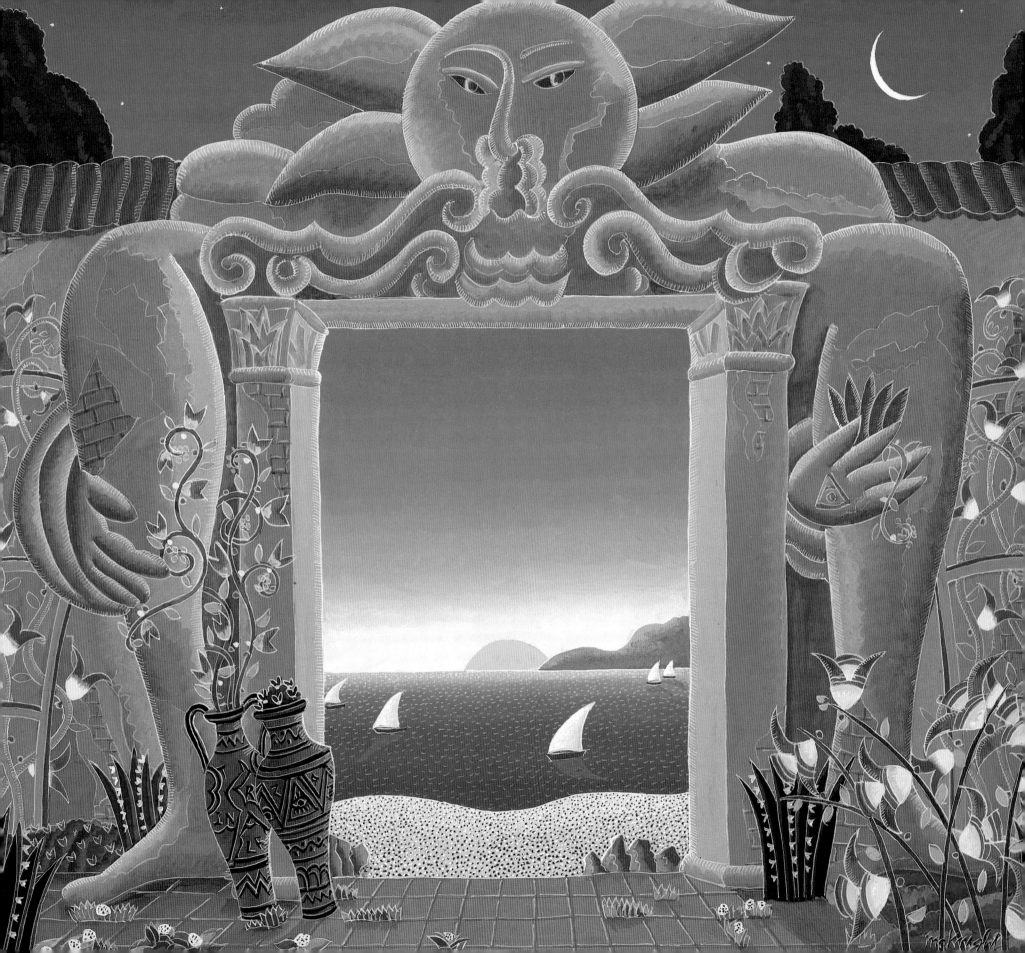

· IV ·

The Voyage In

Transformation Through Water

But there are other ways to walk through the Doorway Past Time. Although we have drifted far from it, the world of the Powers is not long ago or far away, and not all its gateways are stone. To find one, you don't have to travel to Greece or Egypt. You can fall asleep. You can fall in love. Or you can go to the beach.

ANTIPAROS

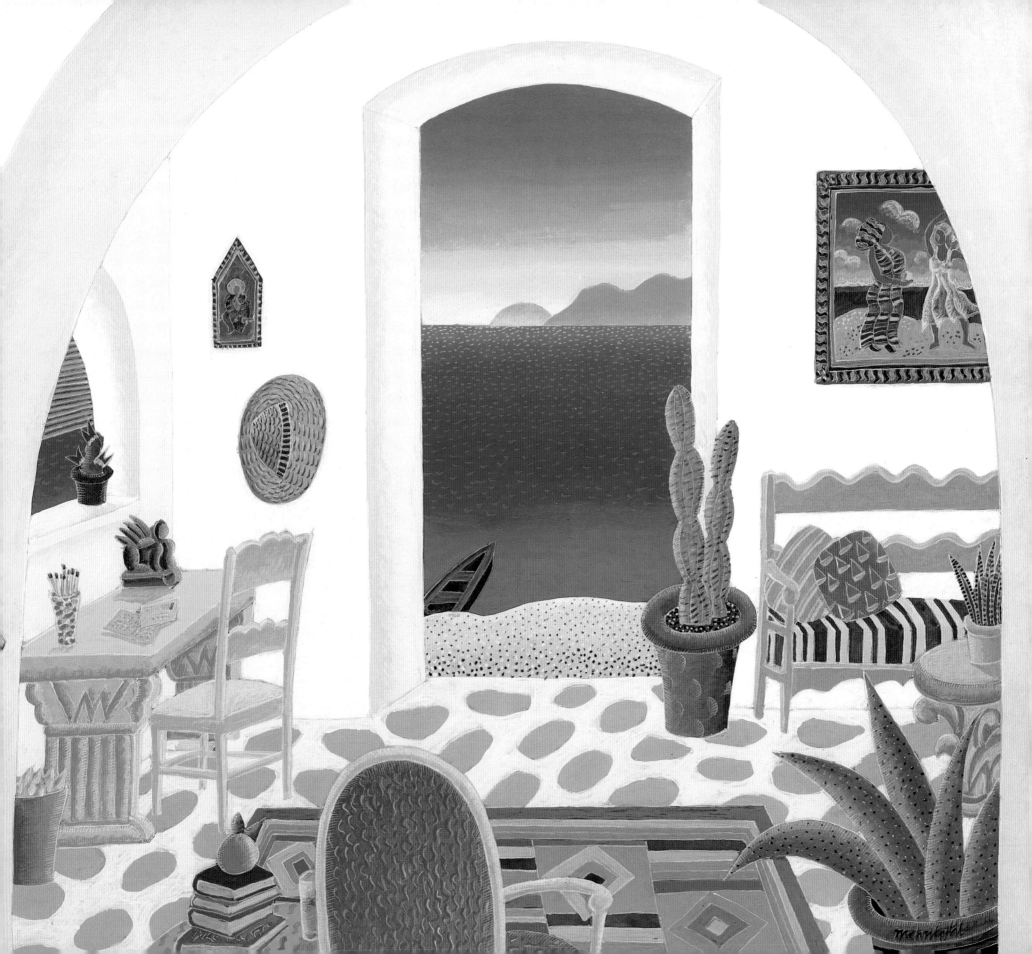

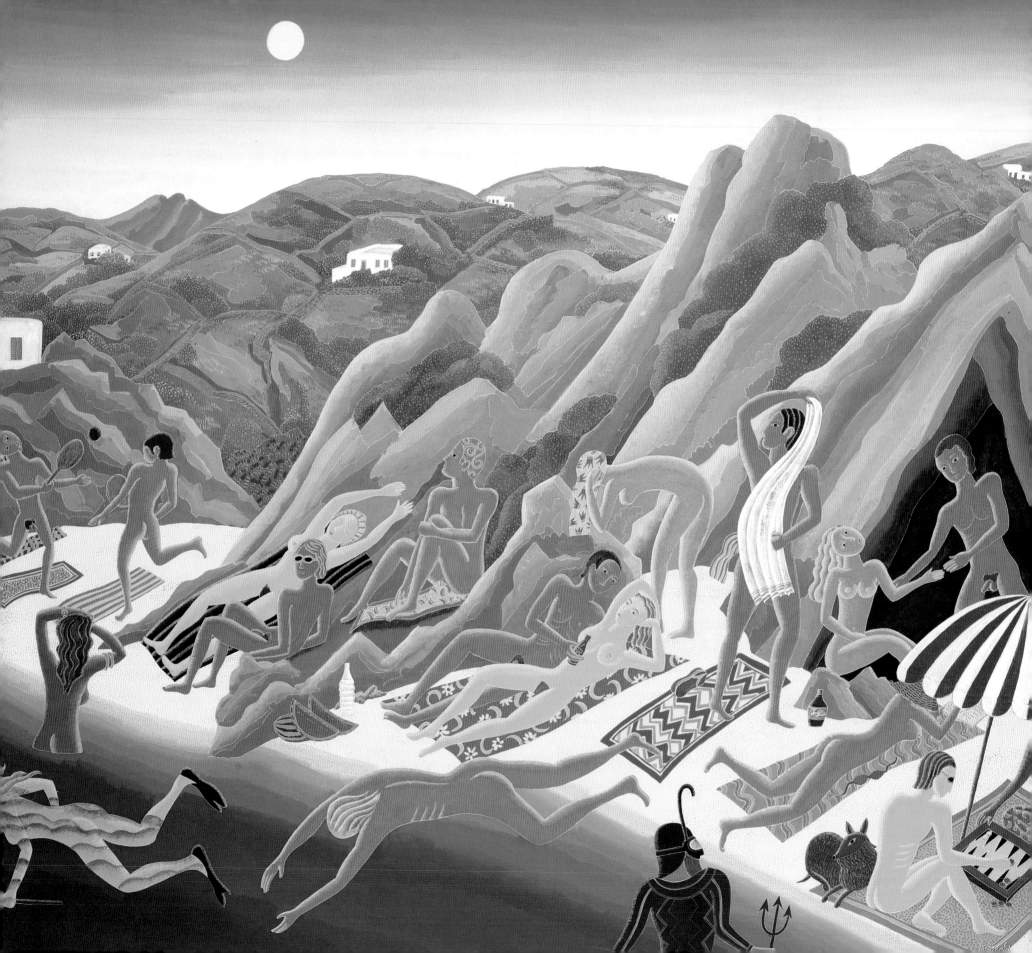

ELIA BEACH BUNGALOW

AGRARI BEACH

Have you noticed that as we get closer to the ocean, we shuck off everything that belongs to a particular time and place? First we abandon the seven-year-old station wagon, then the new running shoes, left gaping forlornly at the joyous spurt of bare prints, finally our clothes, whose style has held our bodies prisoner in history. Are the strings of a bikini the last ties binding you to the late twentieth century, with its peek-a-boo prudery? Take it off! A nude beach could be anywhere, any time. There's a private one on Martha's Vineyard called Windy Gates, where the cliffs bleed red and ocher clay and guests can't resist daubing themselves like aborigines, acquiring a scary terracotta crust that only dissolves in the sea. This one that Thomas McKnight has painted is on Mykonos, where he saw an ancient farmer on a donkey ride indifferently past "people basking like seals," and an old couple all in black, "like Pyramus and Thisbe receiving Apollo," who sold watermelons to "beautiful brown bodies, nude like gods who had just arrived."

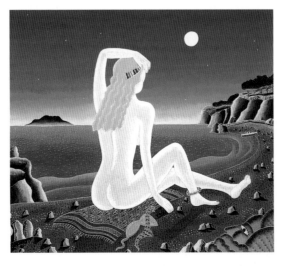

ELIA BEACH WHITE BATHER

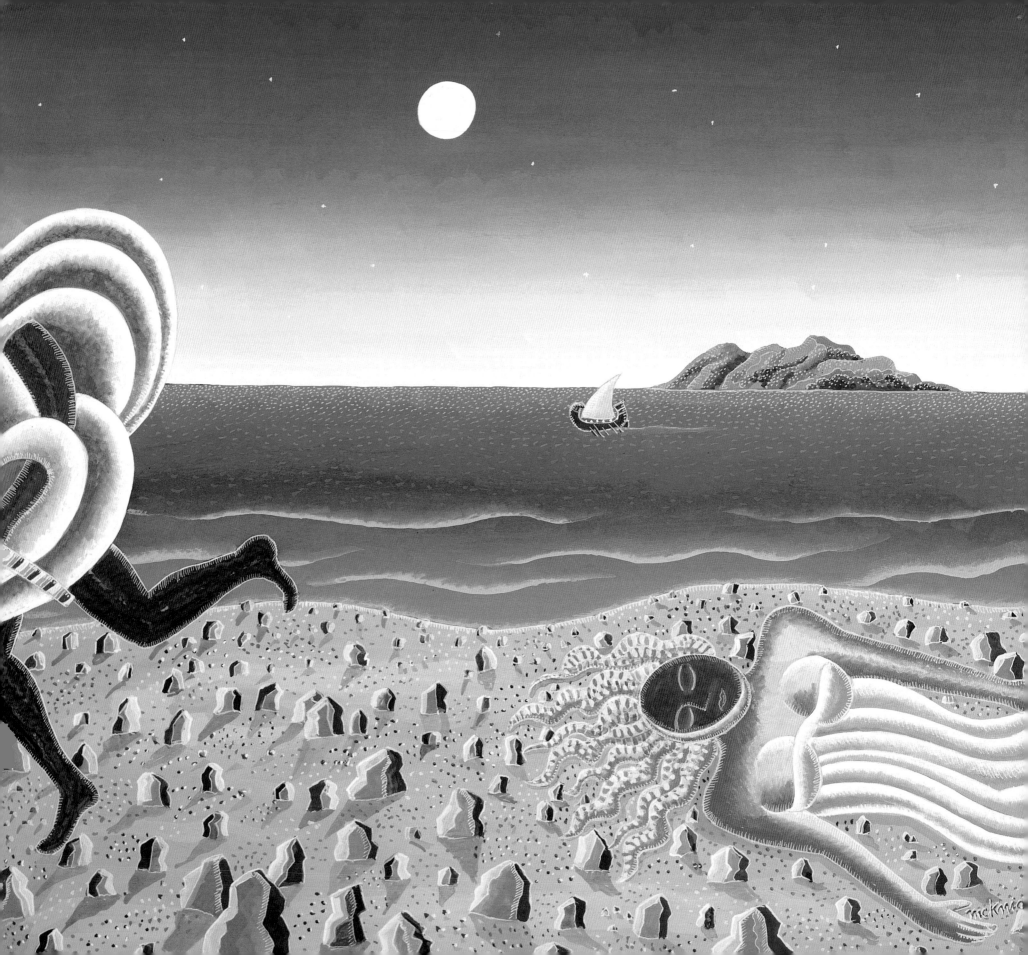

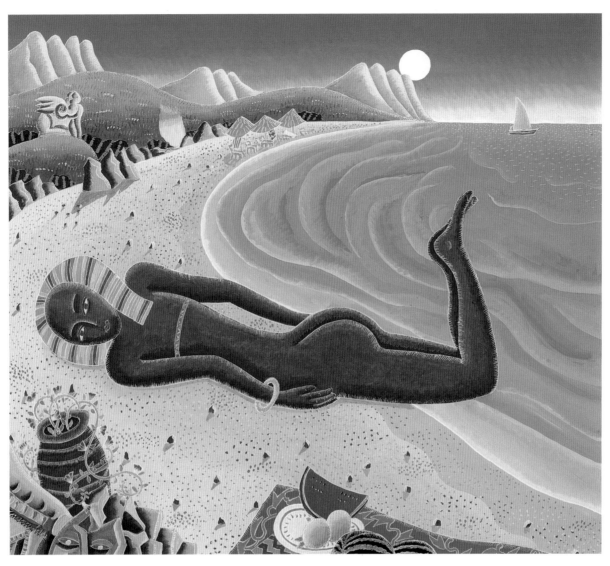

CIRCE

On any beach, as you doze in the sun,
and the smell of sunblock rises in oily
ripples, and the din of family quarrels
and boom boxes fades out,
a god could arrive.

THIEF OF TIME

Odysseus met each of his divine guides on a beach: Circe, Calypso, Athena, and Nausicaa, who was human but so beautiful he had to ask her, "Are you mortal or goddess?" (To look at divine bodies is, of course, one reason we go to the beach.) Like the hypnagogic or hypnopompic border between sleep and waking—the word depends on whether you're falling in or crawling out—the seashore is a threshold, a *limen* between worlds. Here, in Thomas Moore's words, "the dry land of reasons and events" meets "the stream of fantasies." Here we once struggled ashore with the first amphibian, its tail still trailing in the water. Here we rest as trustingly as a newborn baby beside its mother while the drowsy dragon of the infinite licks at our toes. We have come for re-creation, a dip in our dissolving source and a bake in the shaping sun.

Look through this book, and you will find almost no image that does not have water in it. The element of water has meanings for us as bottomless as the sea itself. It is, in Northwest Coast Indian belief, "the saltwater blood of our ancestors that runs in our own veins." It is the womb of nature out of which creatures and civilizations arise and into which they subside, sleeping peacefully in grassy ruins. It is the monster-teeming "collective unconscious" our tiny minds go for a swim in every night. Form is fragile, and utterly dependent for its life on its umbilical roots in the void that will annihilate it. Modern Western civilization tried to play it safe by cutting the umbilical cord, slaying the dragon—and we are dying with her. Thomas McKnight keeps returning to other cultures—and especially to earlier forms of our own culture—that flourished comfortably close to the sea in every sense. His images of Italian coastal towns, Greek island harbors, and Japanese port cities could be emblems of civilization embracing its source.

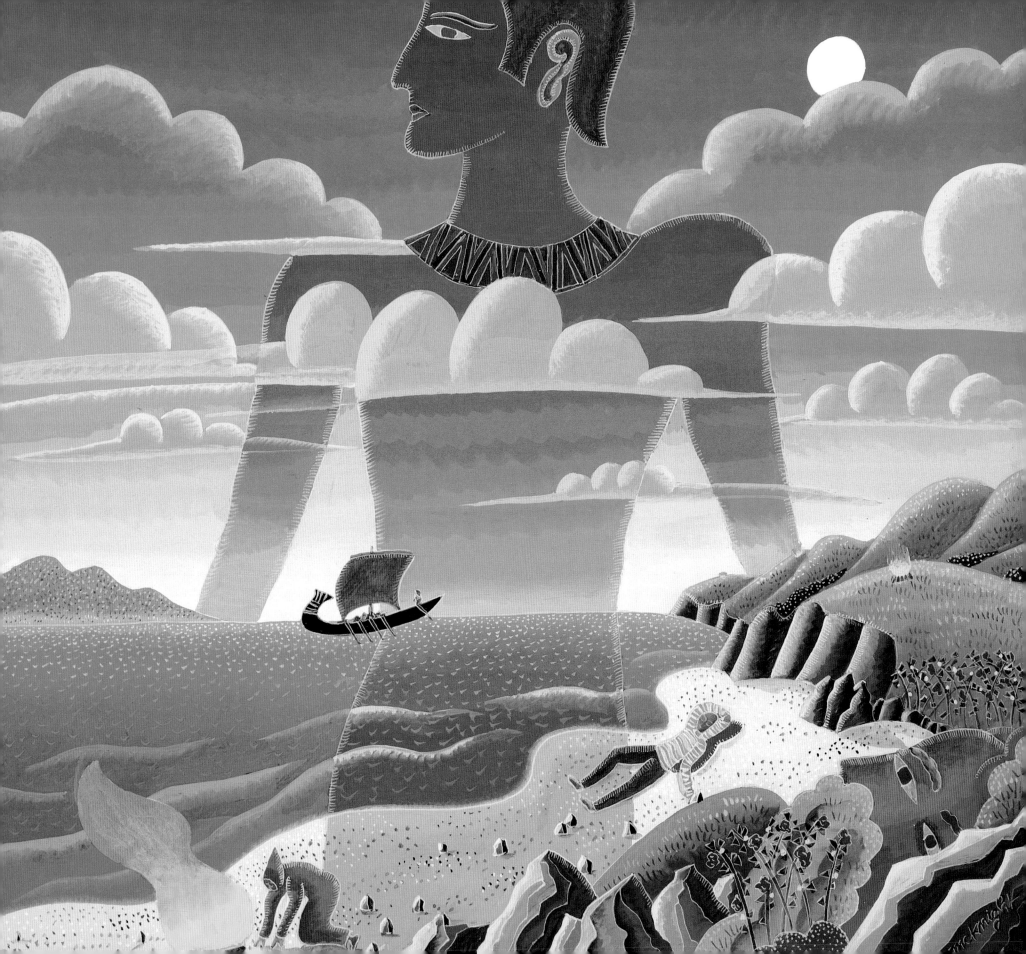

As our civilization starts to make awkward overtures to nature after centuries of estrangement and abuse, individuals, too, feel drawn to find a quiet place and gaze into their source. The proliferation of new therapies, dream workshops, journal keeping, and astrology is often dismissed as narcissism. Critics like Christopher Lasch charge that we have turned our backs on the real world of reasons and events and fallen in love with our reflections in the shallow puddle of the self. It is striking, then, that in Thomas McKnight's variations on the theme of Narcissus, what enraptures the gazer is precisely that the image in the water is *not* himself or herself. It is, if anything, an opposite: hunchbacked Rigoletto, trapped in his clownish body, sees the epitome of beauty; a golden-haired gazer finds a face that is night-black. Water is no manmade mirror, fixing our gaze safely skin-deep. It is a living element whose deceptive surface and strangely peopled depths mirror our real nature, neither shallow nor bounded by our skin. What we see when we look into the stream of dreams and fantasies is not our familiar face. The superficial reflection breaks up, and something else flashes in the depths: a contrary self, an alien beloved.

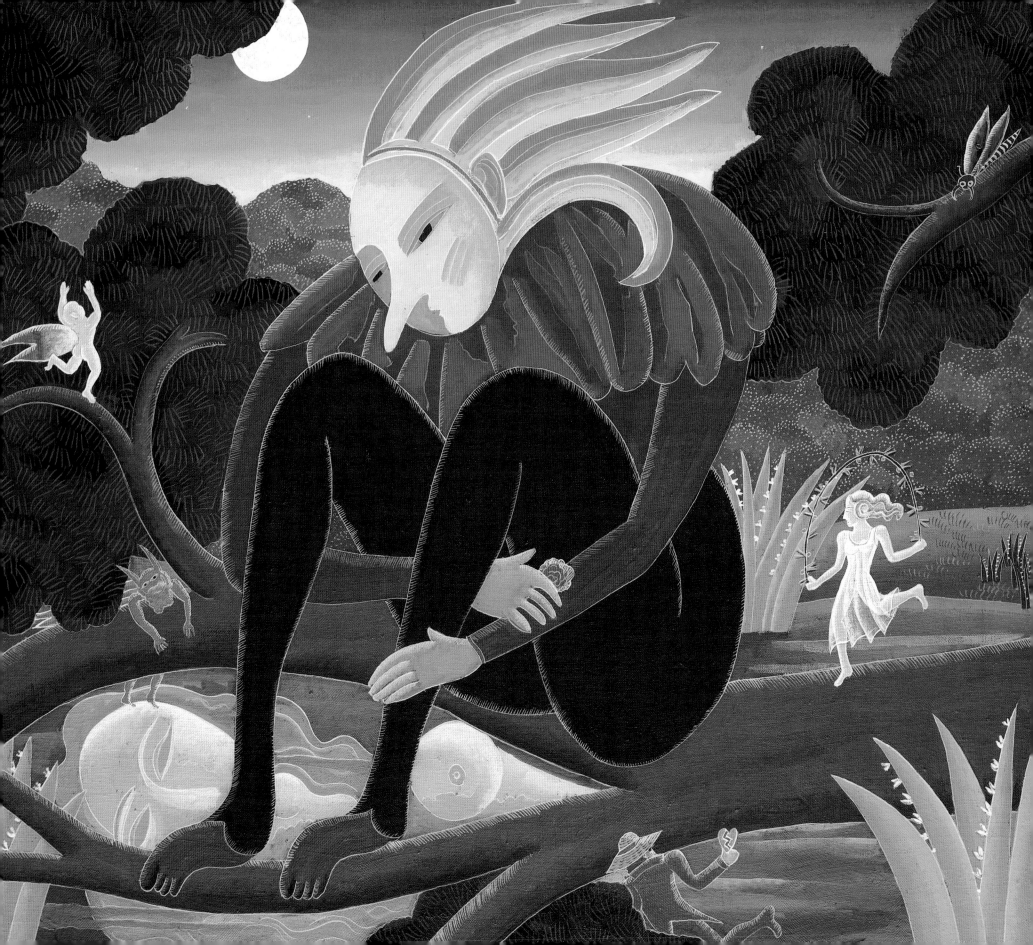

Thomas Moore's reflections on narcissism in his book *Care of the Soul* correspond in uncanny detail to what Thomas McKnight has painted. I would like to quote at length, to show these images reflected in yet another pool:

Narcissus is about to have a transforming, life-threatening, psychotic episode at a pool of water. . . . The neurosis [is] beginning to dissolve in painful disorientation. [In t]he divine breaking up of narcissism . . . identity may become even more confused and fluid. . . .

Narcissism . . . turns gradually into a deeper version of itself. It becomes a true stillness, a wonder about oneself, a meditation on one's nature. . . . Only at a moment of transformation into soul does [the narcissist] enjoy a deeper, inner reflection. . . .

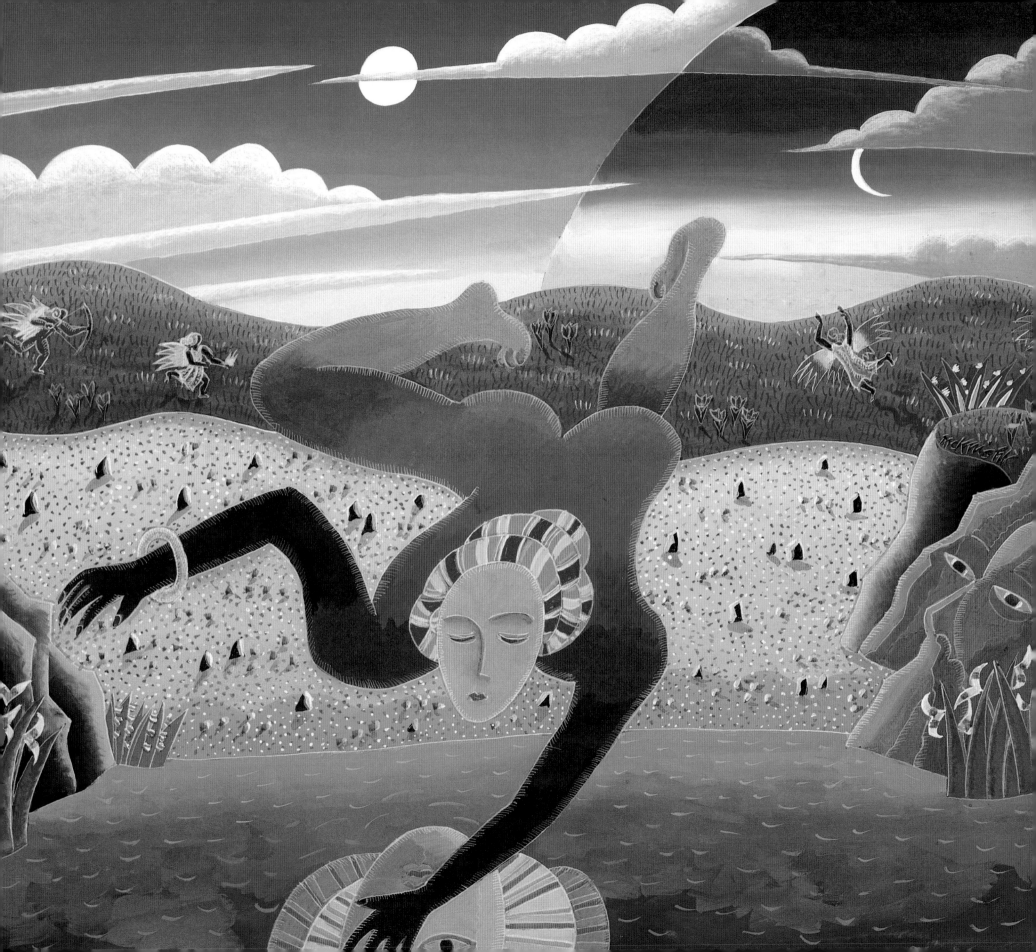

The image in which narcissism is fulfilled is not a literal one. It is not the image one sees in a mirror, not the "image," as they would say on Madison Avenue, that you want to project, not the self-concept, not the way you see yourself. The image Narcissus sees is a new one, something he had never seen before, something "other," and he is mesmerized by it, charmed. Ovid says, "the image you seek is nowhere." It cannot be found intentionally. One comes upon it unexpectedly, in a pool in the woods where the sun doesn't shine brightly and where human touch is absent . . . a place more introverted. . . .

It's particularly suggestive that Narcissus finds this new view of himself in water. In this element that is his special essence, his birthright, he finds something of himself. I don't want to treat this narcissus water as a symbol and say it's the unconscious or mother's womb or something else. It would be better to reflect directly from the image: is there something in me that is like this pool? Do I have depth? Do my feelings and thoughts pool somewhere so off the beaten path that it is utterly still and untouched? Is there someplace wet in me, not the place of dry intellectualism but rather of moist feeling and green, fertile, shady imagination? . . . Do I find myself in rare moments caught in a place of reflection . . . and there catch a glimpse of some unfamiliar face that is mine . . . in the pool, at the very source of identity[?] . . . This is not ego loving ego; this is ego loving the soul, loving a face the soul presents.

154

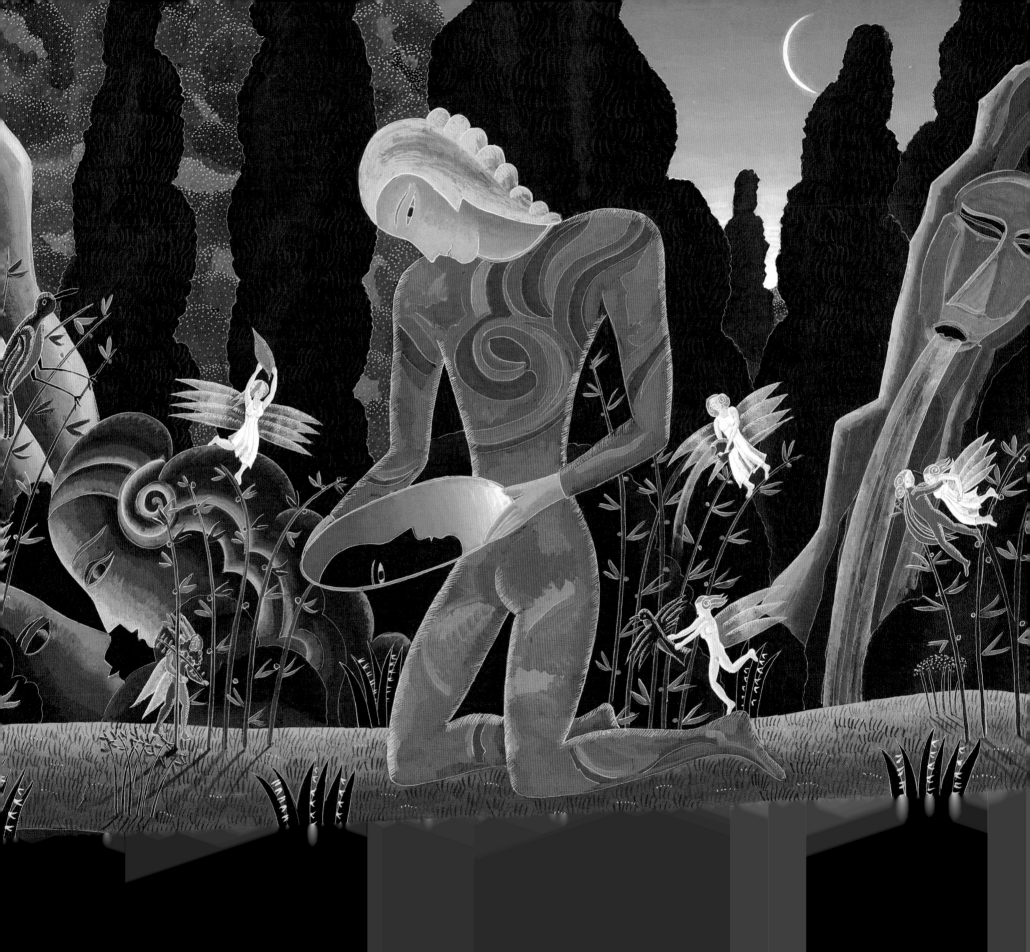

For all this serene, solitary imagery, don't forget that Narcissus discovers his soul by way of a "transforming, life-threatening, psychotic episode": he falls in love. Divine madness, Plato called it—the most common and violent transit across the threshold between worlds. To Thomas Moore, it is a spontaneous rite of initiation, drawing us "out of life toward depth. . . . It may be useful to consider love less as an aspect of relationship and more as an event of the soul. . . . Being 'in love' is like being 'in imagination.'" Narcissus is an image of every lover, not only the self-lover. On the faces of Thomas McKnight's Narcissus figures I see the same fateful fascination I feel when I really fall for someone. "Sometimes the pool may appear in another person," Moore confirms. "In that person I might recognize an image I could love and be. But such chance encounters with an image that is at once both me and not-me are dangerous. Life may never again be the same."

In love, life as you knew it can end. Gaze intently enough, and you "fall in" and drown, like mad Ophelia, who fell into the "weeping brook" for love of Hamlet and became "mermaid-like . . . a creature native and indued / Unto that element," wholly gone. The soul can be a siren like the Lorelei of German folklore, a golden-haired mermaid shining up through the Rhine who sang sailors down to their deaths. The "water of transformation" exacts the death of all that we were and knew before.

And then, like shipwrecked Odysseus, we crawl ashore in a new world.

Where are we? And who is she, rising out of the waters we drown in?

The Nubian

She could be an obsidian sister to Botticelli's Venus. Thomas McKnight calls her a Nubian, and says simply, "She's the opposite of a white male." Though he began to paint her after seeing women in Nubian villages near Aswan, with bright gold jewelry, very black skin, aristocratic features, and proud, erect carriage, his Nubian's blackness is too pure to be human, and her nakedness evokes no way people have lived this side of Eden. We will not find her island on any of our travels in the horizontal dimension. It is a place in the geography of dreams, what Robert Graves called "a fastness of the hills / Where an unveiled woman, black as Mother Night, / Teaches him a new degree of love / And the tongues and songs of birds." She stands here revealed in her full nakedness, that "opposite within" that Narcissus glimpsed in his mirror. But being "within" does not make her familiar. She is strikingly unknown to us, and what is most "opposite" about her is her total calm, ease, and grace. Who is she?

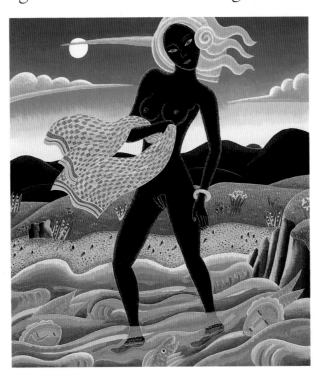

NUBIAN WADING

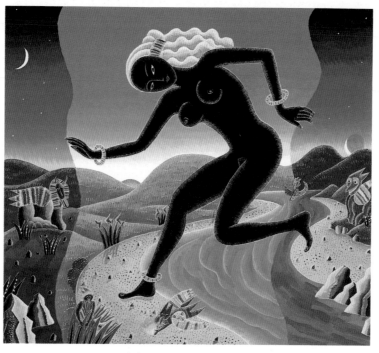

In Jungian analysis a dream of a dark figure is usually understood as "the archetype of the shadow": an image of the parts of ourselves we have repressed, pushed into darkness, because they are not acceptable to our civilization. To Jung in his moralistic time, the shadow was unconscious "animal instinct," and it had a negative, savage, uncontrollable connotation; it was a feared and despised enemy within that nonetheless had to be consciously embraced. This Nubian in her beauty is not that shadow. It would be easy, if mysterious, to embrace her. She is sexual, yes: fully and matter-of-factly, with nothing hidden or overemphasized. If she is what we have repressed, then we have repressed the composure and proportion of instinct along with its power. We have a far more positive and complex conception of instinct, nature, and pleasure today than in Jung's time. We sense that instinct has its own intelligence, form, and restraint, that nature is conscious, that pleasure is as much artisan as animal: it can make a lava flow or a dragonfly's wing. Instinct is no longer an enemy within, but the lost art of being at ease on this earth. The shadow of our civilization is sensuous beauty, pagan joy.

If McKnight's Nubians are "shadows," then, they're the sunniest shadows I've ever seen. They look made to take on the full blaze of the sun and marry it with cool darkness. They are solar, as well as lunar. In fact, they remind me of a solar eclipse, their bright headdresses like coronas of heat radiating from their total blackness. Having made this observation, I was astonished to learn that the nymph Calypso, who hid and loved Odysseus on her island for seven years, "is a minor divinity whose name means 'concealment,' from which we get our word 'eclipse'" (*ekleipsis*).

NUBIAN LEAPING THROUGH DAY

According to Jean Houston, Odysseus was "a solar hero," an embodiment of masculine mastery, which can be destructive in full blaze, and his stay on Calypso's isle was his necessary eclipse by "the Moon Mysteries of the feminine powers" in a life of timeless simplicity and sensual pleasure. Houston notes with amusement that for millennia male commentators on the Odyssey have "view[ed] this episode with considerable anxiety. Many see it as an engulfment by the 'instinctual female principle, physically vital, but intellectually and spiritually lifeless,'" and the striving hero's sojourn in "effortlessness" as "a kind of living death." In a solar eclipse, too, many peoples feared that the sun was being devoured by a dragon. But the Tahitians, who knew as much about Paradise as anyone, said the sun and the moon were making love.

When sun and moon marry in Renaissance alchemy, creativity is born. (Look at the sky in these images: you will see both the moon and the crowning, reborn sun.) The male and female principles fuse in *prima materia*, the fertile, primordial stuff from which all things arise. The Nubian embodies such a fusion of masculine and feminine, a willing eclipse, for hidden behind her is the artist who painted her, and it is the heat of his regard that radiates from her skin. Like sun-soaked Mediterranean towns that seem to grow out of their hills, she takes us back before art and nature separated: her nude body is at once nature's art, the first creator, and the founding provocation of male culture. In her, physical vitality *is* spiritual life. She practices simple, magical crafts—she has caught the sun in her golden net—and she has a strangely direct connection to the gods.

159

NUBIAN FISHER

Pausanias, in his *Guide to Greece*, told "of certain fishermen of Methymna in Lesbos who caught a face made of olive wood in their nets. 'Its appearance suggested something of the divine,' though it was 'outlandish and not like the customary Greek gods.'" Astonished and awestruck, the fishermen took the face to the Pythian priestess, who told them to worship it as Dionysos Phallen. This Nubian, however, is not even mildly surprised to find a horned god's face in her net, or to pour one from her water jar. Nor is she perturbed by the clammy attentions of a merman. She is as calmly alive as the volcano behind her, open to the molten

NUBIAN SIREN

depths. Calypso, Odysseus's "companion in paradise," was the daughter of Atlas, king of Atlantis, the drowned continent of the imagination. She is not the shadow. She is *anima*, the elemental soul, our go-between to the deep gods. "Anima is the function of relationship to the unconscious," writes James Hillman, who once described her as "wading at the river bank, beckoning." "Anima is mediatrix of the unknown, acts as psychopompos [soul-guide] to the unknown, and appears herself as unknown. . . . Finally, anima is the unknown as the mystery of consciousness in its relation with nature and life."

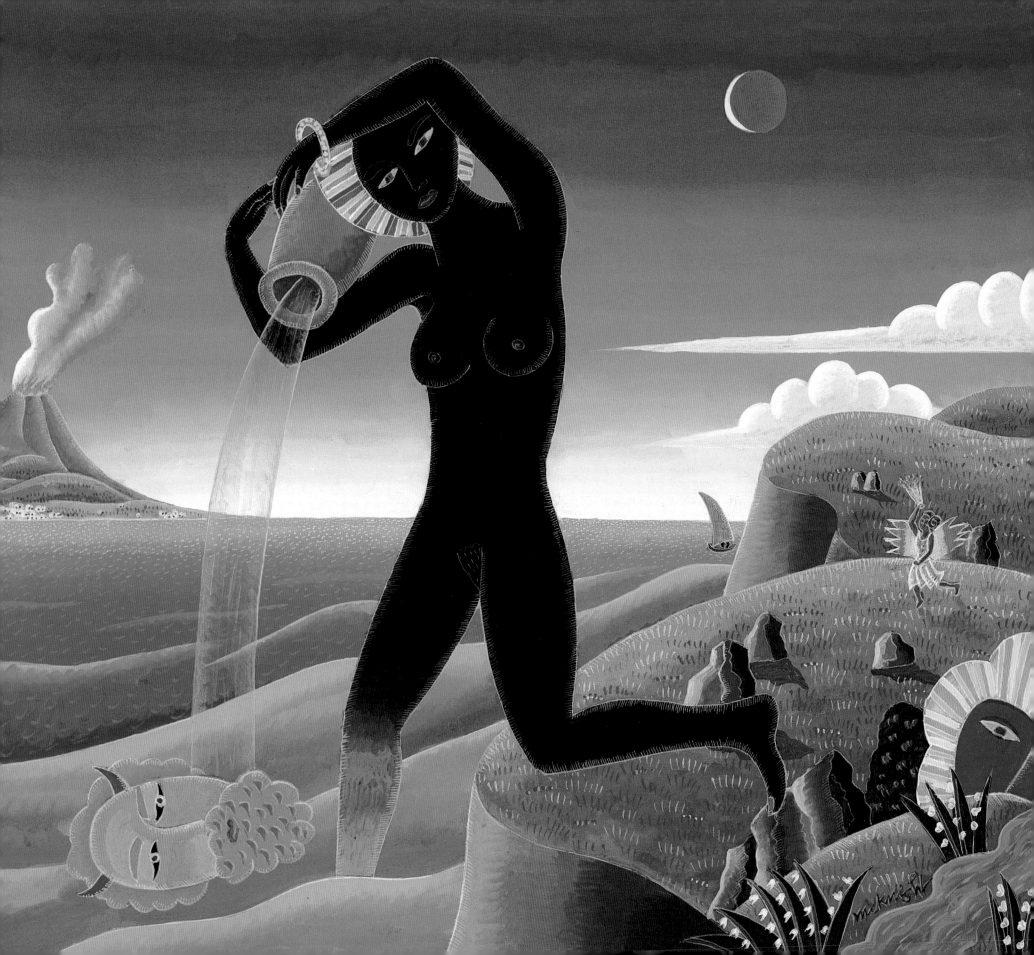

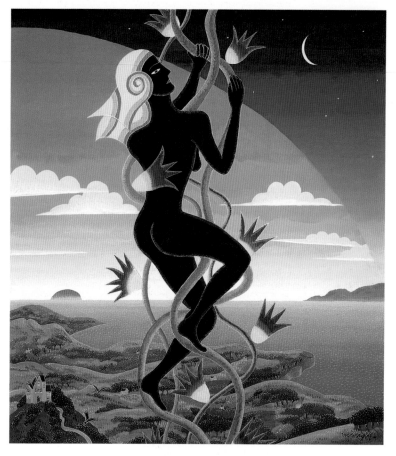

NUBIAN CLIMBER

In these images, soul is rising, ascendant. She climbs, not a stairway to heaven, but an umbilical vine, an earthly cable whose flowers embrace her as her hands caress it. (When vines twine over people's bodies in McKnight's work, I feel as if he is tracing the pathways of pleasure, the network of nerves or of "meridians" that conduct the flow of vital energy.) Even peering through the dome of the atmosphere into space, she is in touch with earth, curiosity and sensuality intertwined. The Nubian's undivided nudity suggests that she knows with her whole body.

Of what is she the opposite? Look at the next image, and the world slams shut with a clang.

NUBIAN ON SWING

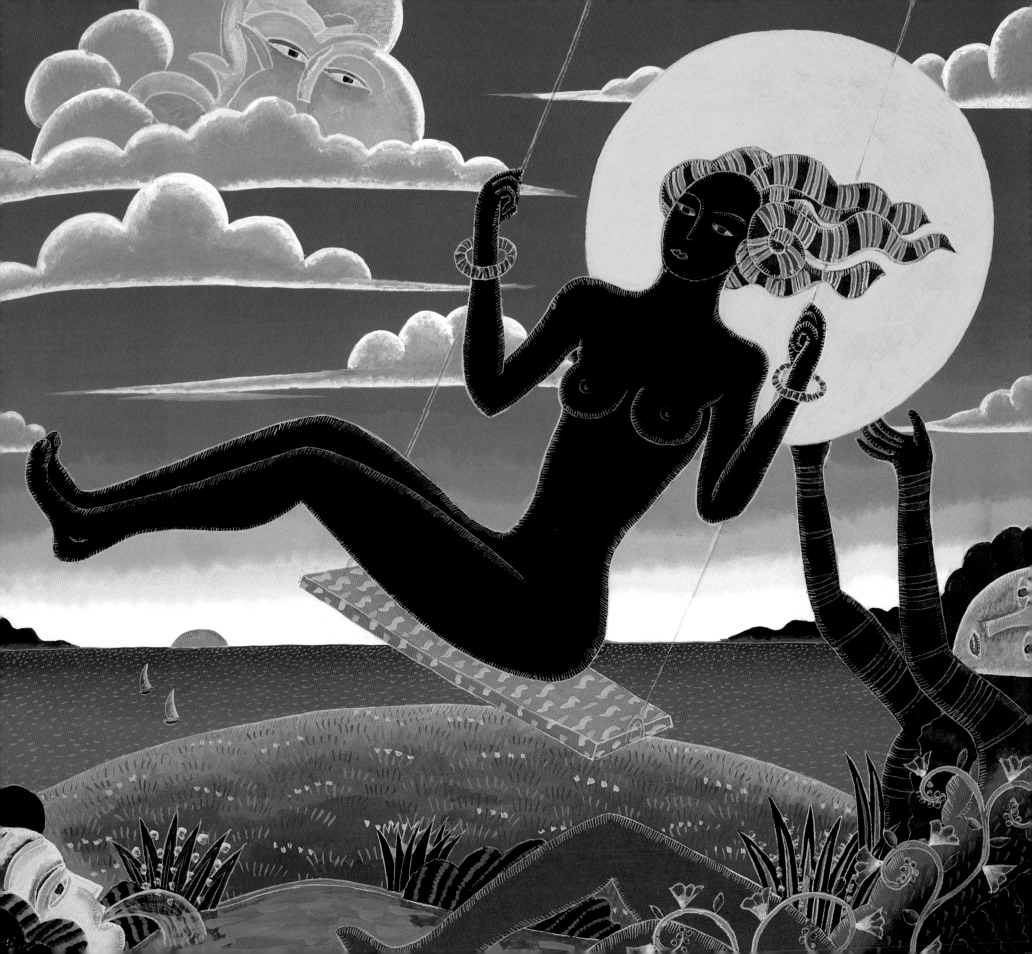

Fall of the Conqueror

To me, this knight's pain is as intense as the Nubian's pleasure was balmy. I think of him as the uptight White Knight. He is more closed than a clam; encased in metal from head to toe, like a Buck Rogers backyard spaceship powered by blazing twin jets of zeal, nothing can touch him, not even the sea wind. Above him, like a banner, he carries the scythe of mind that dismembers all it touches; under him, on his saddle blanket, snow-white and unattainable, is the feminine ideal that drives his crusade. I don't know if the broken statues on the beach are his doing, or if they signify that his civilization is in ruins and he's so sealed into his mission he doesn't know it—like those loyal Japanese soldiers in the island jungle still fighting World War II twenty-five years later. For the knight, the line between land and sea is as strict as if drawn by a ruler—no meander. (Yet his horse looks Nubian: black curves and knowing eye.)

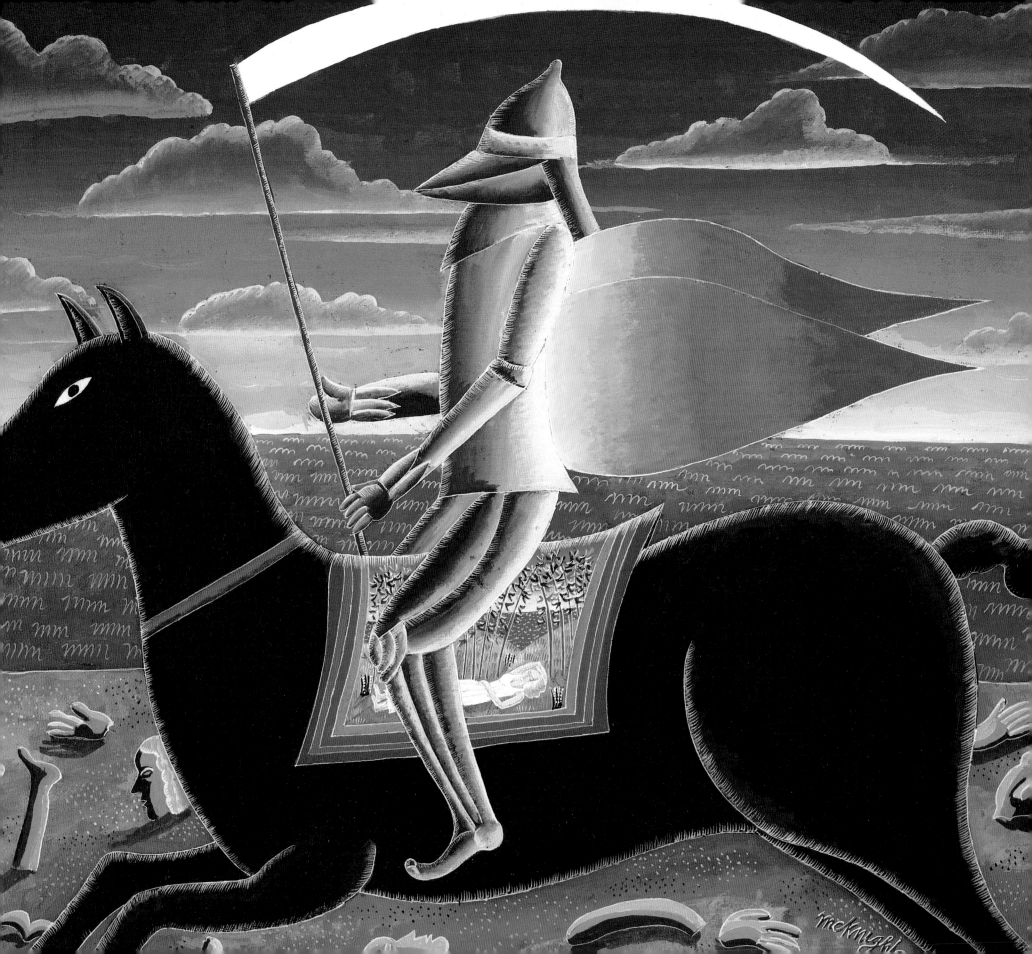

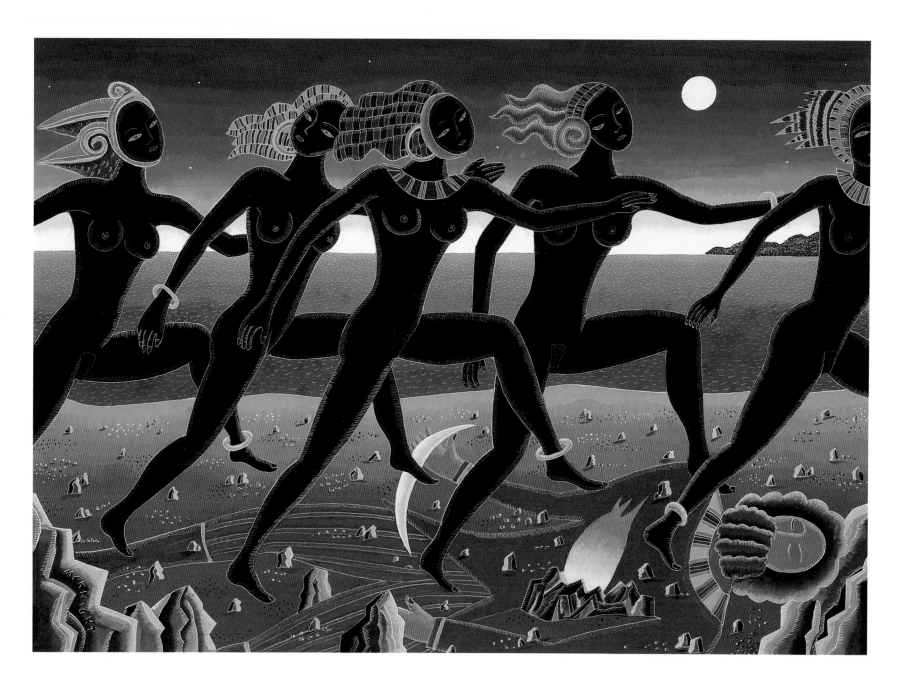

RUNNING NUBIANS

No wonder the face of the conquistador trampled by naked Nubians wears a look of surrender and peace. His scythe has turned into a moon; his heart is on fire. It's like Columbus saying, "I came, I saw, and after five hundred years, finally I was conquered." Now at last we know what journey we are on. It is the reverse of all those voyages of subjugation that set "white male" consciousness—controlling reason, swaggering ego—over the ways of soul. Conquest has been a recurring theme of Western culture ever since Aryan sky warriors galloped into peaceful Crete. The *Odyssey* itself begins with a plundering raid. Rome conquered and converted pagan Europe; a thousand years later Europe bloodily "discovered" the "New World." James Hillman makes it clear that conquest and colonialism have also ruled our inner lives:

If it is common today to fantasy our culture against that of old Rome, it is partly because our psyche has undergone a long Pax Romana. The gradual extension and civilization of outlying barbarous hinterlands is nothing else than ego-development. The classical description of this romanizing process in the psyche is that of Freud: "To strengthen the ego . . . to widen the field of perception and enlarge its organization so that it can appropriate fresh portions of the id, where id was there shall ego be. It is a work of culture." He concludes this paragraph with a simile of draining the sea-marshes to reclaim land, also a preoccupation of the old Romans.

Hillman calls this an "imperialistic fantasy" in which embattled consciousness views "the unconscious as fragmentation and disintegration," "outlandish," chaotic, and in need of imposed control.

FALLEN KNIGHT

But we have gone deep and far to Calypso's isle, and found, not "barbarous hinterlands," but Paradise; not chaos, but wisdom and grace. So the warrior can drop his sword. He is not obliged to keep the world in shape; it *is* in spontaneous shape. The tendons of his vigilance severed in one sweet blow, he tumbles to earth like a discarded marionette. And in its downfall, the dominant consciousness wears an expression of bliss. Here he looks like a Japanese warrior, with a touch of the clown or fool. There's a gaiety in his useless armor as a fairy shows him the face of the soul, the way condemned men in the Middle Ages used to be shown an image of their Savior. The fulfilled fall of the ego is the resurrection of the soul.

And from the soul, the gods are reborn.

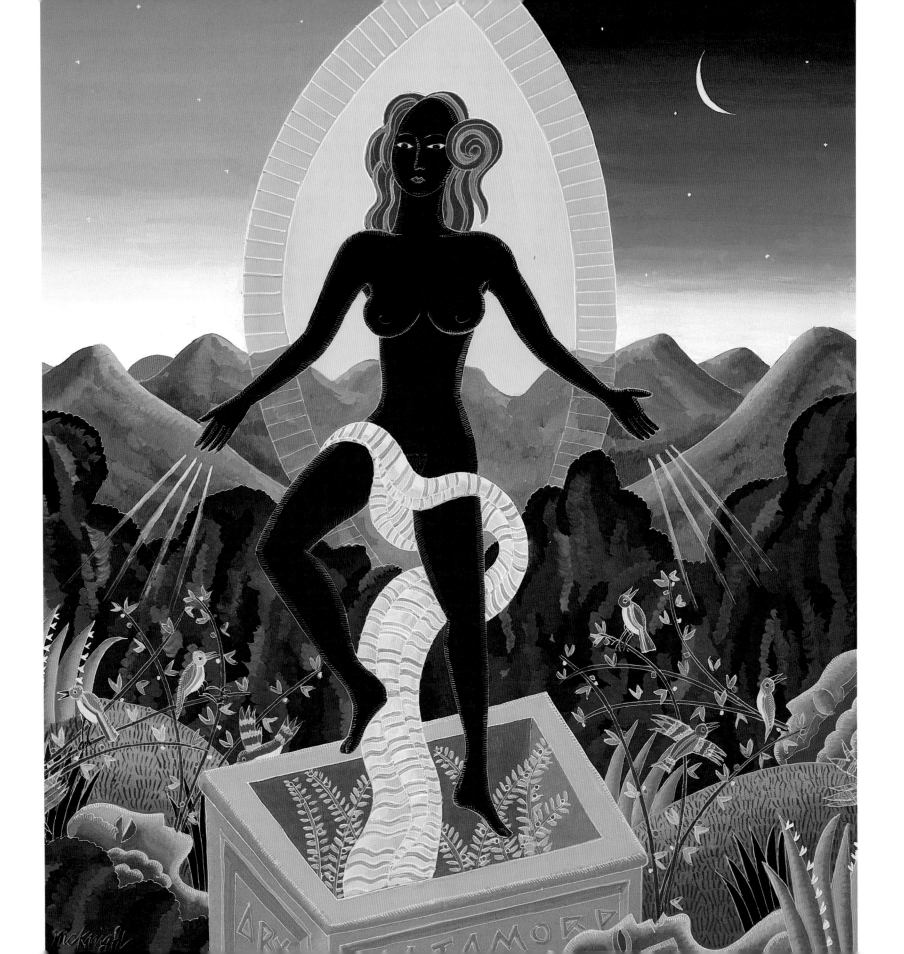

Rebirth of the Gods

At first glance, that seems like a statement of more than Greek arrogance—implying that *we* are the parents of the gods—or of modern reductionism, shrinking the gods to psychological metaphors. That's because we take the word *soul* to mean "the human soul," a subjectivity we suppose exists nowhere but inside ourselves. James Hillman insists that, on the contrary, *we* live inside *soul*, in a world that is alive and aware whether we're aware of it or not:

The psyche displays itself throughout all being. . . . Even if psyche refers to an individual soul here and now lived by a human being, it always refers equally to a universal principle, a world soul or objective psyche. . . . Man exists in the midst of psyche. . . . Therefore, soul is not confined by man, and there is much of psyche that extends beyond the nature of man. The soul has inhuman reaches.

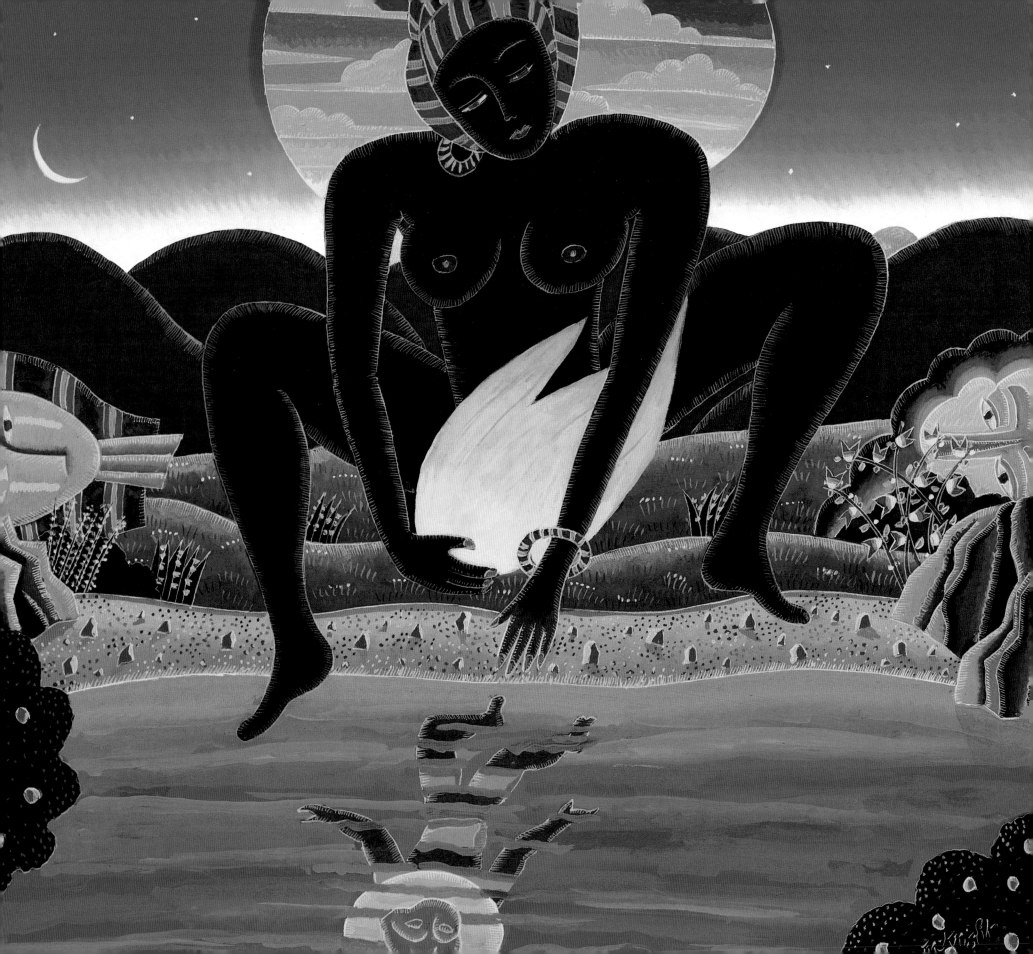

The soul, Hillman says, "may ultimately not belong to human nature at all."

Then this Nubian madonna may be an image of *anima mundi*, "the black soul of the world," also called Sophia or Wisdom, in the "ancient tradition of Wisdom as Blackness," and "Nature, the universal Mother," as the first goddess Isis calls herself in Apuleius's *Golden Ass*. We are witnessing the rebirth of a cosmology older than the Bible and as new as quantum physics. The oldest creation myths begin with a cosmic feminine principle, "a self-fertilizing virgin bringing forth life from herself before all worlds." (The alchemists, who tried to recreate the process of evolution in their vessels, said that the secret of beginning was to be found in "the sex of Isis.") This world soul's first creative act was to give birth to gods: as Cybele, she was called "mother of the first Gods and wild beasts." In the Mesopotamian tradi-

tions that foreshadow the Judeo-Christian culture, her son-lover turned around and killed or exiled her, seizing creativity for the male principle; but in Egypt, honored as queen mother of the immortals, she gave birth to Osiris again and again, gathering him back into her womb for another renaissance every time he was slain by evil. "More than any other goddess, Isis is shown as a nursing mother with the infant Horus at her breast or the infant Harpocrates in her lap." (Or asleep Moses-like in a basket in the bulrushes, guarded by crocodiles, his rainbow wings suggesting his father was a bird.) "In these images lie the origins of Madonna and Child," especially of the mysterious Black Virgins in churches and shrines all over southern Europe—perhaps a secret survival of goddess lore. The soul of the world has never died; all that needs to be reborn is our awareness of her, her image in us, our own souls.

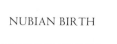

NUBIAN BIRTH

NUBIAN HUNTER

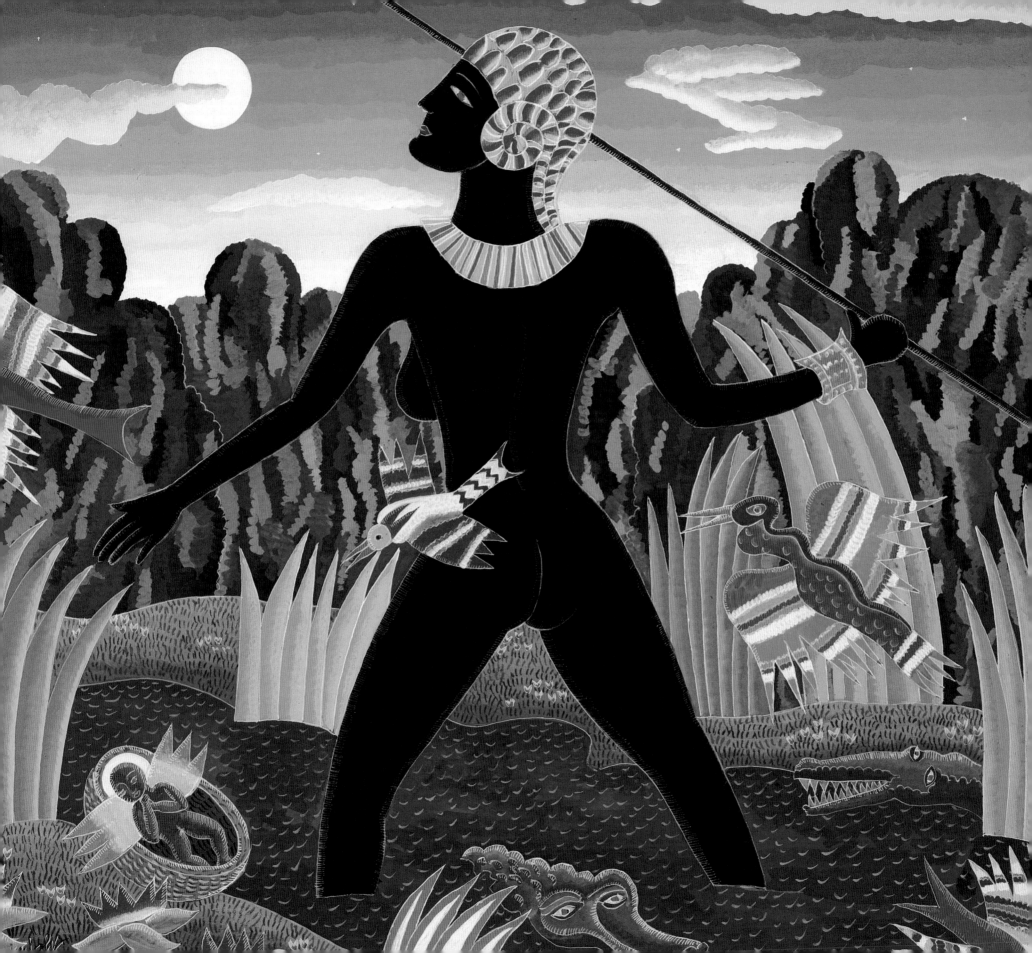

A curious question is why she gives
birth to gods before getting down to the business
of world-making. We are so used to having only one Cre-
ator that this is a subtlety missing from our new Gaia myth.
The gods are her primal act of self-differentiation into the elements
and processes of which the world will be woven: earth, air, fire, and water;
"attraction, repulsion, polarization, coagulation, calcination, sublimation, ex-
altation" (alchemist's terms). These principles lived long before we did, and found
ample expression without us; there were volcanoes before there was "volcanic rage."
Traditional mythologies all over the world have recognized these forces, their priority
and power over us, and personified them as gods. Ares (Mars), the Greek god of war, is
much like the African-Haitian fire-god Ogun, and Ofudosan, the fierce, sword-brandish-
ing warrior-deity of Japan. They are all expressions of one archetype, that of fire and its
human manifestation: the bright passion that it takes to begin, advance, defend, create.

Every time the gods are reborn, the archetypes find new expression—perhaps newer
now than ever before; the Renaissance rediscovered the archetypes in classical marble, but
they are coming to us fresh from the womb of the earth again. "We are living," wrote Jung,
"in what the Greeks called the Kairos—the right time—for a 'metamorphosis of the
gods.'" In a strange way we are lucky in our losses: science scoured away our tradition,
then washed it back up on shore mixed with Kuan Yin and kachinas and quarks, a
million mosaic bits of old cosmologies and new ones. Individualism scoured away
our reverence for convention, freeing the gods to come to each of us in differ-
ent form, without names. Thomas McKnight paints a tiny, fiery archer
beginning again among the ruins, at the will of his mother. The
contrast between his headlong zeal and her sheltering con-
templation says something new about the tenderness
of the universe toward the blindly brave
young spark of creation.

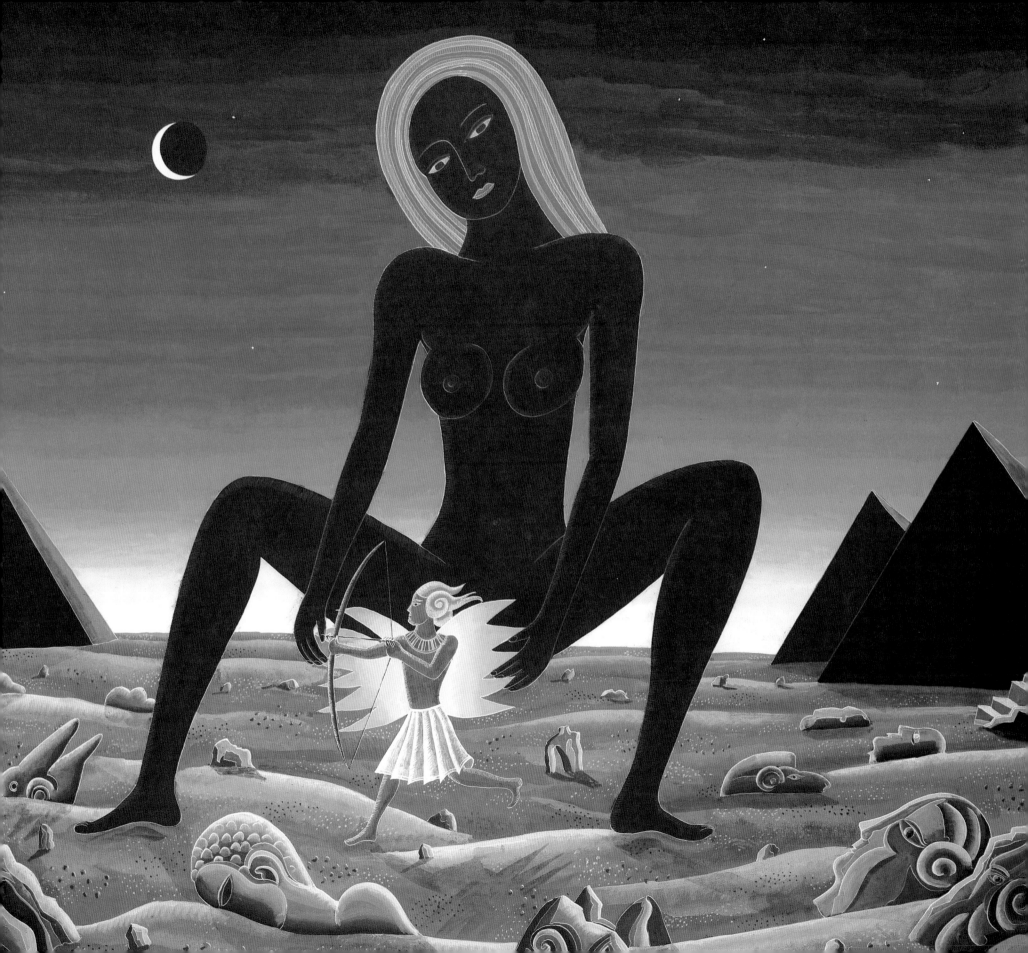

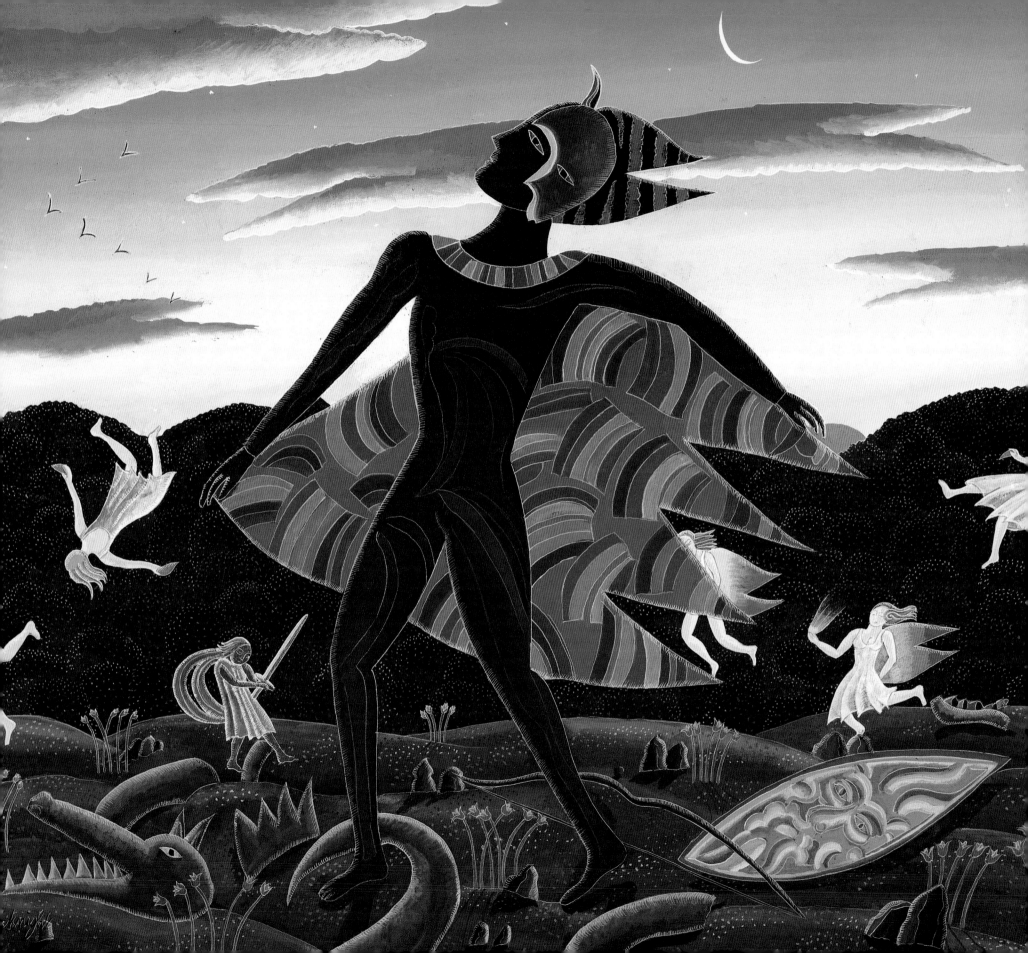

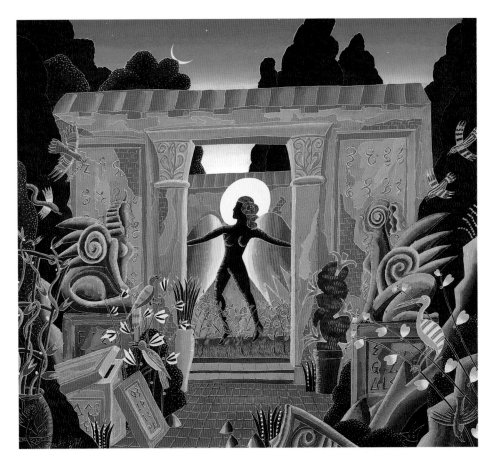

RESURRECTION IN GARDEN

The little warrior grows up to be Mars, but I suspect the title is an afterthought, a nod of recognition to the archetype. We have never seen *this* elemental being before, though we know its source. Part bird, part fire, part shadow, of indeterminate sex, it has a crackling, electric aura that sends tiny assailants or attendants flying. The severed dragon at its feet could be its own crow to the sky: "Don't tread on me!" Unlike the classical Mars, this undefeatable spirit needs no armor, and can come in explicitly feminine form. Her opened tomb and roofless temple announce the return of the gods from oblivion to honor, our becoming mindful of them again.

Gods of Earth

Here, from another opened tomb, the earth-god rises, the male moon. (In German the word for moon is masculine: the crescent moon has horns.) His is an archetype we haven't seen for a few millennia, since maleness departed for the sky, but now Robert Bly and others are drumming him up out of the ground again. He is something startling and strange to us: maleness not only as the driving force of life, but also as the cyclical vulnerability of life, that which rises, falls, sows seed in death, and is reborn. Thomas McKnight's mysterious image has two grandfathers: the sacrificial vegetation god—Attis, Tammuz, Adonis, Osiris, Dionysos—and the horned Lord of the Animals, whom the Celts called Cernunnos: a "powerful, mature, horned figure, seated cross-legged on a throne, beneath which a stag and a bull feed on the plenteous fodder which flows from his lap." The contemporary witch Starhawk might have been looking at this image when she wrote:

Father Earth is the Green Man of the Craft, the God who is pictured crowned with leaves and twined with vines, the spirit of vegetation, growing things, the forest. The image says, "Experience this: you are rooted in earth, know the force that twines upward. . . . Know the cycle. . . ."

The God is an animal: stag, goat, bull, boar. He is the Horned Shaman in the prehistoric cave. He carries the bird wand, He smiles through owl eyes. His image says, "Remember . . . the deeper part of yourself, still untamed, whose strength is that of instinct." . . .

But there is no precedent for the sweet coil of vine in his groin, so evocative of pleasure and generation, or for the light pouring from his palms, radiating the power to heal and to create.

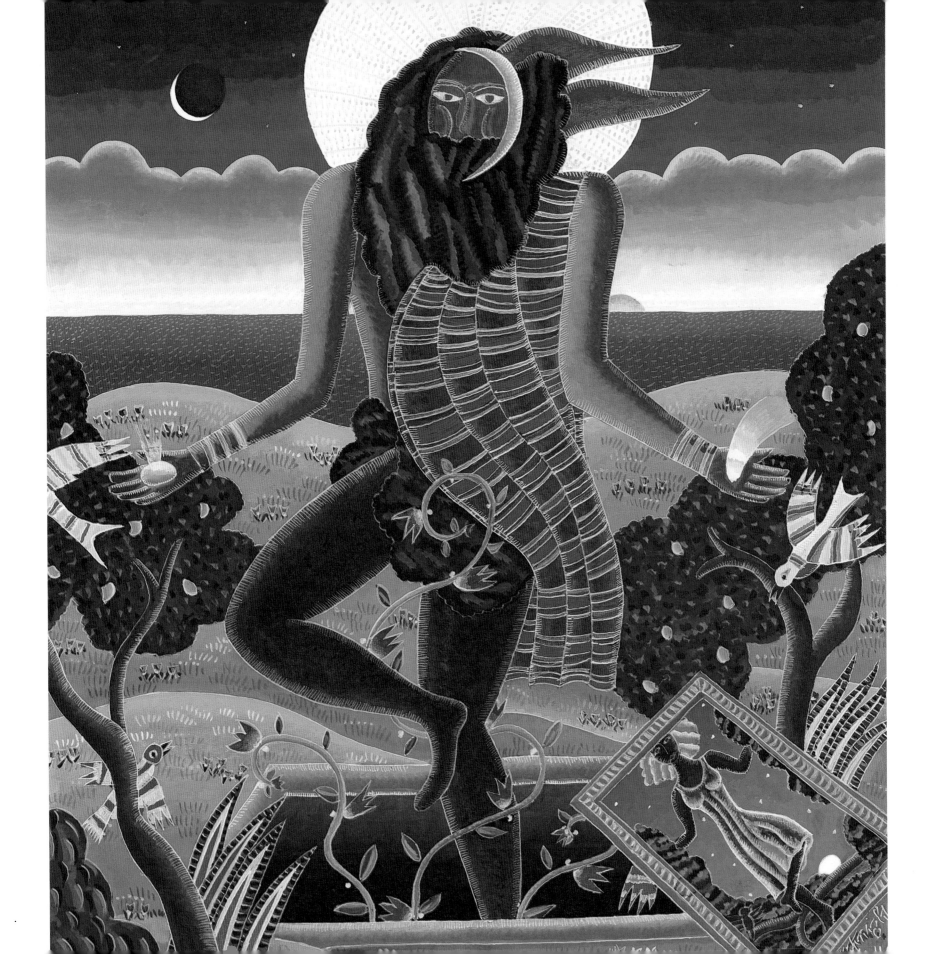

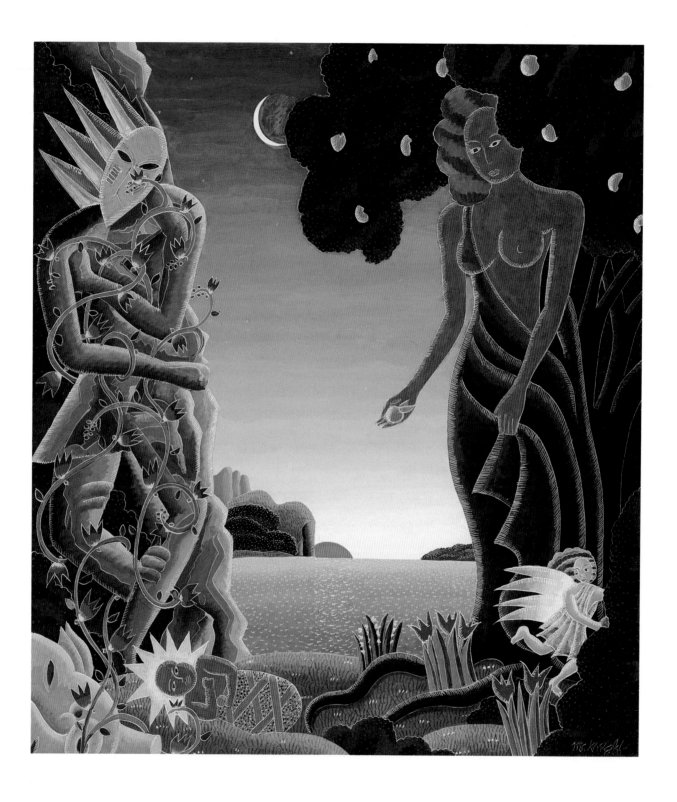

STONE MAN AND POMONA

Woman has often been compared to a fruit-bearing tree, but I've never before seen an image of man (or the male principle) as mineral, a "hard case" entwined all over by tendrils of pleasure determined to crack him, despite his arms wrapped protectively around himself. The child has been laid at his feet, as in a paternity suit, perhaps revealing that life has roots in hard rock and volcanic fire, and can overcome them by its softness. At least, that is one playful reading of this enigmatic image of our two "parents" in nature.

Trees may have been among the first gods. We know that the earliest Greeks had no temples or statues, but served the sacred in groves and by springs. The first devotional objects we know of are plain black stones, especially meteorites, and rough planks with the faintest suggestion of human features incised on them, as if a spirit were barely discernible in the wood, the god just beginning to emerge from the tree. Later Greek myth is full of god-tree alliances and metamorphoses from human to tree and back again: Daphne turns into a laurel to escape Apollo's pursuit, Pitys fleeing Pan becomes a fir tree, Dionysos has a tree-god incarnation, images of Artemis are discovered in willow, myrtle, and cedar. The Tree of Life with its roots in the earth and its crown in the sky is a mystical symbol from Norse myth to the Kabbalah, a forerunner of the Cross and an analogue of the human spine.

Now, even as acres of old growth fall before the chainsaw and rainforests go up in smoke, the tree-god or goddess is coming back to life. We are realizing that "the Tree of Life" is more than a metaphor: trees not only provide wood and shade and beauty and bind the earth against erosion, but we are bound to them by an umbilicus of oxygen: cut it and we die. Ecologists plant trees, and activists hug them, feeling the cool green blood coursing through the rough column. Trees are like us, yet not like us. They have a trunk, a "head" and "feet," and they branch like our arms and fingers, our blood vessels and lungs. But they inhabit time and space so differently. Trees' patience, their relative permanence, makes us feel feverish and momentary. They choose their ground and stand fast, enduring many deaths and resurrections with only a murmur. Although they were here first, it's easy to imagine that they were once mobile beings like us who matured or were spellbound into stillness, yet continue to shelter us like elders.

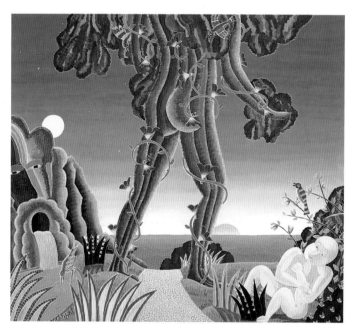

WOMAN AND TREE

ANCIENT TREE

"The great god Pan is dead!" That terrifying cry resounded through the ancient world at a time when centuries of civilization had denuded the Greek hills of Pan's beloved groves, and the birth of Christ foreshadowed the cutting-down of all the old gods. Now, in this time of environmental panic, we can borrow a joke about the Second Coming and proclaim, "The great god Pan is reborn, and is he mad!"

The original Pan was a good-natured herdsman's god with the haunches of a goat, offspring perhaps of some lonely shepherd's liaison with one of his animals—a lewd incarnation of human intimacy with nature. He loved to play his pipes in the shade and to nap at noon, and only if rudely awakened would he frighten the flocks with his shout. But this reawakened Pan Thomas McKnight has painted is no figure of rustic fun. He has kept the darkness and the devil's tail he picked up during his long banishment in the Christian underworld. The fleece on his thighs is green; he is now both animal and vegetal, standing firm for *all* nature ("pan" means "all"). And he is no longer familiar, but remote and ominous, black as a gathering storm. Yet he holds in his hands, like a lightning rod, the instrument of healing. In McKnight's hands even the caduceus, the formal symbol of medicine, comes back to life. Its two snakes— one solar, one lunar—twine like *kundalini* up the spine, an electric jolt that restarts the heart, restoring us to paradise.

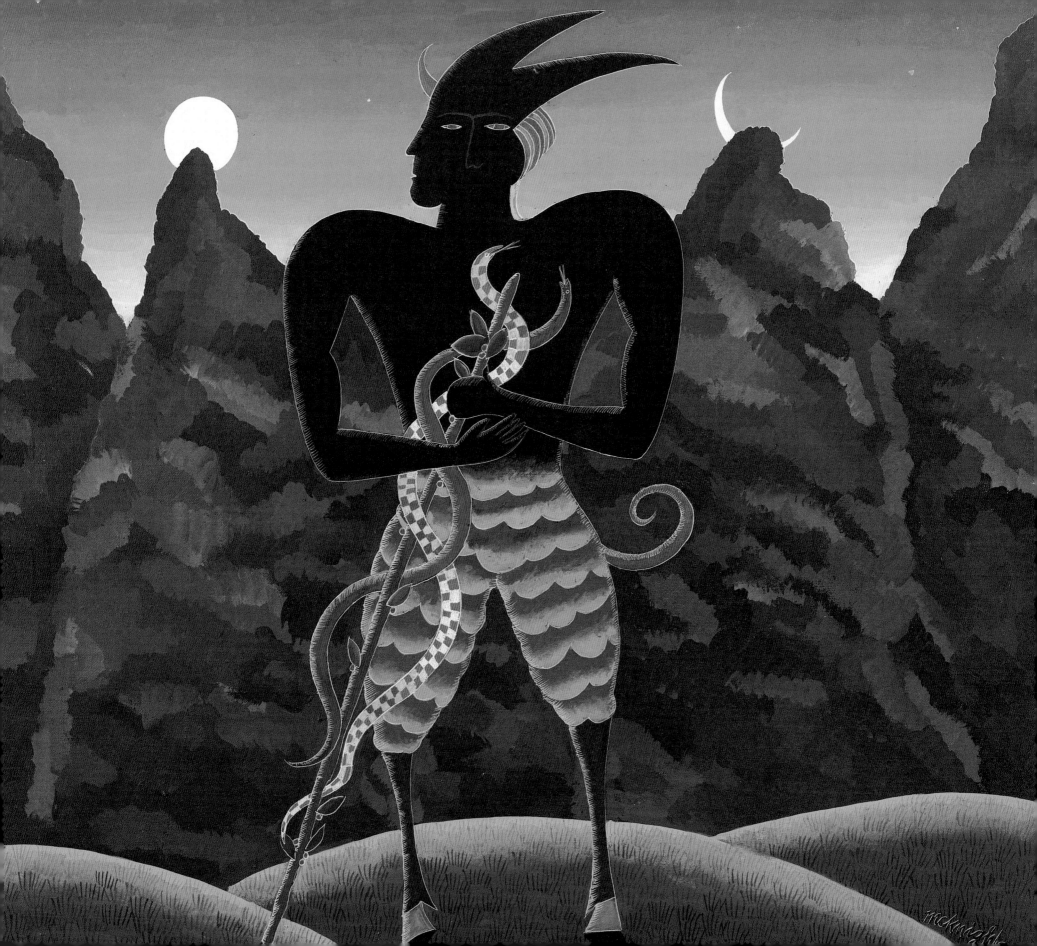

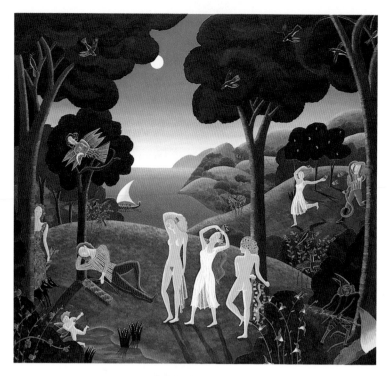

ARCADIA

Playing with the Gods

Look for the Pan-daemon lurking in these pastorales, to-
gether with nymphs and Nubians, mermaids and fairies,
and other fantastic beings we have met on this journey, all
mingling and playing with ordinary humans, with us. Cre-
ation myths say this is how it was at the beginning, before
humans got uppity and decided only we were real. "The
'paradise element' in cosmogonic myths . . . [refers] to a
time in which men and animals lived together; the gods
and men are related in terms of mutual affection," writes
historian of religion Charles H. Long. He tells a Pueblo
Indian creation story: "Long ago when the earth was soft,
all the relations with the spirits were more intimate.
Everything could talk, animals, plants, even wood or stone.
The kachina came in person to dance or . . . to fight. . . . It
was a golden age. . . . Even human persons were wonderful
. . . because the world was still new."

This is paradise as life lived in imagination, as a small child or a tribal person lives, with companions who are not *imaginary*, but real in their own dimension. "These persons continue to appear in our dreams," James Hillman has written. "Nymphs and sirens, heroes and demons, priapic satyrs, monsters, talking animals . . . Gods and Goddesses . . . today we are so unconscious of these persons that we call their realm the unconscious. Once they were the people of the imagination. . . ." Or, as C. S. Lewis so beautifully puts it, "The imagined beings have their inside on the outside; they are visible souls." As we come to the end of a world, and so to a new beginning, we may have the counsel and consolation of these old friends again, but only, Hillman says, if "archetypal persons strike us as utterly real. . . . They must be alien even while familiar, strangers even if lovers, uncanny although we rely on them. They must have full autonomy," recognition as "actual presences and true powers." And then, "We would find ourselves no longer alone . . . as the Angels and Archons, Daemons and Nymphs, Powers and Substances, Virtues and Vices . . . now return to enter again into the commerce of our daily lives."

So enjoy this *al fresco* cast-party with all the characters we have met along the way. It should really be accompanied by music, not words: the zephyrs of a recorder consort, viols and lute, since we are—as the costumes remind us—in a Renaissance. This voice will be silent, except to introduce new guests at the party.

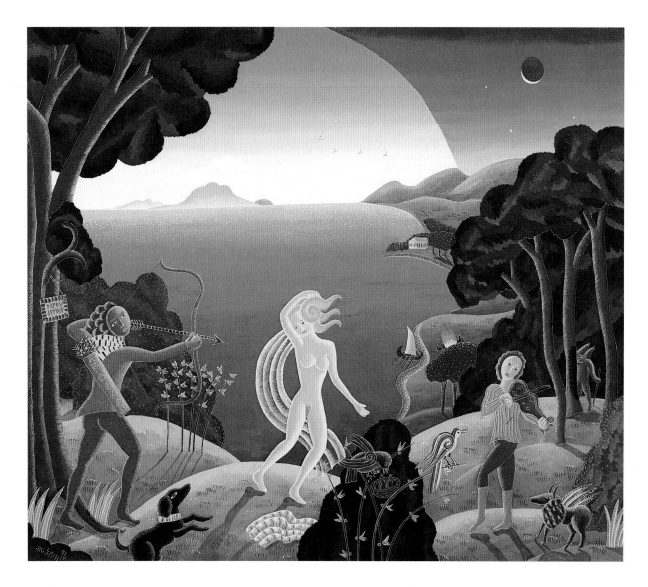

The old man Saturn, or Kronos—Time—is the uninvited guest at every party. His presence is necessary as the limit of life, the grave (in both senses) that makes pleasure sweet. Here he is ceremonially paired with Aphrodite, goddess of love, or with the tree-nymph Daphne, in the medieval motif of Death and the Maiden. He dozes, oblivious to Daphne's flirting, or he lurks on the periphery of the party, ignored by the young lovers, his patient scythe poised to gather them in. These images suggest

SUNRISE, BIRTH OF APHRODITE

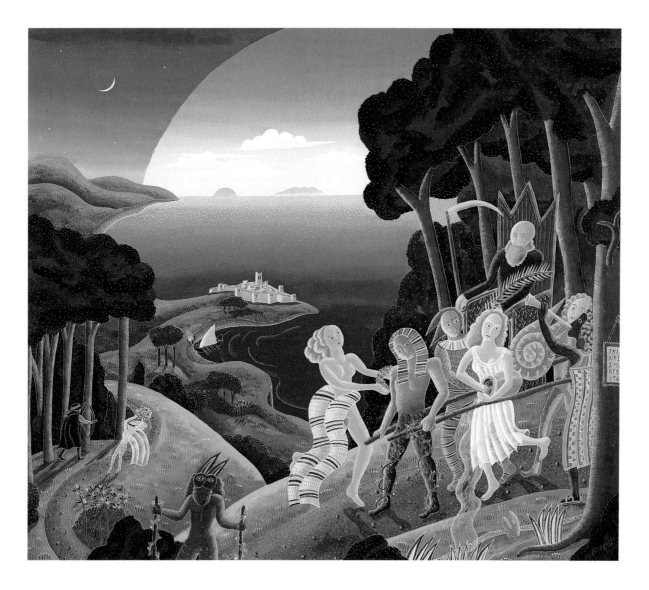

that the old man is not only an unavoidable pest, but to be honored, welcomed festively. Here, in an image painted when Thomas McKnight thought his father was dying, Saturn is borne in to the sound of pipes and tambourines. His complexion is green as death or grass, like the Green Man of ancient vegetation mysteries who endlessly died and sprang up again, young. Death, in McKnight's vision, deserves a temple of its own.

TRIUMPH OF SATURN

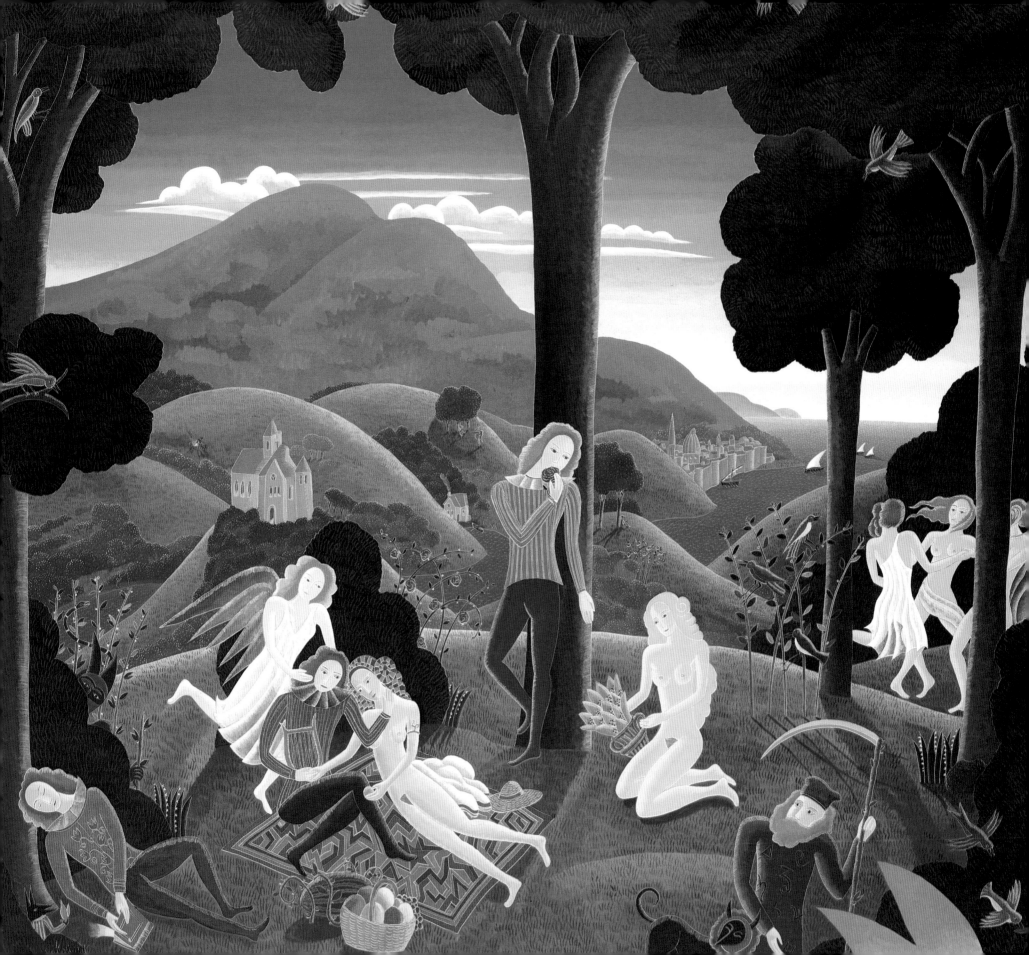

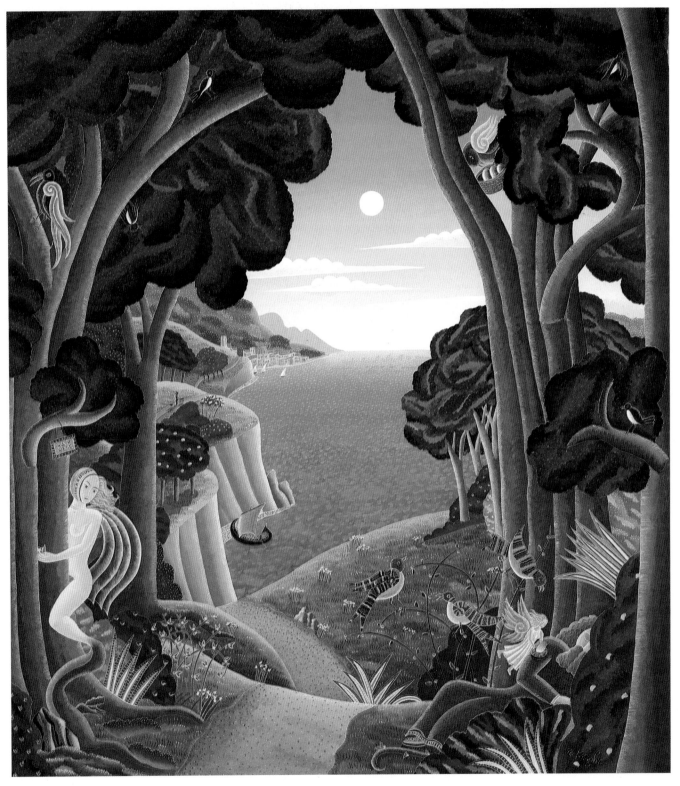

DAPHNE AND SATURN

SACRED AND PROFANE LOVE

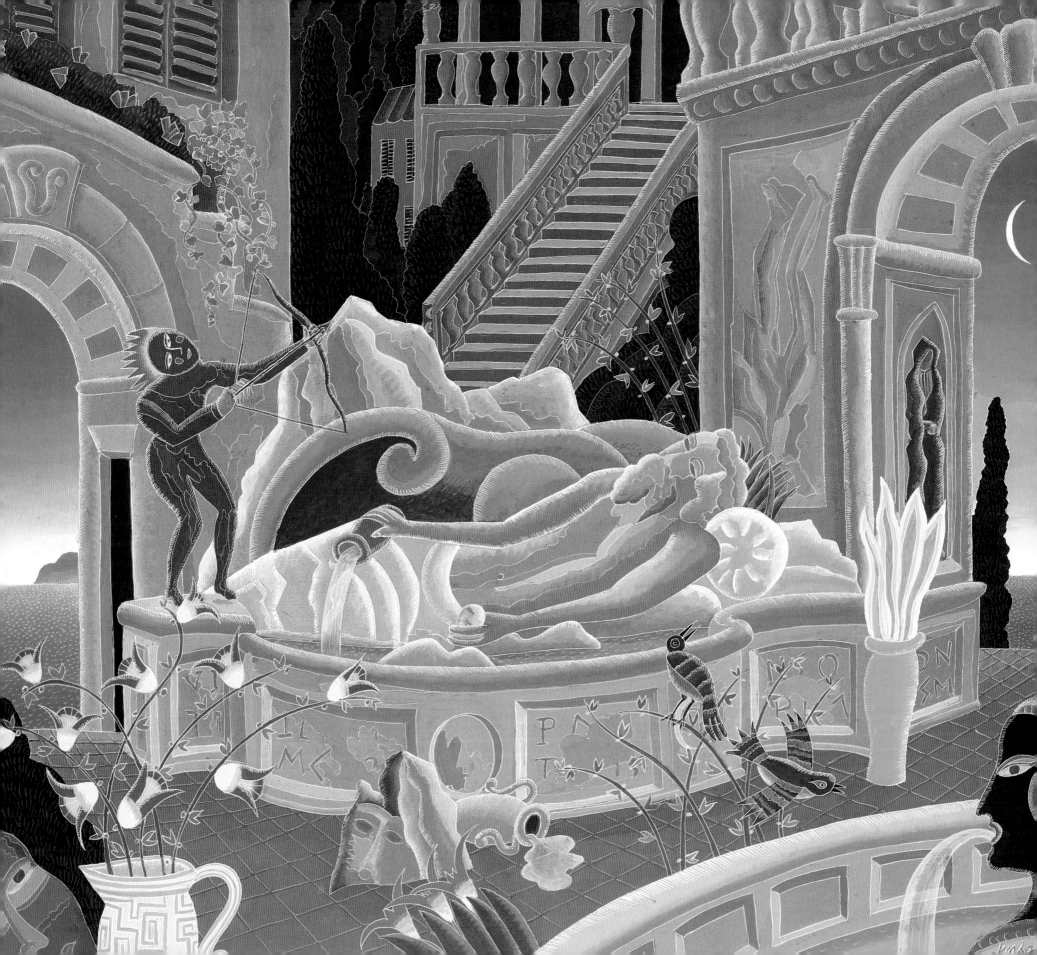

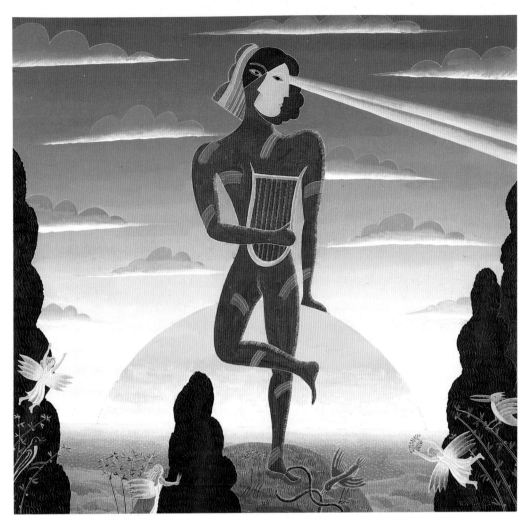

APOLLO

"When I first started to paint," Thomas McKnight told me, "I identified with the Apollo archetype: lucid, calm, trying to radiate serene images of occult knowledge." Apollo is never at the party, always above it. He is the god of light and form, the inventor of music (classical, of course; raw rock is Dionysian), but also the god of distance, "detachment, dispassion," writes Hillman, "clarity, formal beauty, farsighted aims, and elitism." In Camille Paglia's words, "Aristocracy is aboveness," and Apollo is above nature. He himself has emerged from nature— "He was once a wolf god," Paglia says—and he remains a lone wolf, as untouchable and fierce as his sister Artemis. For all his light, he has a dark side. His gaze from afar separates and defines, like the line of Greek light McKnight paints with, but it also kills, an "icy eye-spear" freezing the flux of life into marmoreal forms. Apollo is ancestor of the "objective" science that denies the world a soul.

EROS AND SATURN

Since this image was painted, McKnight has come down to earth without losing his Apollonian light. In this *Grove of Apollo,* can you find Apollo? I think he is our old friend the Fallen Knight, reclining sensually on soft green grass while his eye still radiates that penetrating beam.

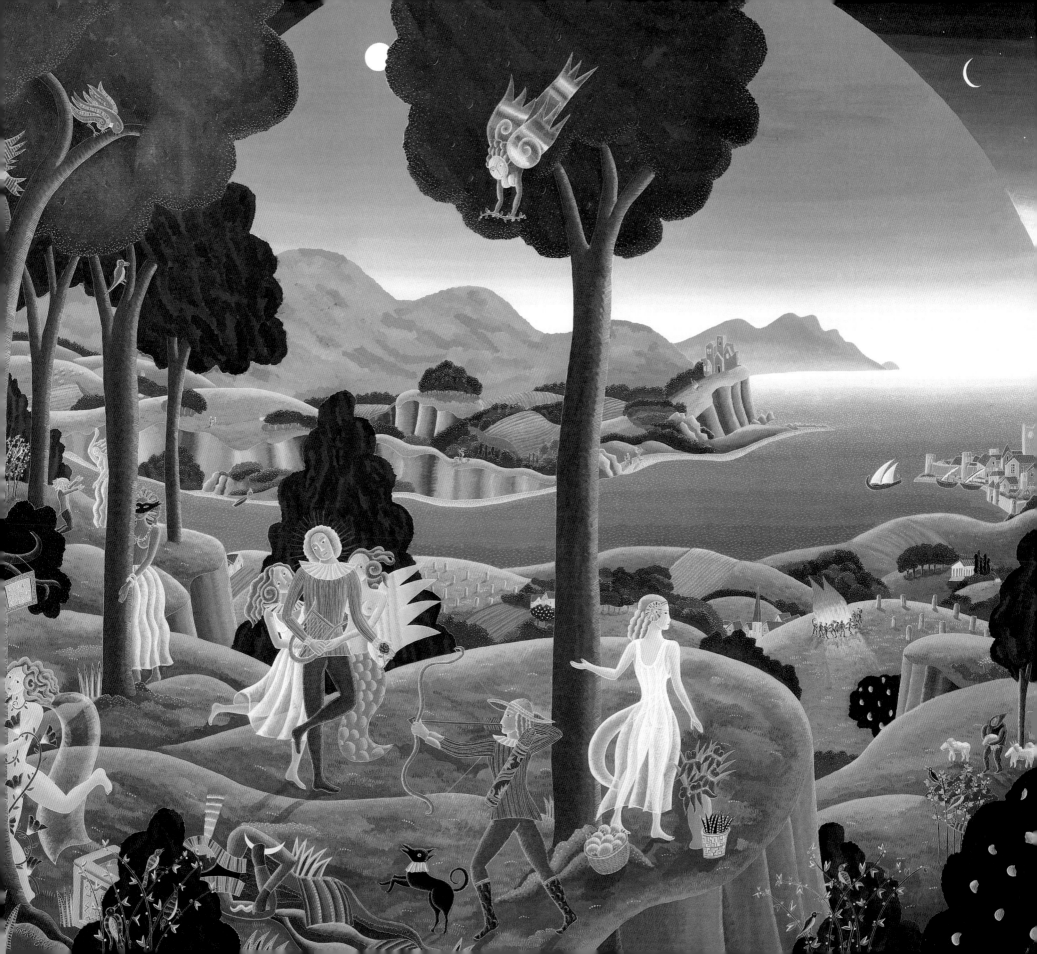

The Voyage Home

GARDEN OF ISIS

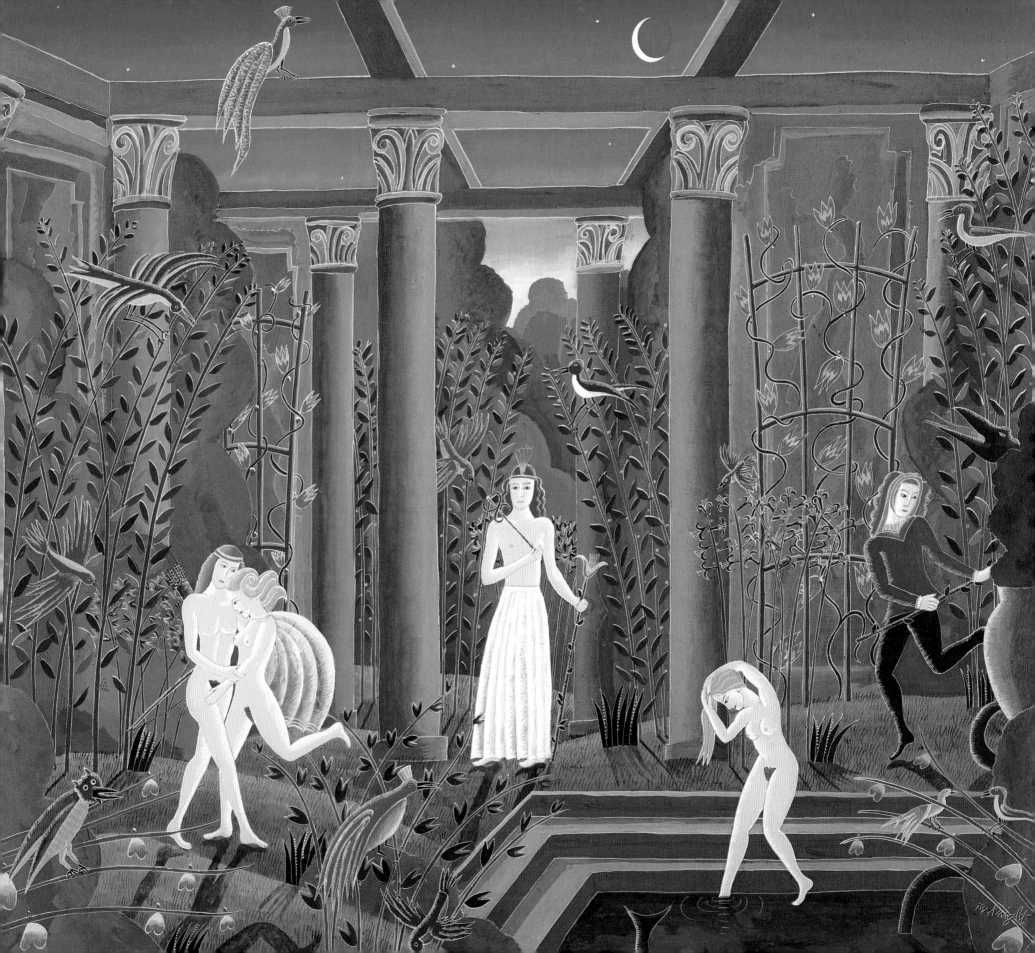

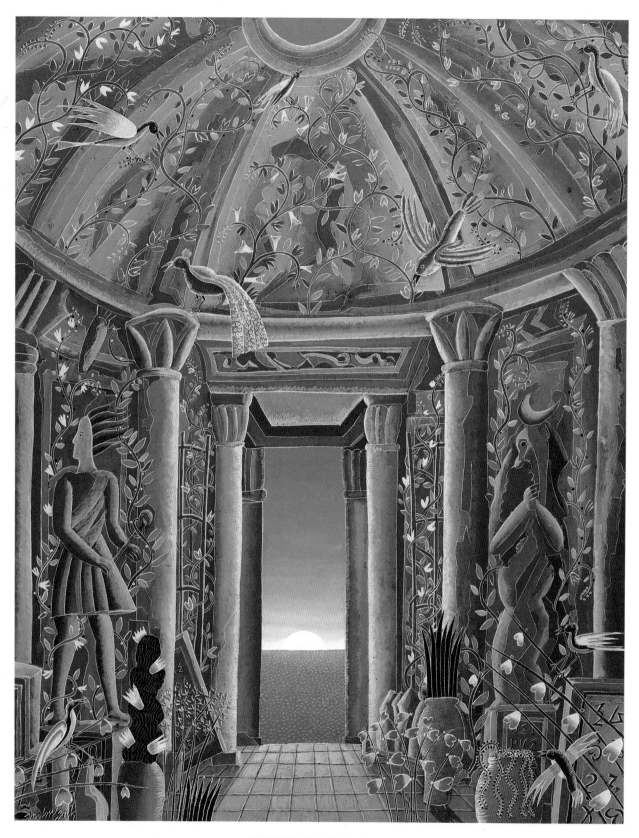

TEMPLE OF THE BIRDS

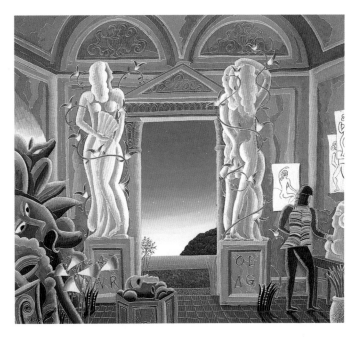

SCULPTOR'S STUDIO

Temples, Gardens, Pools, and Fountains

Yet it is Apollo, the great civilizer, who transforms the grove into a garden, then a temple, and brings a new kind of beauty into the world: symmetrical form and harmonious proportion. The rough, randomly spaced trunks of trees are trained into formal dance as Doric columns. Arched branches interlacing overhead are disciplined into a dome. As a face emerged, first faintly, from the tree, now mind emerges: the pure mathematics buried in nature are divined and distilled into art. As civilization gained power, we can imagine that the artist first flattered nature out of fear; then idealized her out of awe; then enhanced her, in a spirit of egalitarian collaboration; then improved on her with a sense of superiority; then came management; and now, destruction. Our time is violently divided between the zealots of high technology, busy sealing us into a shiny mind-made world, and the zealots of deep ecology, for whom beauty would be a wild earth wiped clean of us. Thomas McKnight goes back to find the balance point, where art grows out of nature and turns back toward her to embrace her in form. This befits a fallen Apollo, an Apollo with cloven hoofs perhaps (McKnight is a Capricorn), an Apollo who has not cut his roots but knows how to untangle and compose them.

The snake, in mythology, is our root in the feminine wisdom of the earth. Not only Christian saints, but Greek heroes feared and hated it. Apollo killed the earth mother's prophetic python at Delphi; two sea serpents sent by Poseidon slung their coils around Laocoön and his two sons and crushed them to death. (Laocoön was the Trojan priest who warned against accepting the wooden horse—"Beware of Greeks bearing gifts.") Thomas McKnight has painted many variations on the Laocoön group— "For me, it represents the struggle to create and tell the truth"—but in these airy temples, the mortal struggle with dragons

EROS AND PSYCHE

of the deep has turned into something much more like a dance, echoing Matisse's cut-out dancers and Picasso's nude sunbathers in *Les Demoiselles d'Avignon*. McKnight often reverses the gender of mythical figures; here Laocoön has grown breasts, the snakes are arms and legs interlacing, and the rhythm is not life and death, but lightness and grace. An image of entrapment has metamorphosed into one of enticement. McKnight has been careful of the gifts of Greeks. He has embraced their paganism, but not the dragon-fighting heroics that set war above love, male above female, and ultimately, man's mind above nature's gods.

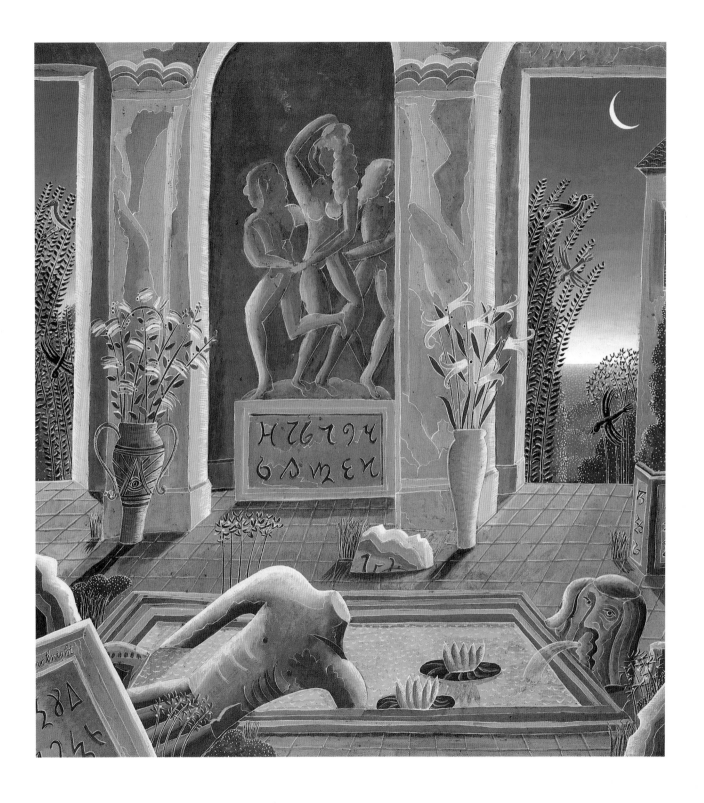

GARDEN WITH LAOCOÖN

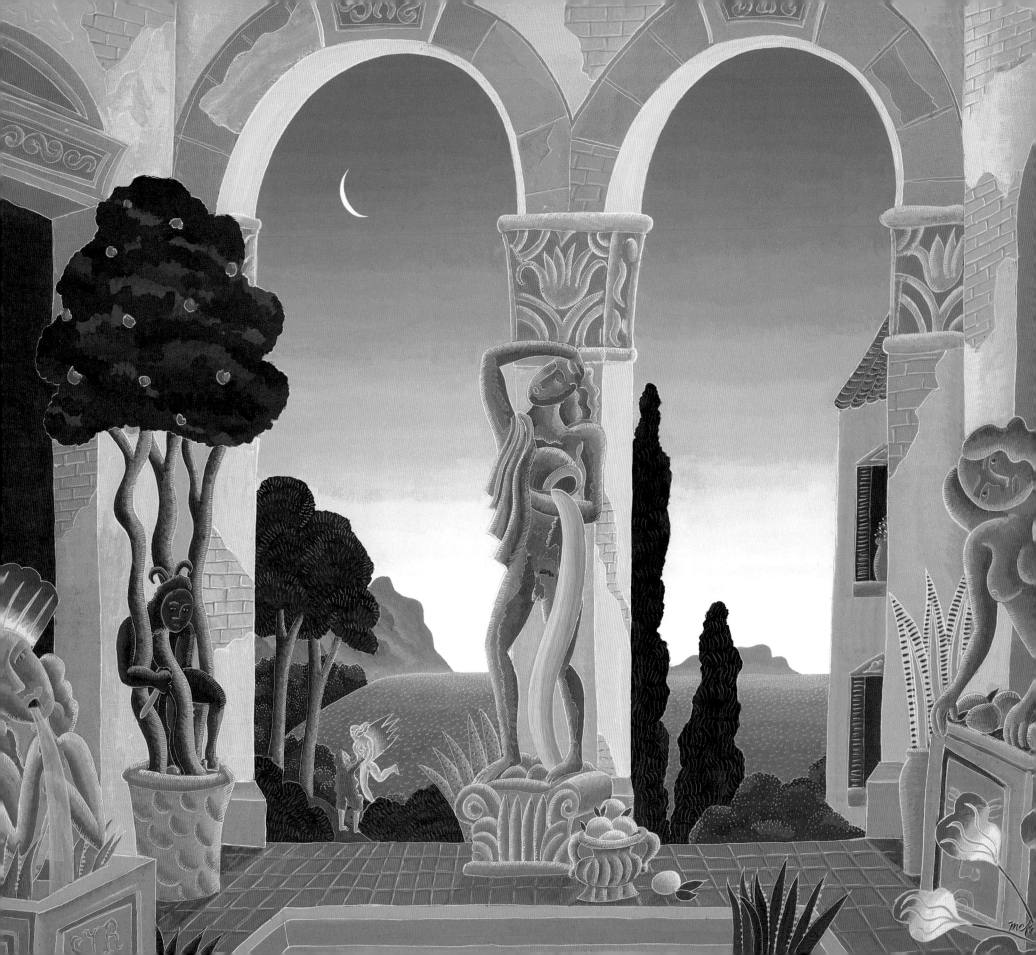

The Greeks, who at first built no temples at all, eventually placed the temple in the middle of the city, where it forgot that it had once been a grove and became a monument to civic pride, a house for a god-sized man or a man-shaped god. The direct descendants of that temple in our lives are the courthouse and the bank, enclosed shrines where we serve social abstractions and never see the sky. The classical and Mediterranean temples McKnight imagines, by contrast, are open. Flowers grow in them, birds fly in and out, and we can almost smell the fragrance and hear birdsong echoing in the dome. The only altar is a framed view of sky and moon.

Poised on the brink of nature, these temples have not forgotten that they are ceremonial groves, or that a natural spring should be represented in the center by a fountain or pool. Springs were among the first sacred places, regarded as openings of the Goddess's womb and "honoured by images of the feminine, life-giving spirit." "All of life comes out of water; and water from a spring is continually being renewed and changed, [suggesting] the possibility of renewal and change." Thomas McKnight returns to both that ancient respect for water and the Renaissance obsession with channeling and framing it in the work of human hands. His gardens are open-air temples, his temples are roofed gardens, and at their heart are serene oblongs and sinuous ribbons of water.

203

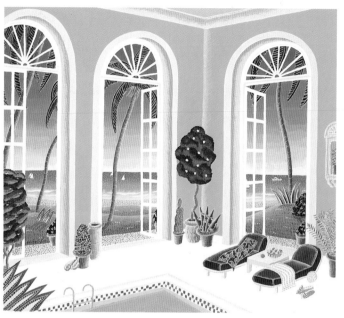

INDOOR POOL, PALM BEACH

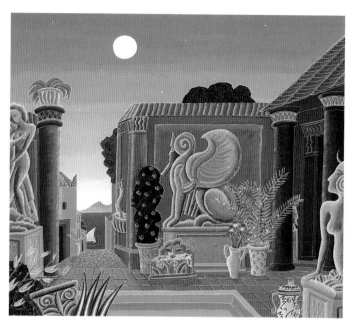

ANCIENT DELOS WITH GRIFFIN

In McKnight's vision, these pagan temples, too, have secretly survived into our time, not as banks or courts or churches, but as our places of pleasure—beach houses! His compositions equate tropical patio and temple portico in a "rhyme" that is more than visual. The spirit enshrined in both is the same: love for the beauty of the elements, sensuous pleasure in nature enhanced by art. Here are the pillars and arches of the "sacred grove"; here is the water of life, the same cool square of fallen sky in the center, whether a stone sphinx reclines beside it or you and I, anointed with sunscreen. The pool is chlorinated now, and meant to swim in. Does that kill mystery, or just dissolve it more intimately in the ordinary? The idea of "vacation fun" as pagan devotion is a startling one, yet our cells commune with the spirits of water every time we splash squealing into the pool. In modern Palm Beach, no less than in ancient Sicily, a turquoise pool refreshes the eyes, the skin, the soul.

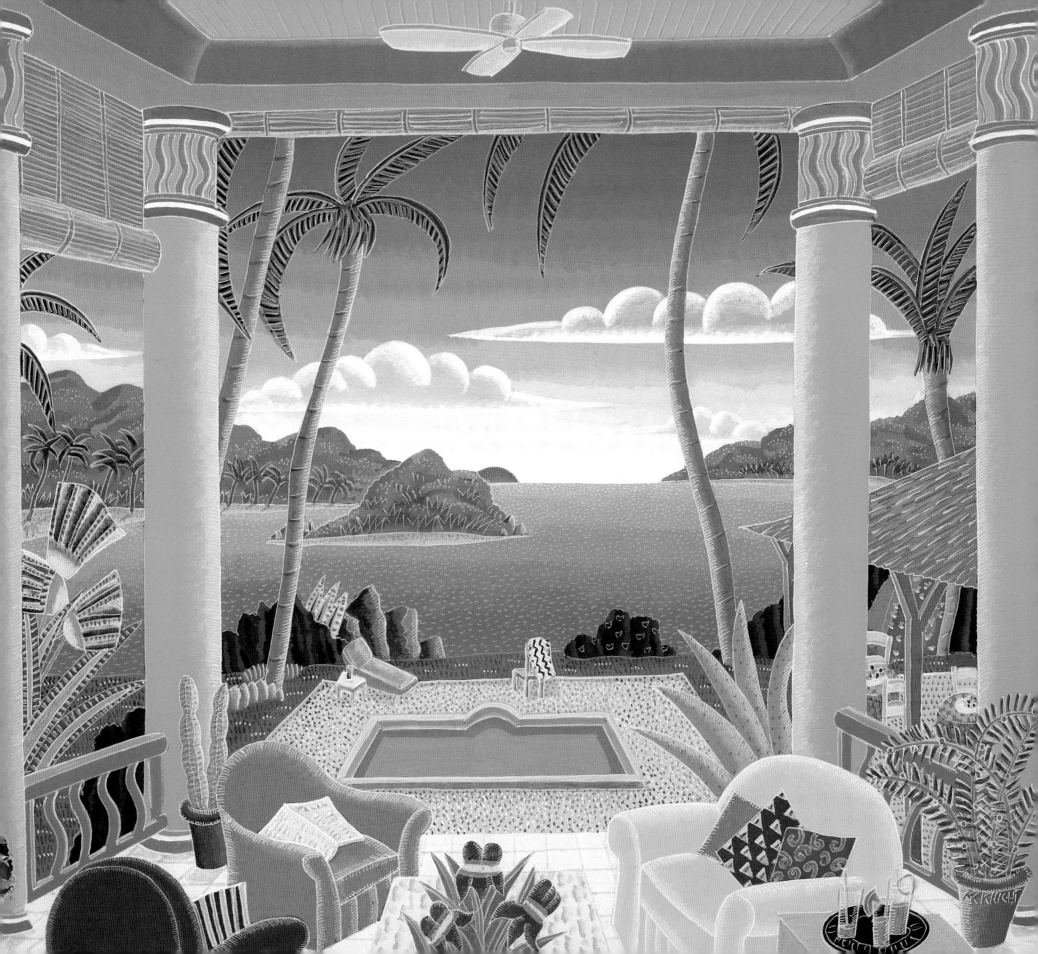

Now, on our return journey, the resonance between ancient Greece, Renaissance Italy, and our own tropics is much richer. The beachside houses McKnight paints are not just pretty places set in a bright, amnesiac present; they are beginning to *remember*, and memory is the deep reservoir that sustains soul. I once stood beside a tiny oceanarium pool in which there lived a large captive orca, or

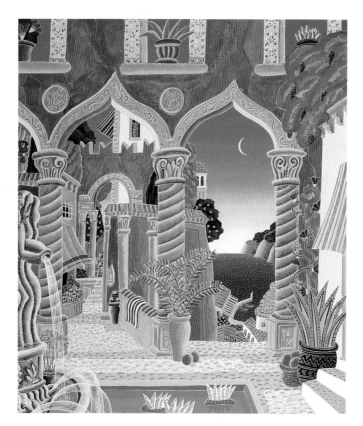

MOORISH GARDEN

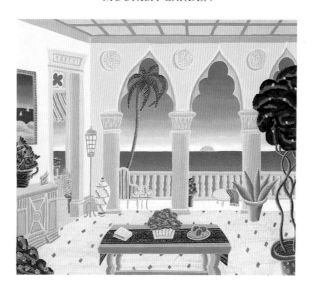

VILLA LAGUNA

killer whale, while an activist who was fighting for its freedom told me, "Imagine being an animal that is used to sending out a sonar beam and getting back echoes of the whole boundless ocean and all its life forms. Now I put you alone in a small cement bowl, where all you can hear is the reflected jabbering of your own voice. You'd go mad." That animal is the soul trapped in

a box-shaped house in a moderate-income development in the suburbs. No depth, no echoes. McKnight paints houses that have echoes centuries deep in the arches of their windows, the columns of their porches, the colors of their walls, the tile of their floors. You can see that the echoes are fainter, less fully conscious, than the well-loved and richly elaborated memories

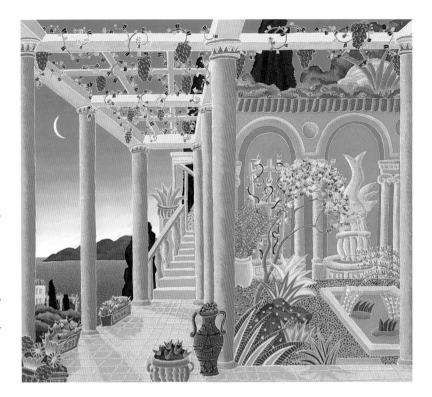

ANCIENT GARDEN

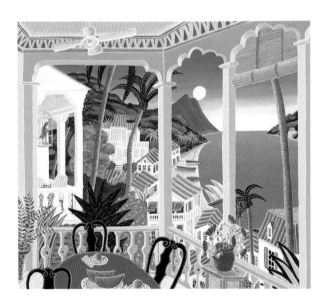

TROPICAL PORCH

worked into Mediterranean gardens. But they are there, answering our call for beauty with deeply familiar forms: arch and column and spiral, an alphabet the soul can still read. These shapes spell out the silent, eloquent scriptures of our alternative tradition, proclaiming pleasure as a sacred response to the world. The sanctuaries of that tradition today are our places of play and leisure.

207

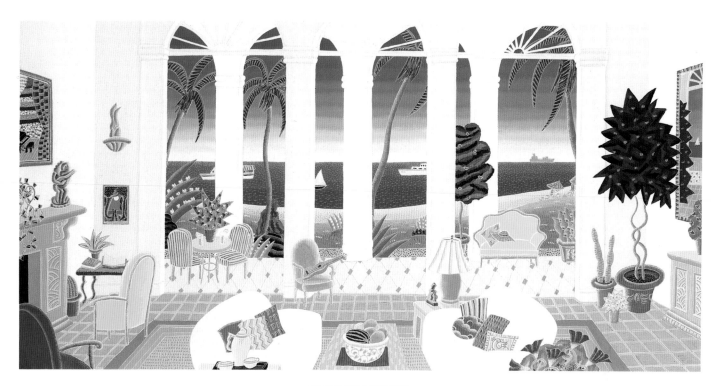

GULF OF MEXICO

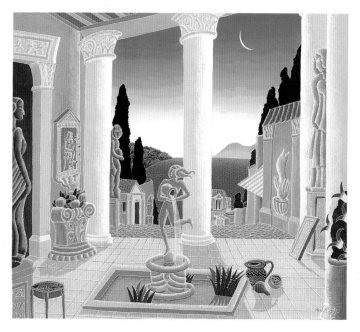

ANCIENT PINK COURTYARD

ANDALUSIAN POOL

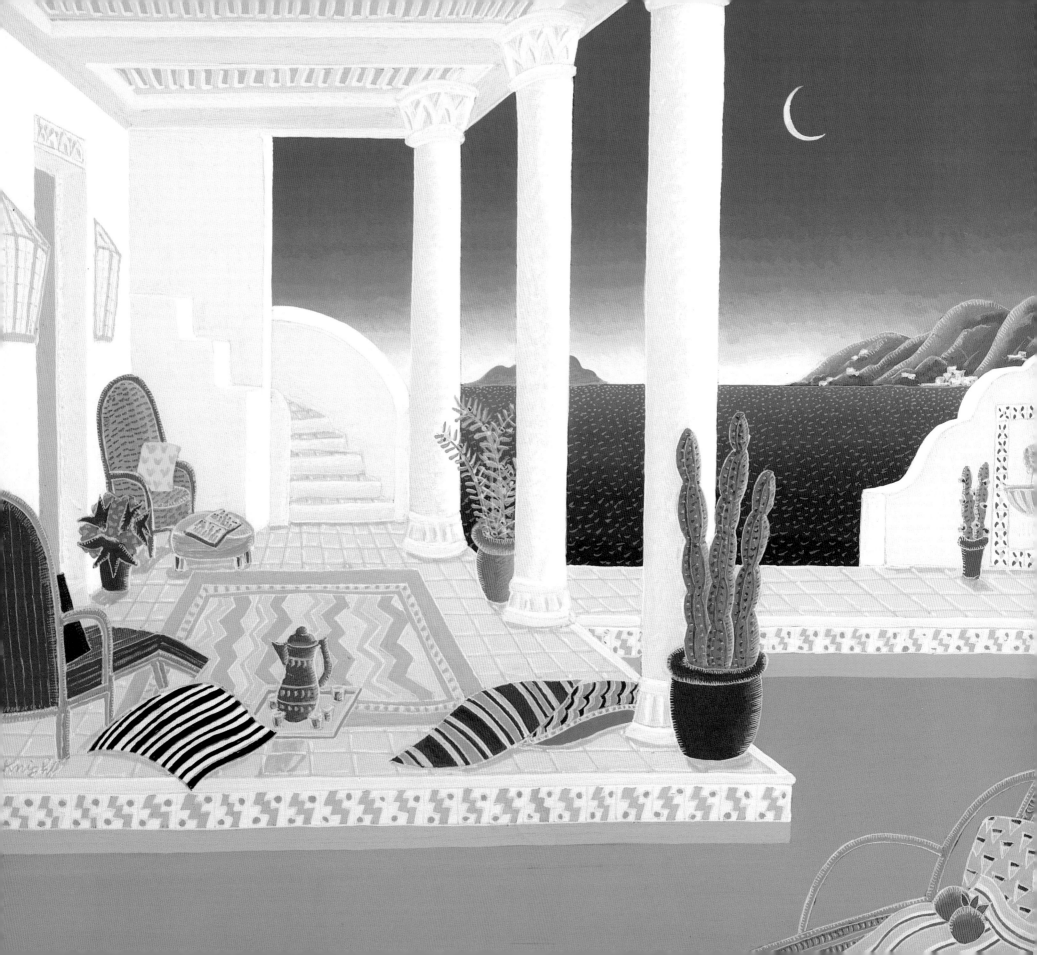

And so, in McKnight's view, even a golf course can echo a temple. Beyond these temple pillars stretches a prospect of nature severely stylized by art and laid out to represent the "course" of life. It is a sort of Pilgrim's Progress, each hole a fresh challenge to our skill, each sand trap a Slough of Despond. The deftest players of this game of life get through it with the fewest strokes and stay calm when they get stuck in the sand. They have what scientists call "elegance": the ability to solve a problem by the simplest, most direct, and economical path. Most games have ceremonial origins—cards began as oracles, the Aztecs played solar handball on calendrical stone courts—and they still satisfy as little rehearsals of the adventure- and obstacle-ridden journey of life. On this course, the journey ends where our voyage began: at the lighthouse, overlooking the whole story, signaling us in to a safe return.

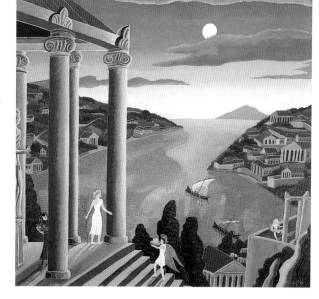

CLASSICAL FABLE

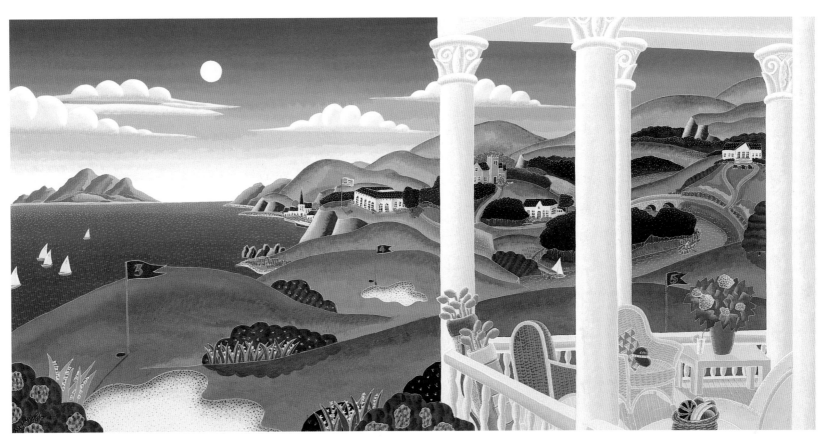

SEASIDE GOLF

RHODE ISLAND GOLF *(overleaf)*

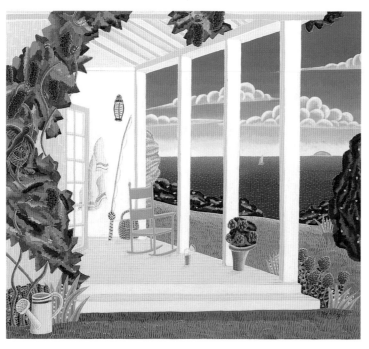

MADAKET, NANTUCKET

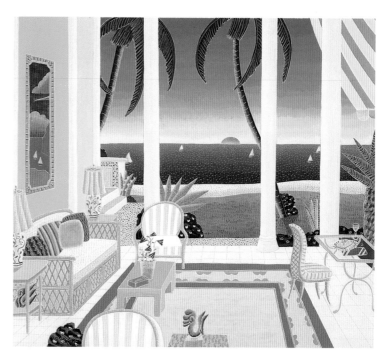

VILLA APOLLO

We will know, now, rocking on a friend's porch by the sea, that we are in a temple. Wherever a dwelling has been made beautiful, in a way that opens and breathes in the beauty around it, we will know that the gods have been invited, and we will feel them come near. We will experience the sacred, not as a blinding light on the road to Damascus, but as "the luminosity of daily life, simple and basic," in the beautiful words of psychologist Ginette Paris.

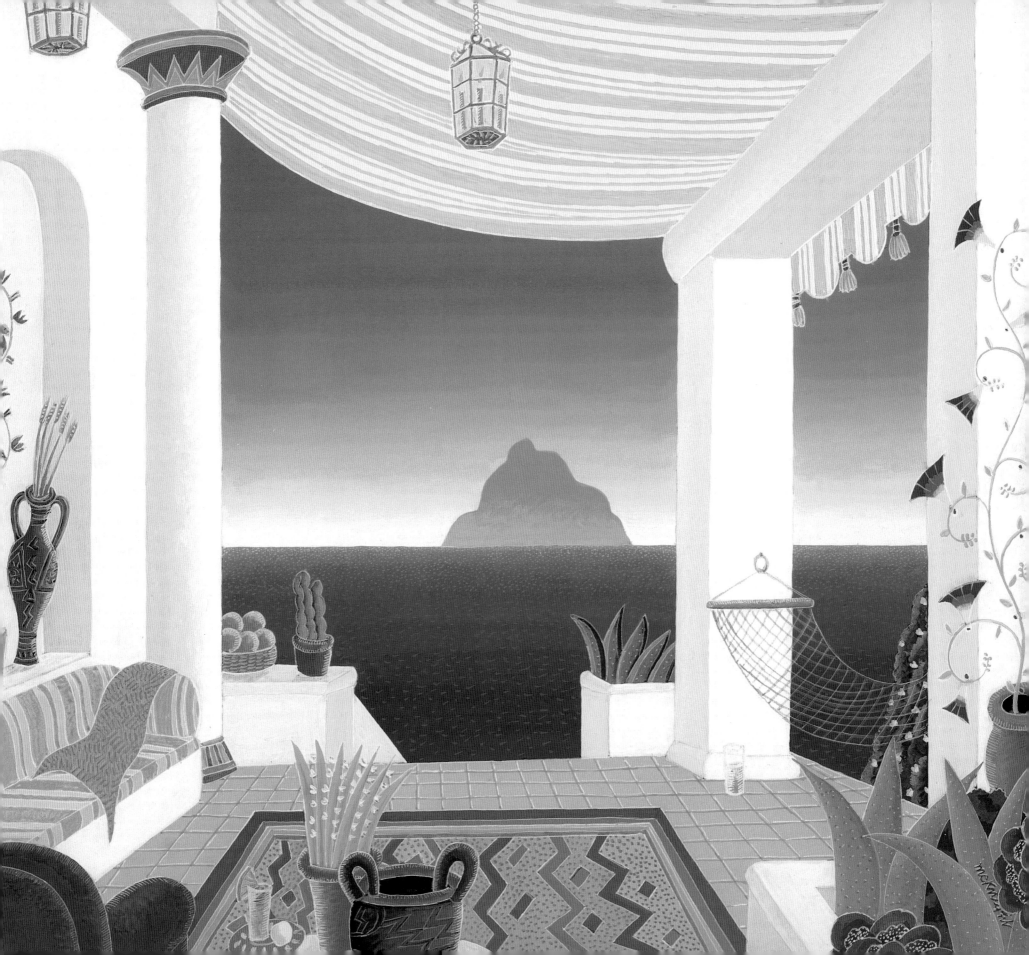

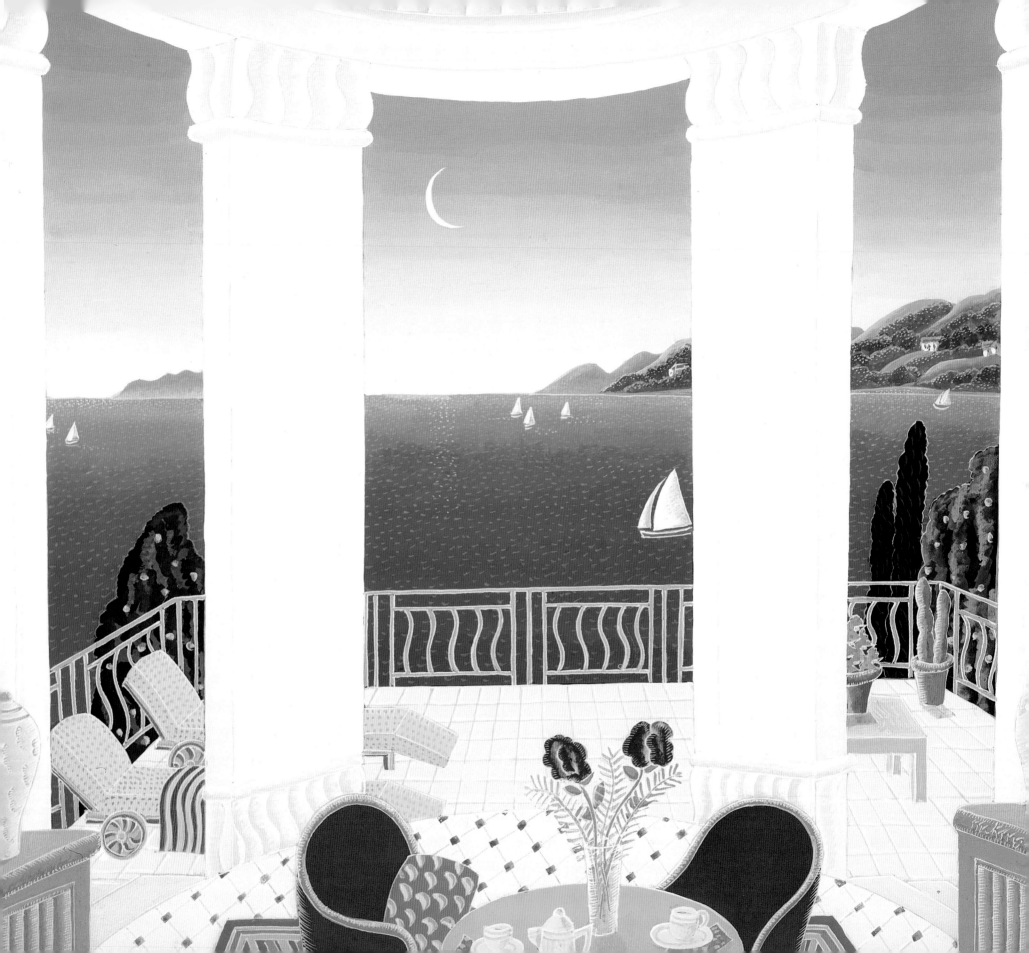

If that experience has grown as rare as Athena's shy spotted owl, in this "real world" of airports, strip malls, polyester-carpeted condos, and other hideous spaces the gods have fled, we can still find it here. Thomas McKnight's imagination is a refuge for endangered beauty, where perhaps, like the whooping crane, it can multiply and gain strength to reinhabit the world. For being a guest in these spare modern "temples" awakens the longing to make our own living spaces more beautiful. And that in itself is a sign that the gods are returning. Their salutation is, "You would not be looking for me if you had not already found me," says Ginette Paris. "Aphrodite lends you the eyes for you to recognize her."

Here, in a haiku for the eyes, is the barest of temples to Aphrodite. Can you find her?

> *High noon.*
> *As still as the pool*
> *So storm-tossed the bed.*

POOL WITH ISLAND

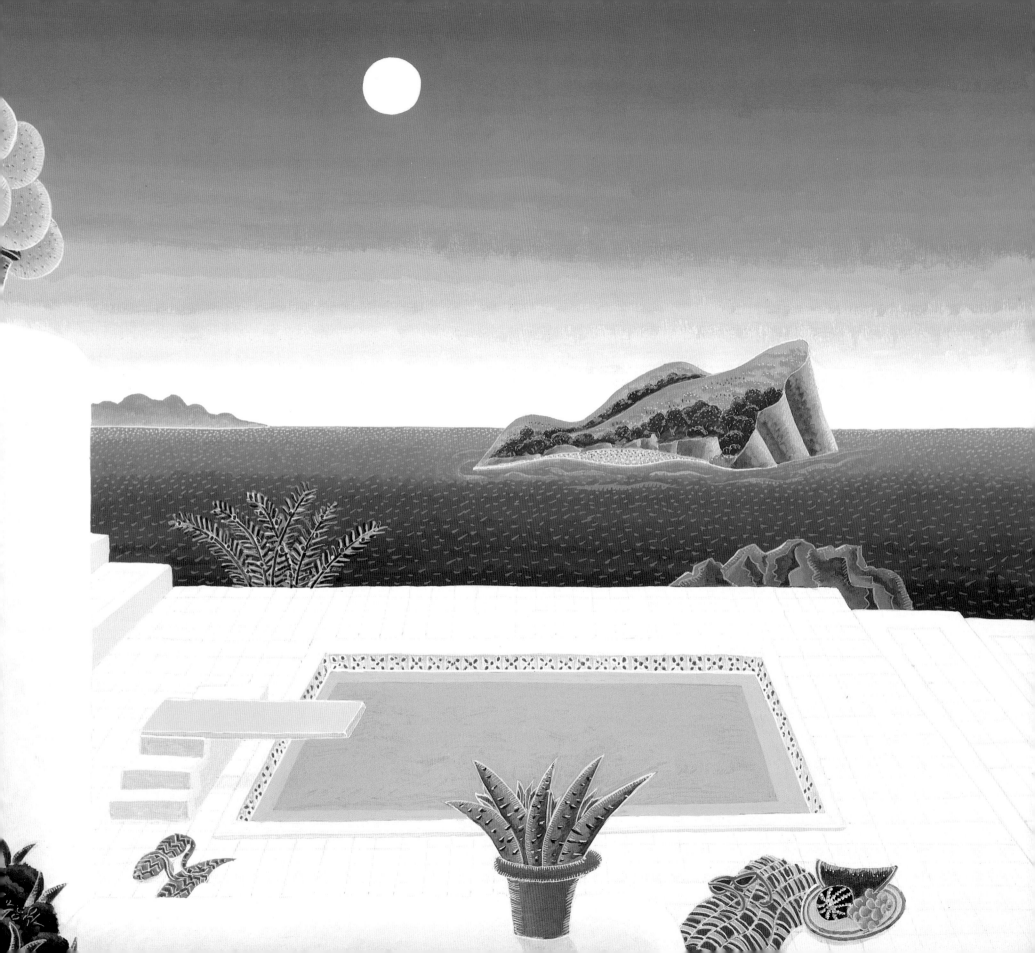

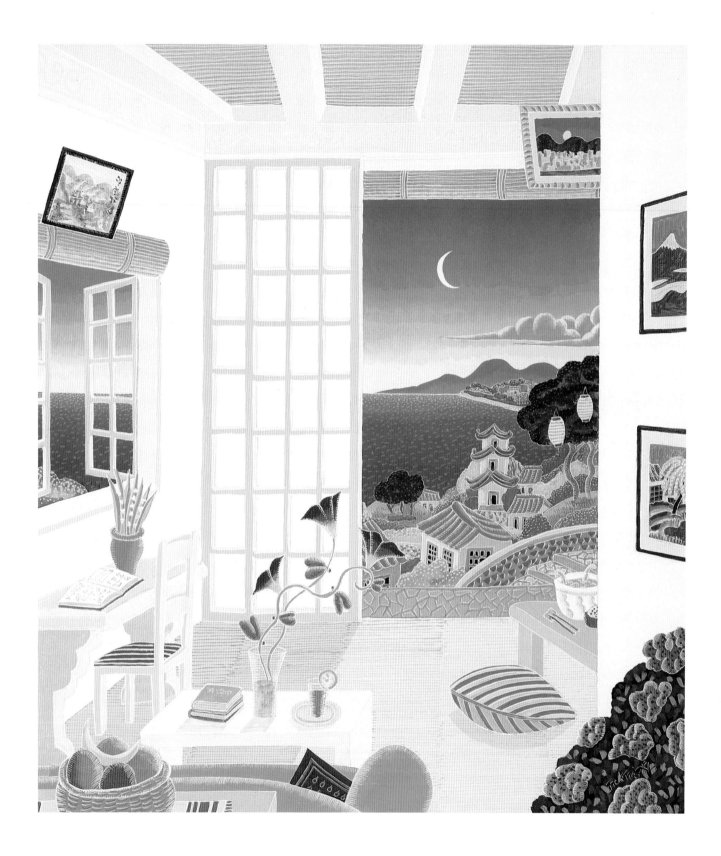

OLD JAPANESE ROOM

Through the Looking Glass

Your ordinary mind—that is the Way!
—Zen saying

While many Westerners have traveled to the East in search of paradise, that was not the tropism of Thomas McKnight's journey. His led south, down through the strata of time into the mythic roots of our own culture. But like the child's belief that if you dig down far enough you'll come out upside-down in China, this quintessentially Western journey has landed McKnight in Japan. The pursuit of some image, idea, or technique did not lead him eastward; rather the Japanese came after him. McKnight's work is wildly popular and deeply cherished in Japan. This year he was asked to be the official artist for the modern port city of Kobe's 1993 festival.

Why? What in this artist's style and vision has struck a nerve on the other side of the earth? It's not just a Japanese enthusiasm for all things Western. On the contrary, it seems to be a very discriminating response, the perception of an affinity. After all, the people that invented haiku and the tea ceremony are connoisseurs of "the luminosity of daily life, simple and basic." I suspect that the Japanese instantly grasp and consciously appreciate aspects of McKnight's work that we in his own country feel without knowing why. "Tell him," said a friend who owns several prints, "that he's made a major contribution to my psychological well-being." We know these pictures make us feel good, but we can't articulate a motive for putting them on our walls beyond interior decoration at its best. Many Japanese people hang a McKnight print in their *tokonoma*, the little alcove that serves as a kind of aesthetic altar for the home, and that traditionally holds a seasonal scroll, or a flower arrangement, or both. That means that these images are meeting the world's most refined and time-tested standards for moving the soul through the eyes.

In Japan, says art critic Donald Richie, who has lived there for over forty-six years, "The visual is not taught, it is known—it is like having perfect pitch." The spatial sense is equally well developed; the Japanese traditionally knew how to strike inner chords by the placement of a building or the proportions of a room. You can walk into a temple in the middle of a roaring city and feel travel stress and jet lag being lifted from you by . . . what? Some force welling up from the earth that guided the choice of this spot? Some restorative ratio in the design of the space? I think the Japanese recognize McKnight as a Western practitioner of that same art, an art not of decoration or distraction, but of healing.

My karate teacher once told me that many things in Japan appear backwards to Americans, and vice versa. We carry our babies in front, they carry theirs on their backs. The way we wave "bye-bye" says to a Japanese, "Come here!" Even our journeys seem to lead in opposite directions: they, the tradition-bound society, are hurtling eagerly into the future, while we, humanity's youngest child, are nostalgia-stricken. Maybe, looking at each other in this reversing mirror, we each see the lesson we need. What we see in Japan is a high civilization that never cut its roots in nature, or left its gods behind . . . until now. What Japan sees in us is the power—and the despair—of a culture that made

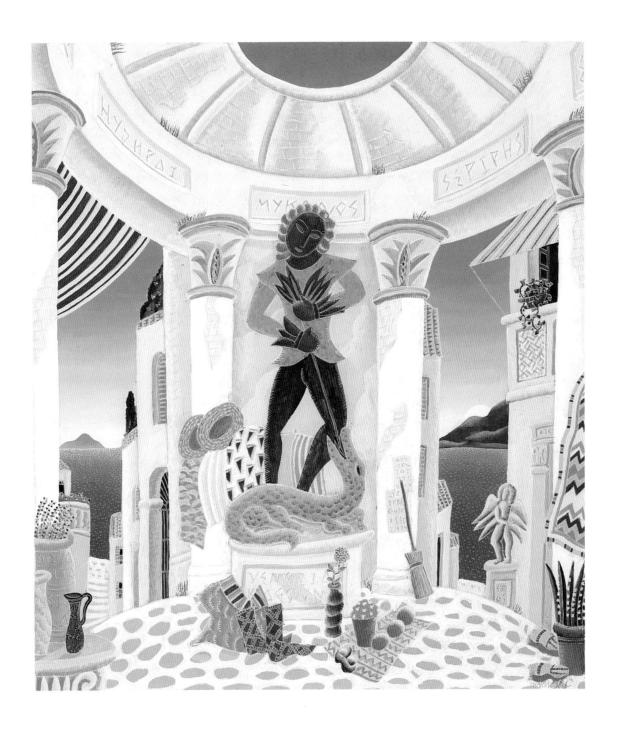

ANCIENT DRAGON SLAYER

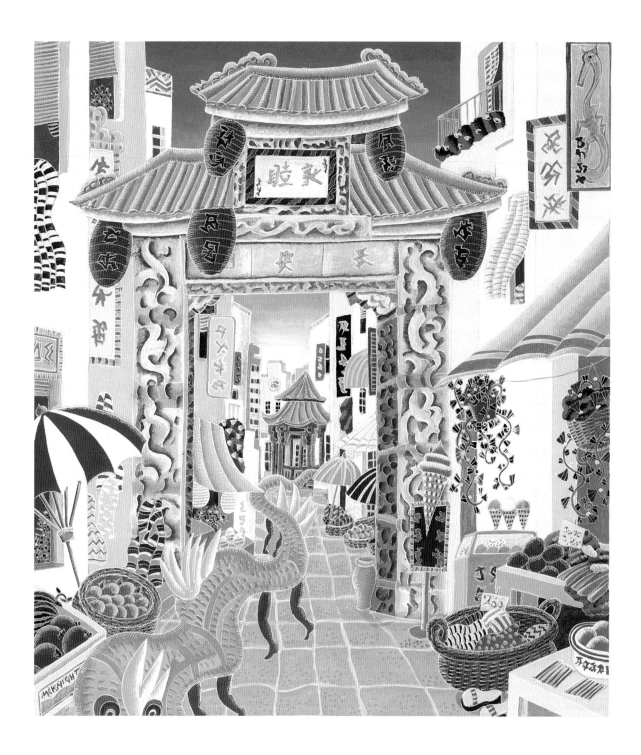

CHINESE GATE, KOBE VARIATIONS

that choice many centuries ago, and is now struggling in the coils of the consequences.

A lively troupe of gods and other "people of the imagination" accompanied the Japanese up to and across the threshold of the modern age. In ancient Shinto, Japan's native religion, the word *kami* meant both "the sacred," a spirit permeating the world, and "the gods," a multitude of particular spirits. The oldest surviving Shinto prayers refer to wind deities and rice deities, a food goddess, a fire-pacifying festival, and a deity of the sea straits who turned into a cormorant (a bird whose graceful bow of the neck was considered a model for human humility). Most of these gods started out as locals, associated with a particular mountain or waterfall, allied with a particular clan. As the clans federated and then came under the rule of an emperor or empress descended from the sun goddess, hundreds of independent local gods were gathered, grumbling, into a pantheon, subordinated to the "Sovereign Grandchild of the Heavens," but soothed with elaborate ceremonies if they stirred up storms or disease. The much more abstract religion of Buddhism, introduced into Japan from China in the fifth and sixth centuries A.D., did not drive out the local gods but coexisted peacefully with them, sometimes merging bodhisattvas with Shinto deities, just as Christian saints fused with pagan gods and goddesses.

But Christianity was intent on exterminating the old gods, and they could survive only in deep disguise. The sophisticated tolerance of Buddhism allowed the nature spirits to thrive well into the twentieth century. It's telling that in Western fairy tales, the dragon is always a monster to be killed, while at Asian festivals he is the guest of honor, invited to dance through the streets, showering blessings. R. H. Blyth wrote that "waterfalls, great trees, deer, monkeys, pigeons, tortoises, crows, and many other creatures are sacred at various shrines" in Japan.

When I first visited, you could go to a shrine in a modern metropolis, tug a thick bell-rope to get the god's attention, make a respectful request, and buy a tiny brocade bag containing a written charm to protect you on your journey. A friend pointed to the stone foxes on the gateposts of a Shinto temple and sang out, "Like angel, fox, in Japan!" The Western visitor saw a seamlessness in Japanese life, a consoling continuity between traditional and modern, the natural and the human. You could live in the thick of the twentieth century and still have foxes for angels, and still perform the small acts of daily life as ceremonies, "re-minded" each time by the beauty of the ordinary objects you held in your hands.

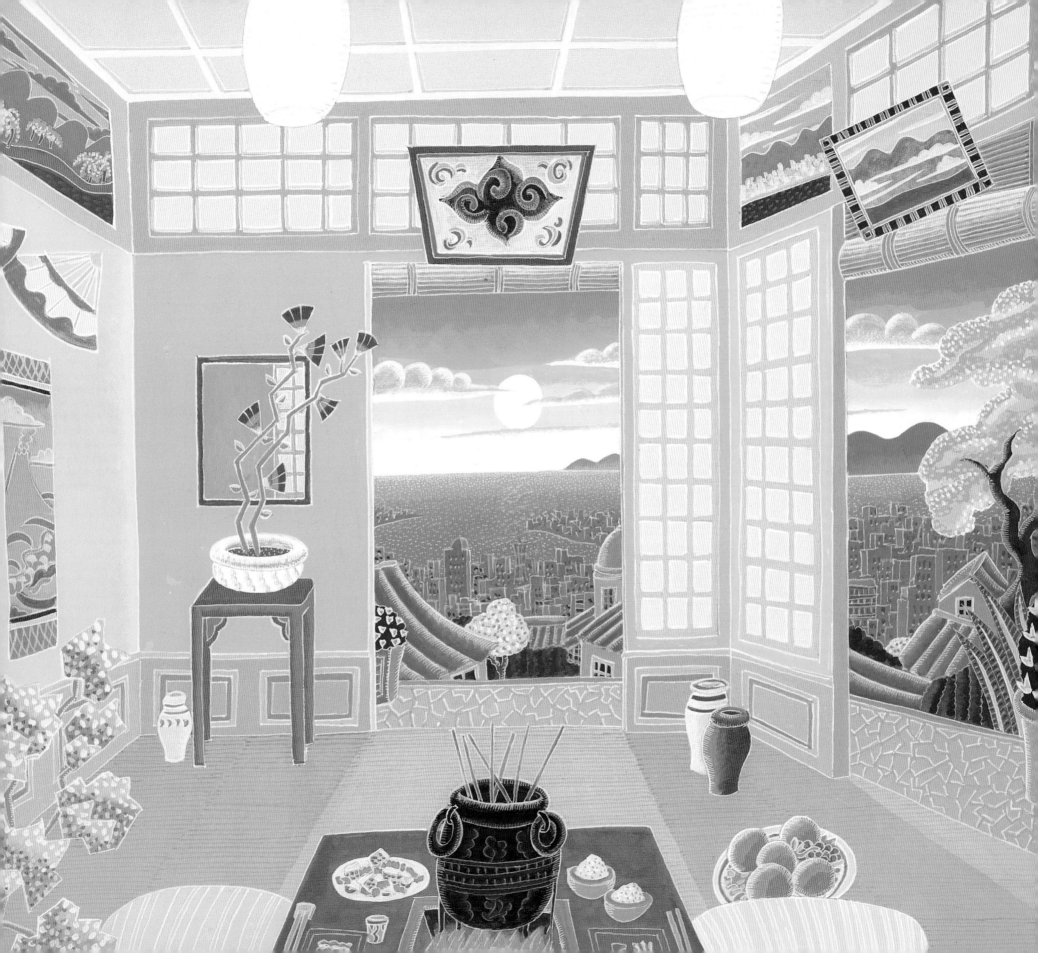

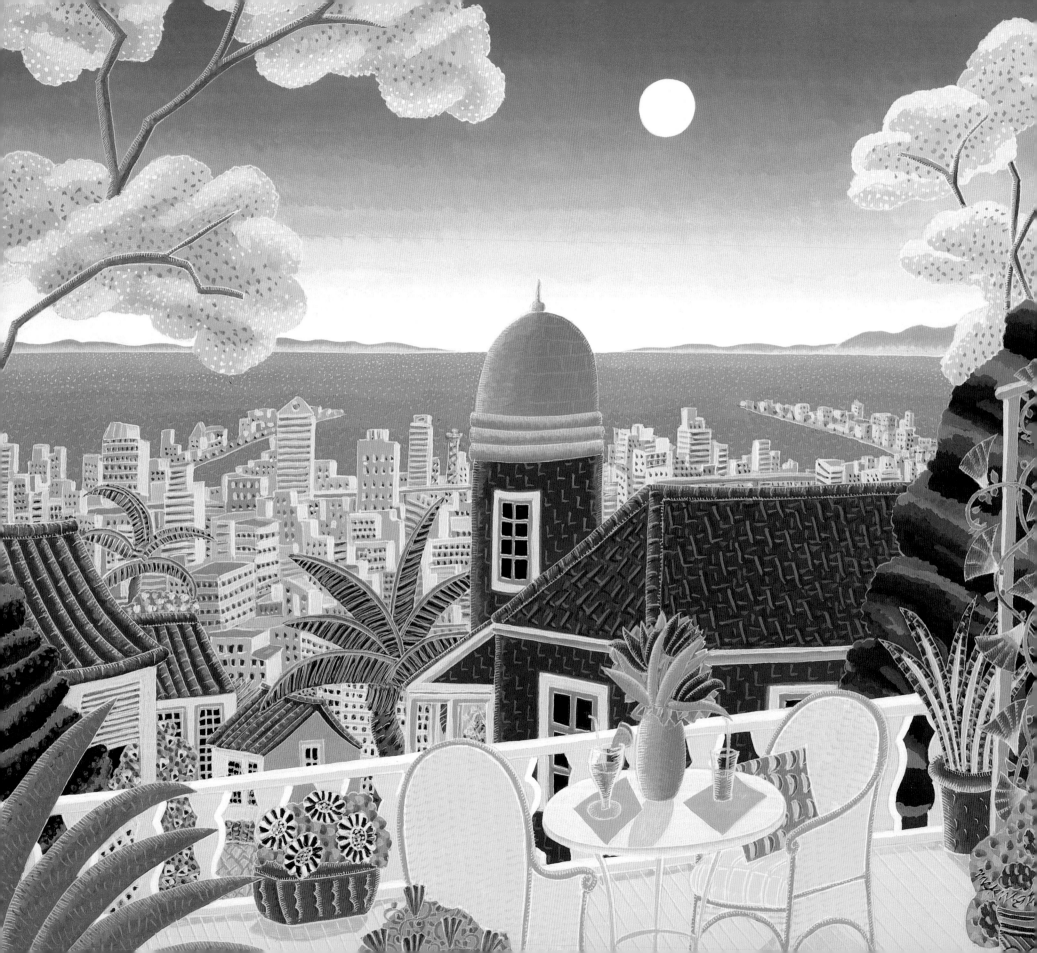

But can that seamlessness survive the accelerating modernization that is driving more and more Japanese into smaller and smaller city apartments, and flooding their lives with Western styles and conveniences? Few Japanese deplore this trend; they're less sentimental about their traditions than we are. The people of Kobe, for instance, take pride in their city's shining white

WINTER ROOM, JAPAN

modernity and cosmopolitanism. Founded as a port for world trade after Japan opened its doors in 1868, Kobe is an interface, a modem, a city whose very identity is built on communication and interchange rather than purity and isolation. One of its favorite landmarks is this nineteenth-century European merchant's house, a site of pilgrimage for romantic young girls ever since a TV miniseries dramatizing the story of a Japanese woman's marriage to one of the traders was filmed here. This city's romance is with the wide world, not the narrow past. Kobeans are impatient with Thomas McKnight's attempts to paint the paradox of traditional and modern in their city. The images they love best are the ones that show the pure twenty-first-century dynamism of Kobe. It is not the persistence of stone foxes and wooden temples, but the incredible mastery of the modern idiom in one century that they claim as essentially Japanese.

KITANO TERRACE

PORT ISLAND PANORAMA, KOBE VARIATION (overleaf)

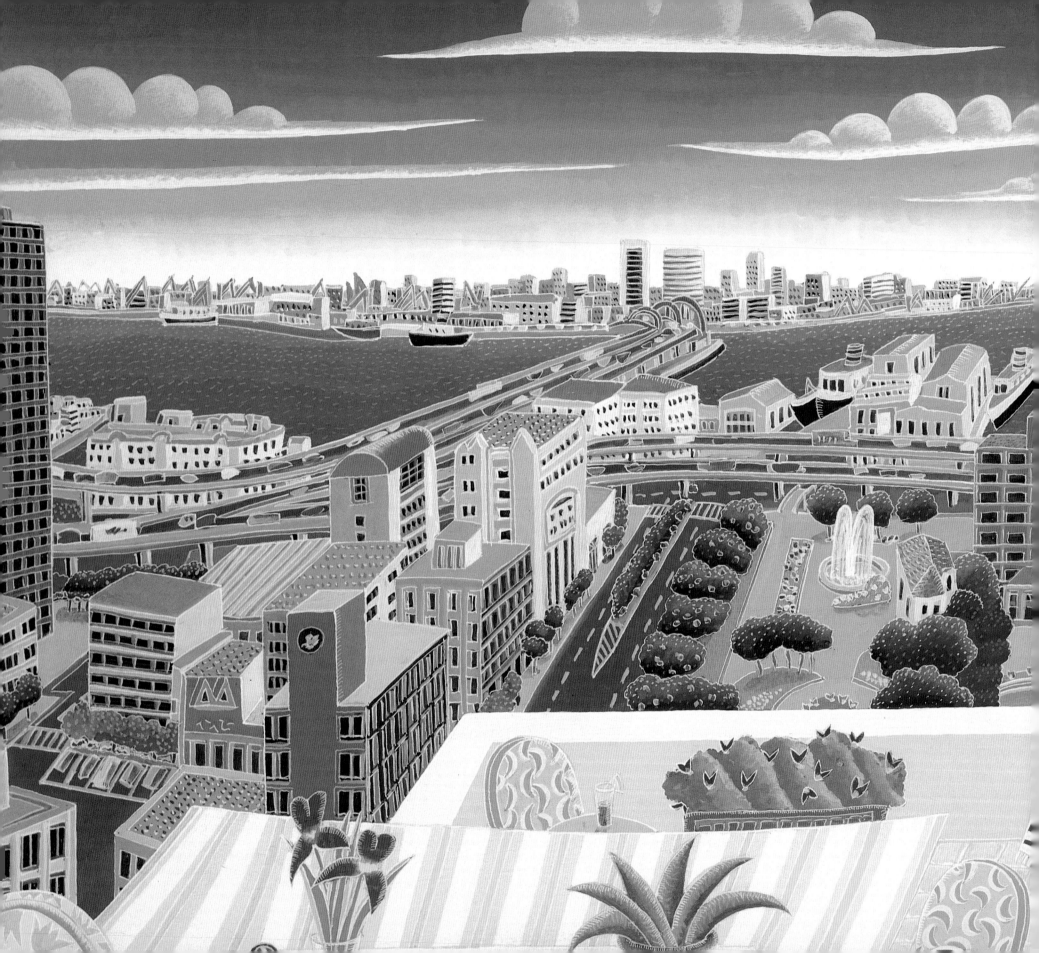

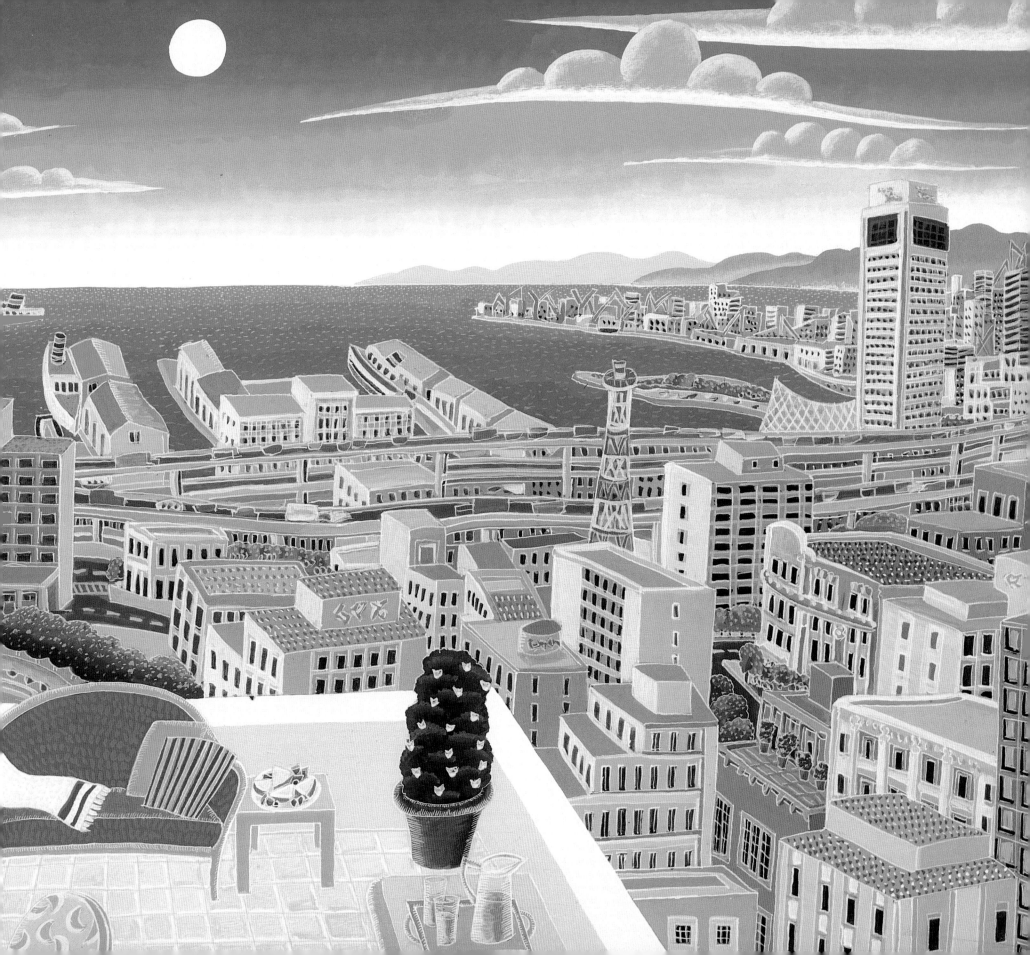

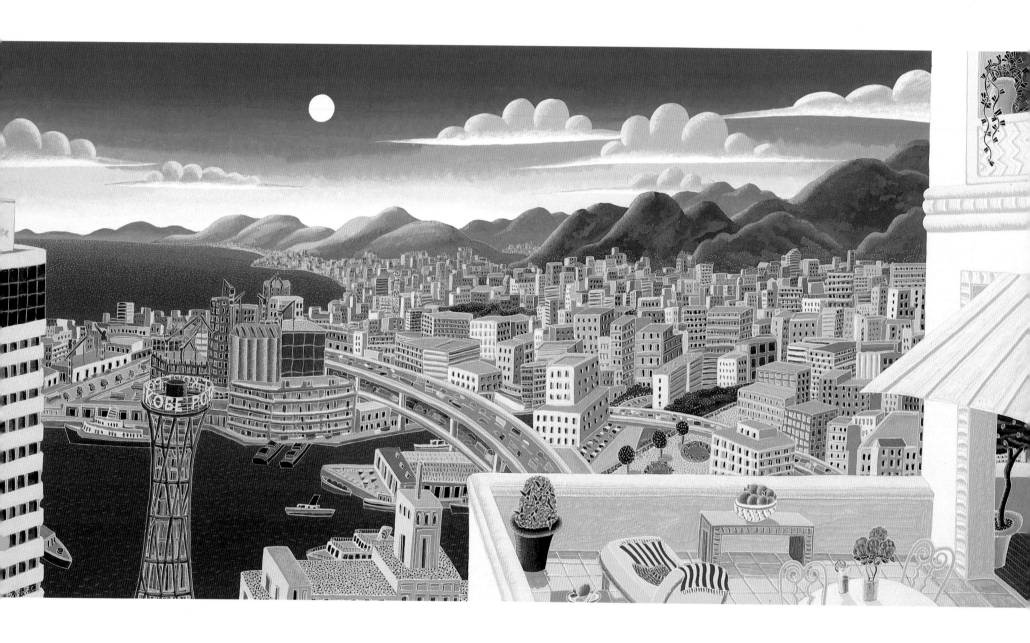

PANORAMA WEST, KOBE

Yet the emblem of the city of Kobe is a flower. On official buildings and cars, where we would put a martial coat-of-arms, is a purple-blue hydrangea blossom. The city is ideally sited according to the ancient principles of *feng shui*, with its back protected by "dragon hills," and facing a curving amphitheater of sea. And in each of the million tiny apartments whose windows McKnight so painstakingly paints (appealing to the Japanese taste for bold shape and intricate detail) is an alcove with "a tiny tree, a flowering branch, a solitary bloom" (Donald Richie). There is little space for gardens in urban Japan, but devoted amateurs show millions of flower arrangements at monthly ikebana shows. "My wife does flower arranging," a Japanese psychologist told an American audience, "and when I come home, I can tell how she is feeling." Nature and human nature are still intimate, the hand and eye still confident of their "response-ability" to the flower. The Japanese are barely a generation past the balance point that Thomas McKnight had to journey back centuries to rediscover. But they are moving fast.

Even when McKnight celebrates the unsentimental vigor of a modern city, he frames it in hills and sea and sky. In fact, view and frame are reversed now: man is the uncontrollable wild energy, while nature's ultimate constraints give form and beauty. It is a twist that the Japanese, as seasoned collaborators with nature, can appreciate: now we are the weeds that need arranging by the severe hand of the gods. And when we come home, we will know how they are feeling, in the *tokonoma* of our hearts and the complexion of the skies.

Souvenirs of the Journey

We bring back from our travels things that will bring our travels back to us. *Souvenir* means, literally, memory; a toy boat's red sail brings back a moment in Mykonos when we fell through strata of time, and a small stone sphinx recalls an evening when an even deeper past opened, rustling. A souvenir is an object that contains, like perfume in a bottle or a story in a book, the whole essence of being in another time and place. It pokes a hole in Here and Now, so the soul can breathe.

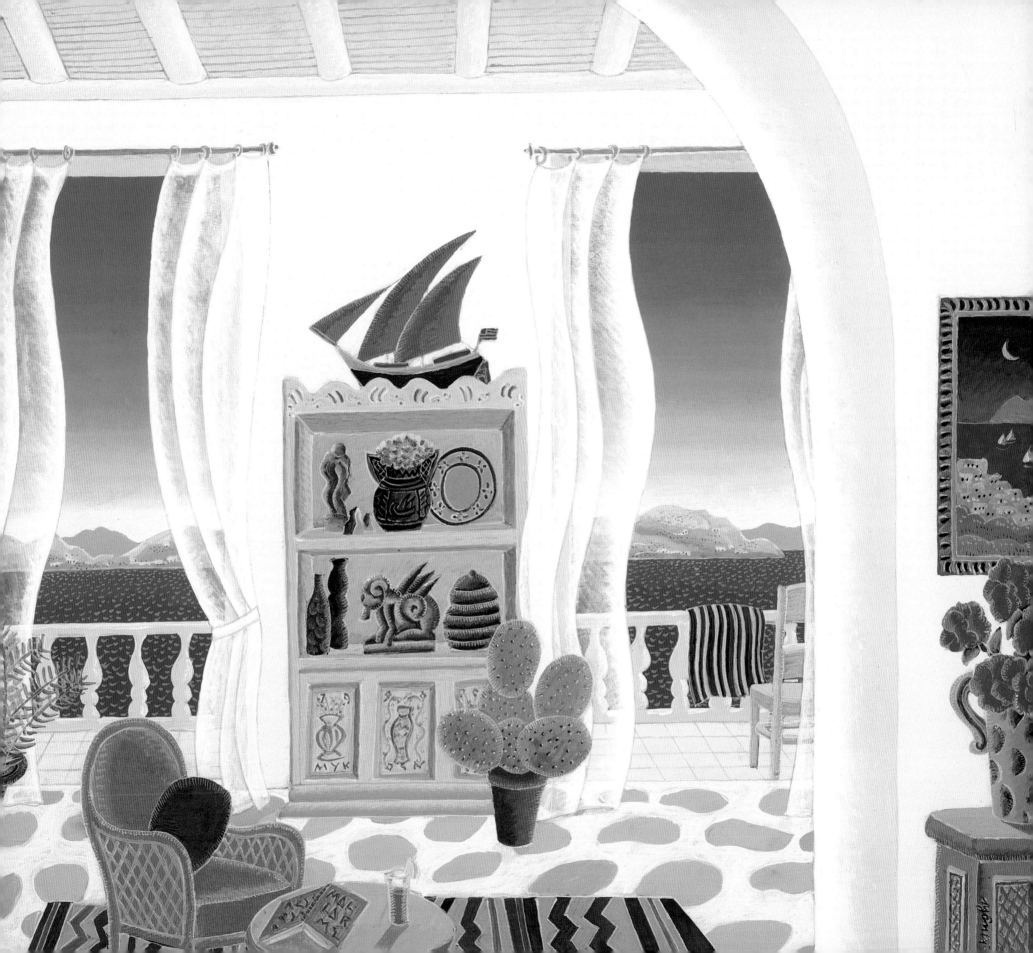

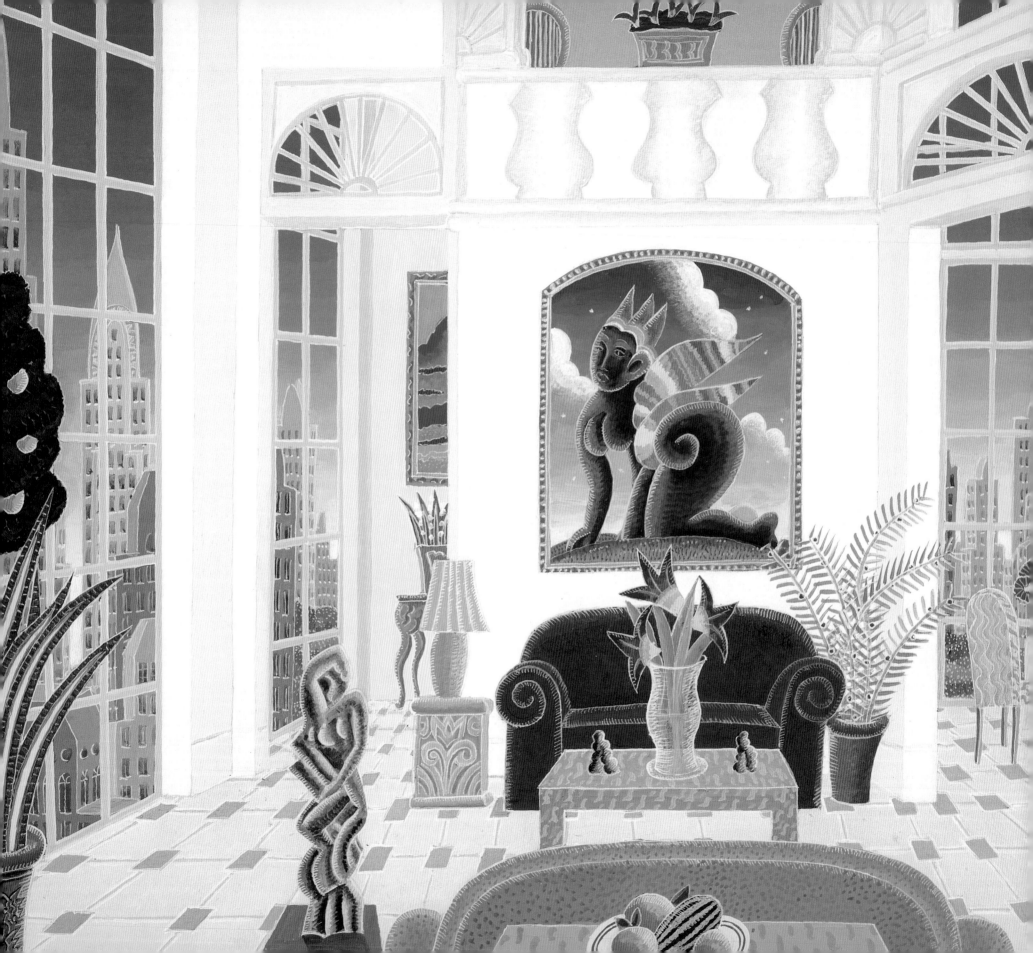

Home is not the same when we come back from a trip or close a book. Its walls have become transparent. New windows open onto other times and places and dimensions, at least as real as the physical view. Gods and nymphs are our near neighbors. The fire in the hearth is the same fire that savages danced around, that guided Odysseus ashore, that lived at the heart of every Greek home and city. "Hestia was

LEAMINGTON LIBRARY

present in the fire in the hearth. As guardian and queen of every household, even the humblest, she assured harmony and stability, peace and goodwill; her benevolence was extended to each guest and stranger who crossed the threshold." Yes, there is a goddess of Home—though perhaps today she lives in the kitchen. She also lives in the city: "Like the households, the cities possessed an altar where the holy fire of Hestia burned for everyman. The soul of the city took its spark from this fire, and each time a town set forth to found a distant colony, the sacred flame lit at the communal hearth accompanied the bold colonists." We are distant colonists of ancient Greece, and Hestia has come all this way with us. We have sometimes felt her presence even when we didn't know her name.

237

BOUTIQUE OF DR. CALIGARI

CHELSEA DEPARTMENT STORE

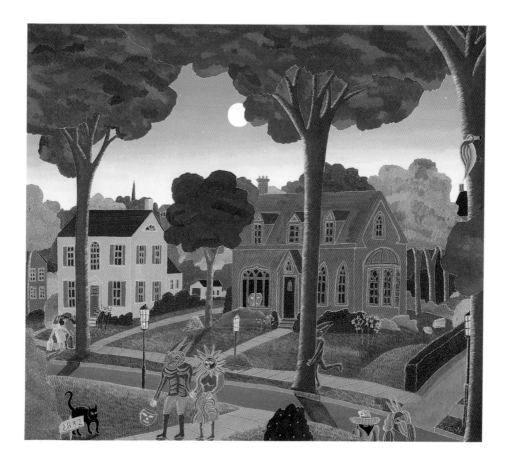

There are many presences around us, always. The gods and little people are our constant companions, though we open the eyes to see them only in our dreams. Small children are aware of them in broad daylight; adults walk right past without looking. But a traveler becomes like a child again: it is the real goal of every voyage. Being in a strange place opens our dream-eyes, and if we are careful, and remember, when we come home they won't close again. "The real place is in the heart," Henry Miller wrote. Thomas McKnight's images remind us that paradise is in the eye.

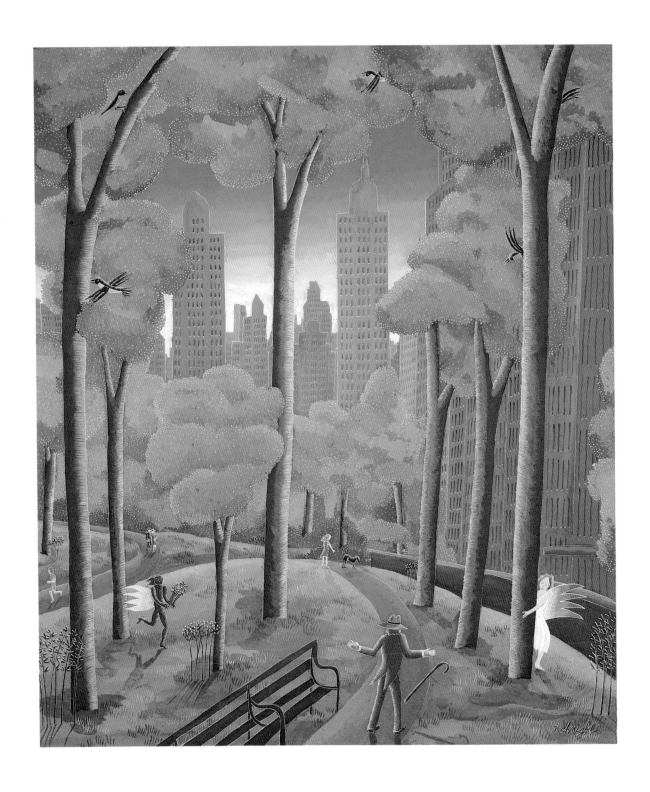

CENTRAL PARK SPRING

Notes

Unattributed quotations from Thomas McKnight are from personal
conversations with Annie Gottlieb, Spring 1992.

I. Where the Journey Begins

P. 19 THERE IS A MOVING AWAY: Jean Dalby Clift and Wallace B.
Clift, *The Hero Journey in Dreams* (New York: Crossroad, 1988),
p. 13

P. 23 YOU CAN STAY HERE: *The Book: An Introduction to the Teachings of
Bhagwan Shree Rajneesh* (Rajneeshpuram, Oregon: Rajneesh Foundation International, 1984), p. 653

P. 24 THERE IS A BIBLE: James Hillman, *Re-Visioning Psychology* (New
York: Harper & Row, 1975; Harper Colophon, 1977), p. 28

HOME IS THE PIVOTAL PURPOSE: Jean Houston, *The Hero and the
Goddess: The Odyssey as Mystery and Initiation* (New York:
Ballantine Books, 1992), p. 52

II. The Voyage Down

P. 30 A MAGNIFICENT YOUNG PALM TREE: Dore Ogrizek, ed., *The World
in Color: Greece* (New York: McGraw-Hill, 1955), p. 376

P. 43 VENTURING SOUTH: Hillman, *Re-Visioning*, p. 223

"SOUTH" IS BOTH AN ETHNIC: James Hillman, *Archetypal Psychology: A Brief Account* (Dallas: Spring Publications, 1983), p. 31

THE DIRECTION DOWN INTO DEPTH . . . DISTURBANCE: Hillman,
Re-Visioning, pp. 223, 260n

NOW THE OLD MAN WENT MAD: Lawrence Durrell, *Prospero's
Cell* (New York: E. P. Dutton, 1960), p. 20

P. 44 THE GREAT BRONZE AND MARBLE STATUES: Ean Begg, *The Cult of
the Black Virgin* (London and New York: Penguin Books, Arkana,
1985), p. 49

P. 47 THE PURITY OF THE SKY . . . WHAT I ENJOY MOST: Johann
Wolfgang von Goethe, *Italian Journey (1786–1788)*, trans.
W. H. Auden and Elizabeth Mayer (San Francisco: North
Point Press, 1982), pp. 26, 282–83

THE LITTLE EARLY GRAPES: Durrell, *Prospero's Cell*, p. 101

P. 51 AN ETERNAL SPRING . . . FISHING FROM THE WOODEN BOATS: *The
Berlitz Travellers Guide to Northern Italy and Rome 1992* (New York
and Oxford: Berlitz, 1992), pp. 553, 555, 567

P. 52 THE EIGHTEENTH-CENTURY NEAPOLITAN: Thomas McKnight,
Thomas McKnight (New York: Hugh Lauter Levin Associates,
1984), p. 50

P. 55 MEDIEVAL CONCEPTIONS OF GOOD AND EVIL: Linda Fierz-David,
The Dream of Poliphilo (Dallas, Tex.: Spring Publications, 1987),
p. 4

WE SEE HOW THIS MAN: Giordano Bruno, *The Expulsion of the
Triumphant Beast*, trans. A. D. Imerti (New Brunswick, N.J.:
Rutgers University Press, 1964), p. 70

P. 56 SINGLE VISION: William Blake, letter to Thomas Butts, 22 November 1802, *The Poetry and Prose of William Blake*, ed. David V.
Erdman (Garden City, N.Y.: Doubleday, 1970), p. 693

IDEAS HARDENED LIKE THE SHELLS: Robert Harbison, *Eccentric
Spaces* (New York: Knopf, 1977; Avon, Discus, 1980), p. 77

THOSE HALE OLD DOGES: Mary McCarthy, *Venice Observed* (New
York: Harvest, Harcourt Brace Jovanovich, 1963), p. 16

P. 57 A TRANSITION BETWEEN TWO ERAS: C. G. Jung, foreword to
Fierz-David, *Dream of Poliphilo*, p. xiv

AUTOBIOGRAPHY OF THE SOUL . . . JOURNEY THROUGH MANY
REGIONS: Fierz-David, *Dream of Poliphilo*, pp. 1, 11

P. 58 THE UNMISTAKABLE, FASCINATING ORIENTAL: *Berlitz Travellers Guide
to Northern Italy*, p. 347

SPREAD LIKE THE CYCLADES . . . CARNIVAL THAT LASTED HALF A
YEAR: McCarthy, *Venice Observed*, pp. 5, 7

P. 61 DURING THE DAYTIME: Goethe, *Italian Journey*, pp. 71, 87

P. 62 A CARNIVAL BELONGED . . . THOSE MASKED PEOPLE: Marie-Louise
von Franz, *The Golden Ass of Apuleius* (Boston and London:
Shambhala, 1992), p. 54

P. 65 NOTHING CAN BE SAID HERE: McCarthy, *Venice Observed*, pp. 12,
13

P. 66 IT IS AN ENDLESS SUCCESSION: Ibid., pp. 11, 12, 13

THE LIGHT IS SO CONTINUOUSLY: Harbison, *Eccentric Spaces*, p. 60

P. 71 GOOD NIGHT! WE NORTHERNERS: Goethe, *Italian Journey*, p. 73

PASTEL SWEET BY DAY . . . OPEN ONTO TERRACES: *The Berlitz Travellers Guide to Southern Italy and Rome 1992* (New York and Oxford: Berlitz, 1992), pp. 202, 204

FIRMLY BELIEVES THAT HE LIVES: Goethe, *Italian Journey*, pp. 174–75

P. 72 SICILY IS MYSTERIOUS . . . SITUATED WITH THE GREEK GENIUS: Barbara Coeyman Hults in *Berlitz Travellers Guide to Southern Italy*, pp. 253, 275, 276

EMPEDOCLES OF AKRAGAS: Ibid., pp. 282–83

P. 75 THIS NATURAL PHENOMENON: Goethe, *Italian Journey*, p. 133

P. 76 SOMEWHERE BETWEEN CALABRIA: Durrell, *Prospero's Cell*, p. 11

P. 78 THE PRISMATIC HEART: Lawrence Durrell, *The Greek Islands* (New York: Viking Press, 1978; Penguin Studio, 1980), p. 216

OUT OF THE SEA, AS IF HOMER: Henry Miller, *The Colossus of Maroussi* (New York: New Directions, 1941), p. 13

THE PRESENCE OF SO MANY: Durrell, *Greek Islands*, p. 216

THE SUBLIMINAL THRESHOLD: Miller, *Colossus of Maroussi*, p. 153

P. 80 GREECE IS NOW, BARE AND LEAN: Ibid., p. 48

THE ISLAND GREECE . . . THE HEART: Durrell, *Greek Islands*, p. 227

PEOPLE . . . WHO FIND ISLANDS: Lawrence Durrell, *Reflections on a Marine Venus* (New York: E. P. Dutton, 1960), p. 15

SMOKE-GREY VOLCANIC TURTLE-BACKS: Durrell, *Prospero's Cell*, p. 12

MEDALLIONS OF PLACE: Durrell, *Greek Islands*, p. 227

IS TO BECOME AWARE OF THE STIRRING: Miller, *Colossus of Maroussi*, p. 56

P. 82 GREECE IS THE HOME OF THE GODS: Ibid., p. 235

THEN LETO CLASPED: cited in Durrell, *Greek Islands*, p. 238

REASON (APOLLO) IS AS IMPORTANT: Ginette Paris, *The Sacrament of Abortion* (Dallas: Spring Publications, 1992), p. 7

P. 85 POWER TO HER ARM: Durrell, *Greek Islands*, p. 249

P. 94 THERE IS NOTHING QUITE LIKE THIS: Ibid., pp. 228, 230

THE VOLUPTUOUS SHAPES . . . THE ARCHITECTURE IS OF NO SPECIAL TIME: Ibid., pp. 228, 230, 232

P. 97 EVERYTHING IS DELINEATED: Miller, *Colossus of Maroussi*, p. 146

P. 101 AT THE END OF EVERY GYRE: Durrell, *Greek Islands*, pp. 228–30

P. 102 THE TREMBLING AMETHYST . . . YOU SLEEP IN A COCOON: Ibid., pp. 226, 230, 231

THE SMALL CHANGE OF THE GODS: McKnight, *Thomas McKnight*, p. 44

III. The Voyage Back

P. 111 A BRUTAL INVASION: Jean Hatzfeld, *History of Ancient Greece* (New York: W. W. Norton, 1968), p. 25

P. 114 HUMAN SHAPE AND PASSIONS: Ibid., p. 85

P. 117 A HUNDRED STATUES OF THE SUN . . . IN THE SACRED PRECINCTS: Ogrizek, ed., *World in Color*, pp. 72, 74, 382

P. 118 EACH CITY AND EACH DISTRICT: Ibid., p. 81

P. 121 BUT EVEN GODS FALL: Ibid., p. 383

ONE OF THOSE SUDDEN EARTHQUAKES . . . ITS VERY FINGER: Durrell, *Reflections*, pp. 90–92

HIS ENTRAILS OF ROCK: Ogrizek, ed., *World in Color*, p. 383

THE MEN OF OLD: Socrates, *Philebus*, trans. R. Hackforth, *The Collected Dialogues of Plato*, ed. Edith Hamilton and Huntington Cairns, Bollingen Series LXXI (Princeton: Princeton University Press, 1961), p. 1092

THE COUNTRY OF MAGIC: Von Franz, *Golden Ass*, p. 47

P. 122 WHEN EVENING COMES: Durrell, *Greek Islands*, p. 241

P. 123 O WHAT A MIRACLE: Hermes Trismegistus, *Asclepius*, cited in Frances Yates, *The Art of Memory* (Chicago: University of Chicago Press, 1966), p. 147

MAN ASCENDS: Hermes Trismegistus, *Corpus Hermeticum X*, cited in R. A. Schwaller de Lubicz, *Nature Word*, foreword by Christopher Bamford (Rochester, Vt.: Inner Traditions International, 1990), p. 22

P. 125 A SPHINX OVER SIX FEET LONG: Ogrizek, ed., *World in Color*, p. 92

P. 126 I AM AT CORINTH: Miller, *Colossus of Maroussi*, pp. 57, 212

P. 128 RECOVER THE LOST: Deborah Lawlor, introduction to Schwaller de Lubicz, *Nature Word*, p. 63, back cover

P. 130 THE HUMAN FORM DIVINE: William Blake, "The Divine Image," in *Songs of Innocence, Poetry and Prose of William Blake*, p. 12

P. 132 THE HOMERIC VOCABULARY INCLUDES: Hatzfeld, *History of Ancient Greece*, p. 51

P. 134 REJOICED IN CONTINUAL FESTIVITY: Murry Hope, *Atlantis: Myth or Reality?* (London and New York: Penguin Books, Arkana, 1991), p. 132

P. 136 BEYOND THE PILLARS: Ibid., p. 51

BARBARIC SPLENDOR . . . THERE OCCURRED VIOLENT EARTH-QUAKES: Plato, *Critias*, trans. Ignatius Donnelly, cited in Hope, *Atlantis*, pp. 18, 24, 28, 29

NOWADAYS MAN THINKS: Rudolf Steiner, *Cosmic Memory* (San Francisco: Harper & Row, 1969), p. 43

IV. The Voyage In

P. 148 ARE YOU MORTAL: Homer, *The Odyssey*, trans. Richmond Lattimore (New York: Harper & Row, 1967), p. 106

THE DRY LAND OF REASONS: Thomas Moore, *Rituals of the Imagination* (Dallas: Pegasus Foundation, 1983), p. 106

THE SALTWATER BLOOD: Brenda Peterson, "Drowning," in *Living by Water: Essays on Life, Land and Spirit* (Seattle: Alaska Northwest Books, 1990), excerpted in *The Sun* 197 (April 1992), p. 18

P. 152 NARCISSUS IS ABOUT TO HAVE: Thomas Moore, *Care of the Soul* (New York: HarperCollins, 1992), pp. 59, 60, 61, 63

P. 156 OUT OF LIFE . . . SOMETIMES THE POOL MAY APPEAR: Ibid., pp. 63–64, 78, 80, 91

WATER OF TRANSFORMATION: Ibid., p. 62

P. 157 A FASTNESS OF THE HILLS: Robert Graves, *Mammon and the Black Goddess*, cited in Begg, *Cult of the Black Virgin*, p. 126

P. 158 IS A MINOR DIVINITY: Houston, *Hero and the Goddess*, pp. 221–22

P. 159 A SOLAR HERO . . . THE MOON MYSTERIES: Ibid., p. 82

VIEW[ED] THIS EPISODE: Ibid., p. 222, citing Charles H. Taylor, "The Obstacles to Odysseus' Return," in *Essays on the Odyssey: Selected Modern Criticism*, ed. Charles H. Taylor (Bloomington: Indiana University Press, 1963), p. 90

EFFORTLESSNESS: Houston, *Hero and the Goddess*, p. 222

P. 160 OF CERTAIN FISHERMEN OF METHYMNA: Pausanias, *Guide to Greece*, bk 10, cited in David Freedberg, *The Power of Images: Studies in the History and Theory of Response* (Chicago and London: University of Chicago Press, 1989), p. 34

COMPANION IN PARADISE: Houston, *Hero and the Goddess*, p. 229

ANIMA IS THE FUNCTION: James Hillman, *Anima: An Anatomy of a Personified Notion* (Dallas: Spring Publications, 1985), p. 129

WADING AT THE RIVER BANK: Hillman, *Re-Visioning*, p. 144

ANIMA IS MEDIATRIX: Hillman, *Anima*, pp. 129–31

P. 167 IF IT IS COMMON TODAY: Hillman, *Re-Visioning*, pp. 25–26

IMPERIALISTIC FANTASY . . . OUTLANDISH: Ibid., p. 26

P. 170 THE PSYCHE DISPLAYS ITSELF: Ibid., pp. 173, 181

P. 172 MAY ULTIMATELY NOT BELONG: Ibid., p. 177

THE BLACK SOUL OF THE WORLD: Victor Hugo on Lilith, cited in Begg, *Cult of the Black Virgin*, p. 35

ANCIENT TRADITION OF WISDOM AS BLACKNESS: Graves, *Mammon and the Black Goddess*, cited in ibid., p. 126

NATURE, THE UNIVERSAL MOTHER: Apuleius, *The Golden Ass*, cited in ibid., p. 61

A SELF-FERTILIZING VIRGIN: Ibid., p. 43

MORE THAN ANY OTHER GODDESS: Ibid., p. 62

P. 174 ATTRACTION, REPULSION, POLARIZATION: Schwaller de Lubicz, *Nature Word*, p. 64

WE ARE LIVING: C. G. Jung, *The Undiscovered Self* (London, 1958), cited in Begg, *Cult of the Black Virgin*, p. 127

P. 178 POWERFUL, MATURE, HORNED: Ibid., pp. 79–80

FATHER EARTH IS THE GREEN MAN: Starhawk, *Dreaming the Dark* (Boston: Beacon Press, 1982), p. 87

P. 186 THE "PARADISE ELEMENT" . . . LONG AGO WHEN THE EARTH WAS SOFT: Charles H. Long, *Alpha: The Myths of Creation* (New York: Collier Books, 1963), pp. 21, 59

P. 187 THESE PERSONS CONTINUE TO APPEAR: Hillman, *Re-Visioning*, pp. 34, 36

THE IMAGINED BEINGS: C. S. Lewis, "The Dethronement of Power," in *Tolkien and the Critics*, ed. Neil D. Isaacs and Rose A. Zimbardo (Notre Dame, Ind.: University of Notre Dame Press, 1968), p. 15

ARCHETYPAL PERSONS STRIKE US . . . WE WOULD FIND OURSELVES:
Hillman, *Re-Visioning*, pp. 41, 42

P. 193 DETACHMENT, DISPASSION: Ibid., p. 132

ARISTOCRACY IS ABOVENESS . . . ICY EYE-SPEAR: Camille Paglia,
Sexual Personae: Art and Decadence from Nefertiti to Emily Dickinson
(New York: Vintage Books, 1991), pp. 73, 74

V. The Voyage Home

P. 203 HONOURED BY IMAGES OF THE FEMININE: Begg, *Cult of the Black
Virgin*, p. 75

ALL OF LIFE COMES OUT OF WATER: Clift and Clift, *Hero Journey
in Dreams*, pp. 46–47

P. 214 THE LUMINOSITY OF DAILY LIFE: Ginette Paris, "Lifestyles of
the Gods and Goddesses," paper delivered at the Festival of
Archetypal Psychology, University of Notre Dame, Indiana,
July 10, 1992

P. 217 YOU WOULD NOT BE LOOKING FOR ME: Ibid.

P. 222 THE VISUAL IS NOT TAUGHT: Donald Richie, *A Lateral View: Essays
on Culture and Style in Contemporary Japan* (Berkeley, Calif.: Stone
Bridge Press, 1992), p. 19

P. 226 WATERFALLS, GREAT TREES, DEER: R. H. Blyth, *Haiku*, vol. 1 of
Eastern Culture (Tokyo: Hokuseido, 1949), p. 158

P. 233 A TINY TREE: Richie, *Lateral View*, p. 13

MY WIFE DOES FLOWER ARRANGING: Kazuhiko Higuchi, "Death
Poems: Dying in Beauty," paper delivered at the Festival of
Archetypal Psychology, University of Notre Dame, Indiana,
July 11, 1992

P. 237 HESTIA WAS PRESENT: Ogrizek, ed., *World in Color*, p. 72

LIKE THE HOUSEHOLDS: Ibid.

P. 240 THE REAL PLACE: Miller, *Colossus of Maroussi*, p. 80

Biography

Thomas McKnight is an artist somewhat out of sync with his times. Born in Lawrence, Kansas, in 1941, by generation he should have been an early pop artist or a late neo-expressionist. But he came of age artistically during the 1970s, when art had practically done itself in with minimalism and conceptual experimentation. His

THOMAS AND RENATE McKNIGHT

work, full of color and image, seems to be a reaction to that gray decade.

McKnight discovered art at about thirteen when his mother gave him a set of oil paints, and his first painting—a snowy castle on a hill—was not unlike some of those he still creates. When he was sixteen, McKnight's choice of career was confirmed by the famous designer and art director of *Harper's Bazaar*, Alexey Brodovitch, who told him that he "had it."

After growing up in various suburbs of Washington, D.C., Montreal, and New York, he attended Wesleyan University, a small liberal arts college in Middletown, Connecticut, where he was one of only five art majors. Perhaps this fostered his independent, even eccentric, approach to the art "isms" of his time. He spent his junior year in Paris where he developed a lifelong love of European civilization. After a year of graduate work in art history at Columbia University, McKnight decided against pursuing a career as an art professor or curator. In 1964 he found a job at *Time* magazine where he would work for eight years, interrupted by a two-year stint in the army in Korea. McKnight held many jobs at *Time*, beginning as a file clerk and ending by writing advertising copy.

During a vacation in Greece in 1970, McKnight realized that life in a corporation was not for him. He had been reviewing art for a radio program around that same time, and it became clear to him that the art currently popular was not his cup of tea either. Two years later, with the cushion of his profit-sharing plan, he left *Time*, summered on the Greek island of Mykonos, and commenced painting in earnest.

His work began to sell, although slowly, in America and Germany. In the early 1980s he discovered a larger audience by creating limited edition serigraph prints. By then he had found that, for his work, the silkscreen technique was a natural choice— its brilliant colors and clean shapes echoed his own visions.

In 1979 in Mykonos, McKnight finally met the muse he had been searching for in Renate, a vacationing Austrian student. The couple married the following year and Renate moved to America.

Throughout the 1980s McKnight's art became increasingly popular, and by the end of the decade he was at the top of his field: four books (including one in Japanese) were devoted to his work, and hundreds of silkscreen editions sold. His art was perhaps even more well-known in Japan, where he was commissioned to paint a series of views of Kobe for the city's 1993 fair.

Today, McKnight and his wife live in Palm Beach, Florida, in a Mediterranean-style house surrounding a courtyard garden filled with tropical flowers and a fountain. His happiest hours are spent in his tower studio, creating a steady stream of pictures of imaginary and real Arcadias. The search is never ending—there is always another vision to capture that might be better than the last.

Afterword

A sometime fly on the wall at gallery openings of Thomas McKnight's work, I like to overhear the reasons why people are so attracted to it. There are many artists in the world but very few who appeal so widely. A little girl tells McKnight that she, and her cloth rabbit, like the colors. A woman who had been sick in the hospital says that the images made her convalescence peaceful. A businessman cannot articulate his feelings— "They just make me feel good, that's all."

Rarely have I heard someone say they are buying a McKnight solely because it's a good investment, or because it will go up in value. The ultimate merit of Thomas McKnight's work is in the here and now—it is valuable because it stimulates, soothes, and adds a little harmony to the world.

—David Rogath